IAN ASSERSOHN

Dies Irae

A CANTATA

IN REMEMBRANCE

Dies Irae was commissioned by Leatherhead Choral Society and Epsom Male Voice Choir in 2014. It was first performed, by them and under the direction of the composer, on November 26th 2016 in the Dorking Halls, Surrey, at a gala concert to commemorate the centenary of the Battle of the Somme in 2016.

Copyright © 2015 Apple Tree Music

Ian Assersohn has asserted his right under the Copyright, Designs and Patents Act, 1988, to be identified as Composer of this Work.

First published by Apple Tree Music 2015

www.appletreemusic.net

All rights reserved. No part of this publication may be reproduced, stored in a retrieval system, or transmitted, in any form or by any means without the prior permission in writing of the copyright holder, or as expressly permitted by law.

Permission to perform this work in public should normally be obtained from the Performing Rights Society (PRS) 29/33 Berners Street, London W1T 3AB or its affiliated Societies in each country throughout the world, unless the owner or occupier of the premises being used holds a licence from the Society.

Ian Assersohn is a composer, teacher, and choral director living in Surrey, England. He studied composition at the Royal College of Music in London with John Lambert and Koninklijk Conservatorium in Den Haag with Louis Andriessen. Ian's other choral works include *The Song of Songs* (2009), *A Drop O' Nelson's Blood* (2010), *In Memoriam* (2011), *Songs of Catullus* (2012) and many shorter works including the award-winning songs *As The Rain Hides The Stars* and *Crossing The Bar*. More details, including audio samples, are available at ian.appletreemusic.net.

Scoring: Dies Irae is scored for soprano and baritone soli, chorus and small orchestra: strings, trumpet or cornet in Bb, piano and percussion (1 player - snare drum, 2 tubular bells D & A, whip, triangle, glock). The chorus parts may be sung by a single mixed choir but for full dramatic effect three choirs are recommended: upper voice children, SATB mixed choir and lower voice choirs. Some of the movements may also be sung individually.

Duration: approximately 70 minutes

Resources: More copies of this vocal score may be purchased directly from Apple Tree Music. An orchestral conductor's score and parts are also available to hire or buy. Other material may become available over time - please see diesirae.appletreemusic.net for the latest information.

Contact: info@appletreemusic.net

ISBN 978-1-326-53343-4

Composer's Statement

Dies Irae is the most ambitious work I have attempted to date in terms of its structure and scale, and also in its musical and emotional range. The choice of texts was obviously very important and I spent a very long time searching and sifting. My final choices are, I think, powerful and meaningful, if in some cases unexpected.

Using three choirs may seem an indulgence, but they each play very different roles in the piece: the male voice choir and the male soloist represent the combatants, the children's choir represents the spirits of hope and innocence, and the mixed chorus and female soloist represent the rest of us.

Throughout the compositional process I have kept the practicalities of performance very much in mind. I hope that it is as rewarding to rehearse, perform and listen to as it was to write.

Ian Assersohn

Historical Note

The Battle of the Somme, which was really a whole series of battles and engagements, began on 1 July 1916 and lasted for 141 days. It was one of the largest, bloodiest battles in human history. On the first day alone there were nearly 70,000 casualties, and in the battle as a whole more than a million men were wounded or killed.

It was the first really mechanised battle, with heavy use of air power and the first battlefield appearance of the tank. For the British it was also the first combat experience for many members of the army of inexperienced recruits created by Lord Kitchener.

Performance Notes

Many upper voice and lower voice choirs perform without scores and these parts have been written with this requirement in mind.

If movement 10 (Battle) is performed in context then there should be no break between it and 11 (Consolation). If performed alone then it should end with the chord in bar 88.

In 11 (Consolation) the baritone soloist is asked to sing a pianissimo ascending scale finishing on a top A. An *ossia*, finishing on an F, has been provided if the A is out of the performer's range but a falsetto A would be preferable solution.

Although Dies Irae is best performed by three separate choirs it may also be performed by mixed voice choir alone. In this case, and if the choir is not large enough to allow for all the parts to be successfully performed, then the following suggestions are offered:
- 1 - **Memorial**. Omit the upper voice part starting at figure C.
- 6 - **Hymn**. Omit the lower voice part. Other performance suggestions are in the score.
- 10 - **Battle**. Tenors and basses switch to the lower voice staves at bar 75.
- 14 - **Elegy**. Use the alternative SATB version on p.118
- 15 - **Threnody**. Altos sing the upper voice part after bar 131. Tenors and basses sing the lower voice part from bar 133

CONTENTS

	Page

1. **Memorial:** In memoriam (Easter 1915) 1
 Baritone, upper voices and SATB chorus

2. **Exhortation:** England, to her sons 8
 Soprano, SATB chorus and lower voices

3. **Valediction:** Farewell, my own true love 21
 Soprano, baritone and SATB chorus

4. **March:** When they were up they were up 26
 Upper voices and lower voices

5. **Invocation:** Before action 35
 Baritone and lower voices

6. **Hymn:** In the midst of earthly life 41
 Soprano, baritone, upper voices, SATB chorus and lower voices

7. **Foreboding:** I have a rendezvous with death 49
 Baritone and lower voices

8. **Arrival:** At once, as far as angels ken, he views 56
 Baritone and SATB chorus

9. **Covenant:** Be not afraid for the terror by night 60
 Soprano, SATB chorus and upper voices

10. **Battle:** Now storming fury rose 65
 SATB chorus and lower voices

11. **Consolation:** He that shall endure to the end shall be saved 76
 Soprano, baritone and SATB chorus

12. **Longing:** My bonny lies over the ocean 82
 Soprano and upper voices

13. **Petition:** My boy Jack 88
 Soprano and SATB chorus

14. **Elegy:** Fear no more the heat o' the sun 96
 Lower voices

15. **Threnody:** The dead 103
 Soprano, baritone, upper voices, SATB chorus and lower voices

 Appendix: Elegy (SATB version) 118
 SATB chorus

Dedication

I am indebted to the committees of Leatherhead Choral Society and Epsom Male Voice Choir for their vision and support, and to my wife Jan for everything.

Sponsors

Bringing this work before the public for the first time was a major undertaking for the commissioning choirs, and so a sponsorship scheme was created, inviting the choir members, with their families if desired, to support the project. That they so happily did so is a wonderful testament to their great generosity and enthusiasm, for which the committees and I are extremely grateful. I would like to extend my personal thanks to all those who supported the project, some of whom wished to remain anonymous.

Some people have generously sponsored individual movements. Their dedications appear in the score at the head of the appropriate movement.

The dedication at the head of the movement 1. Memorial, is my own. The others are by:

2.	Exhortation	**The Triantafillou Armitage family**
3.	Valediction	**Peter Horsfield**
4.	March	**Jim and Liz Cruise, Ann and Alistair Napier**
5.	Invocation	**Owen Rowe, Tony and Angela Rowe, Liz Hall, James, Victoria and Jonathan Rowe, Nick Hall and Alison Thevendra**
6.	Hymn	**Terence and Diana Halfpenny**
7.	Foreboding	**Pam and Charlie Holme**
8.	Arrival	**Oskar Orlygsson and Robin Brown**
9.	Covenant	**Jan and Phil Rouse**
10.	Battle	**David and Christine Bates**
11.	Consolation	**Charles Wood**
12.	Longing	**Helen and Les Hereward**
13.	Petition	**Alison and Graham Hunt**
14.	Elegy	**Lynne Gillespie**
15.	Threnody	**The McCaffry Family**

Many thanks are also due to these sponsors for their generous support:

Alan Ferne; Bernard and Diane Marley; Bob and Jane Butterfield; Chris and Frances Westbey; Colin Davies; Godwyns Onwuchekwa and Justin Inniss; Gordon Rodgers; Graham and Sheila Hill; Joan Stocker; John Marr; Malcolm and Linda Brown; Martin Trenaman; Maurice Buckley; Michael Barber; Norman Cameron; Ray Bishop; Sarah and Andrew Murphy; Tony, Carole and Laura Dunn; Vince Freeman

Baritone solo
Upper voices
SATB Chorus

In loving memory of Betty and Jerrold Assersohn

Dies Irae
1 - Memorial

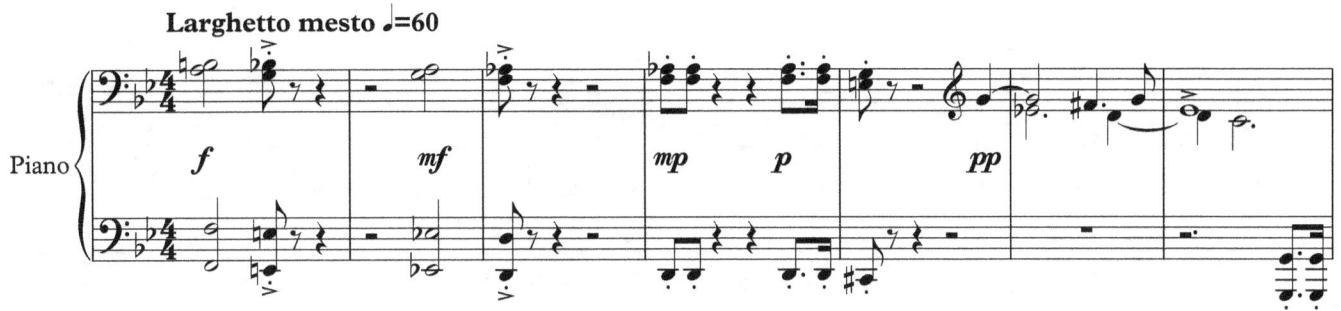

1 - Memorial

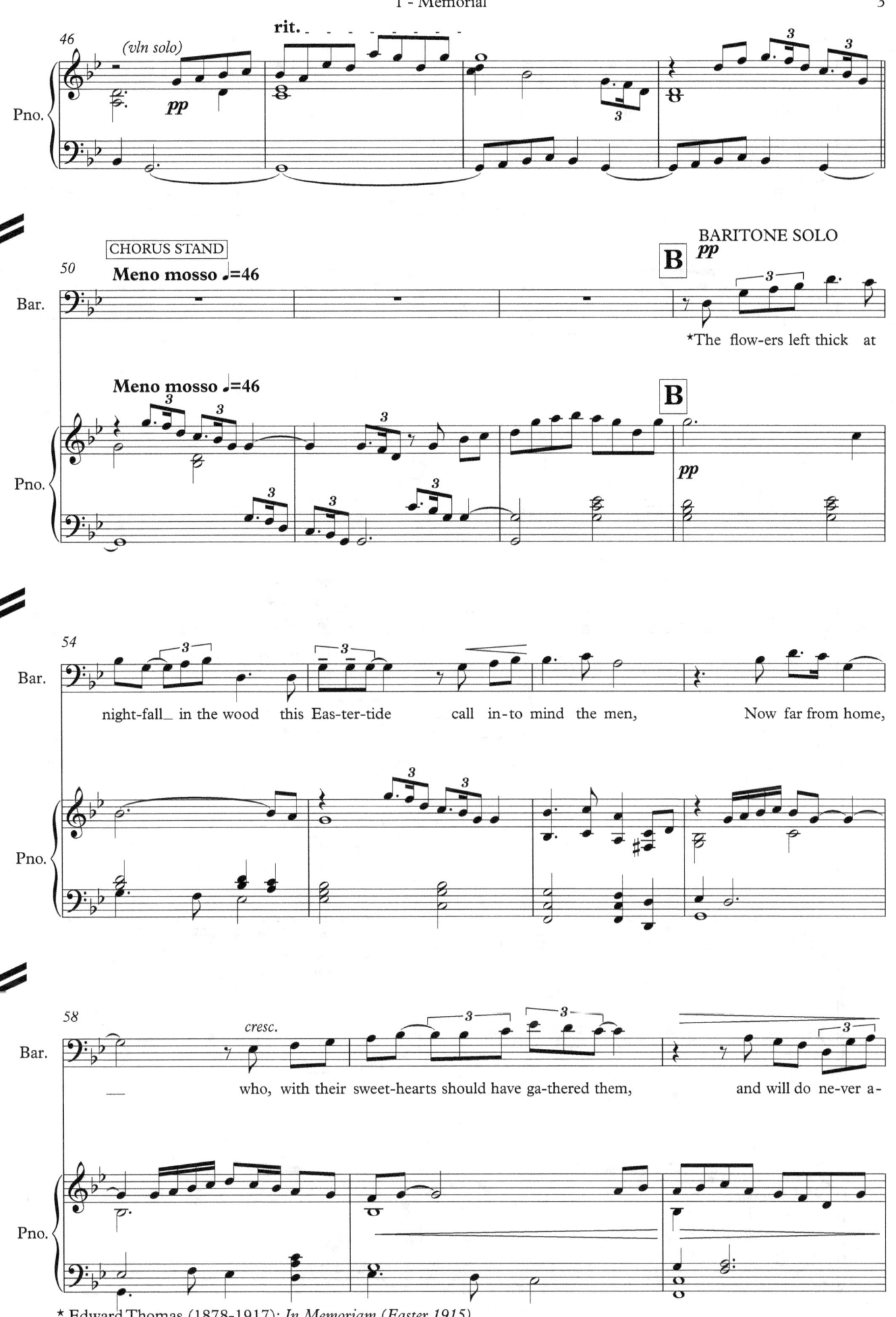

*The flow-ers left thick at night-fall in the wood this Eas-ter-tide call in-to mind the men, Now far from home, who, with their sweet-hearts should have ga-thered them, and will do ne-ver a-

* Edward Thomas (1878-1917): *In Memoriam (Easter 1915)*

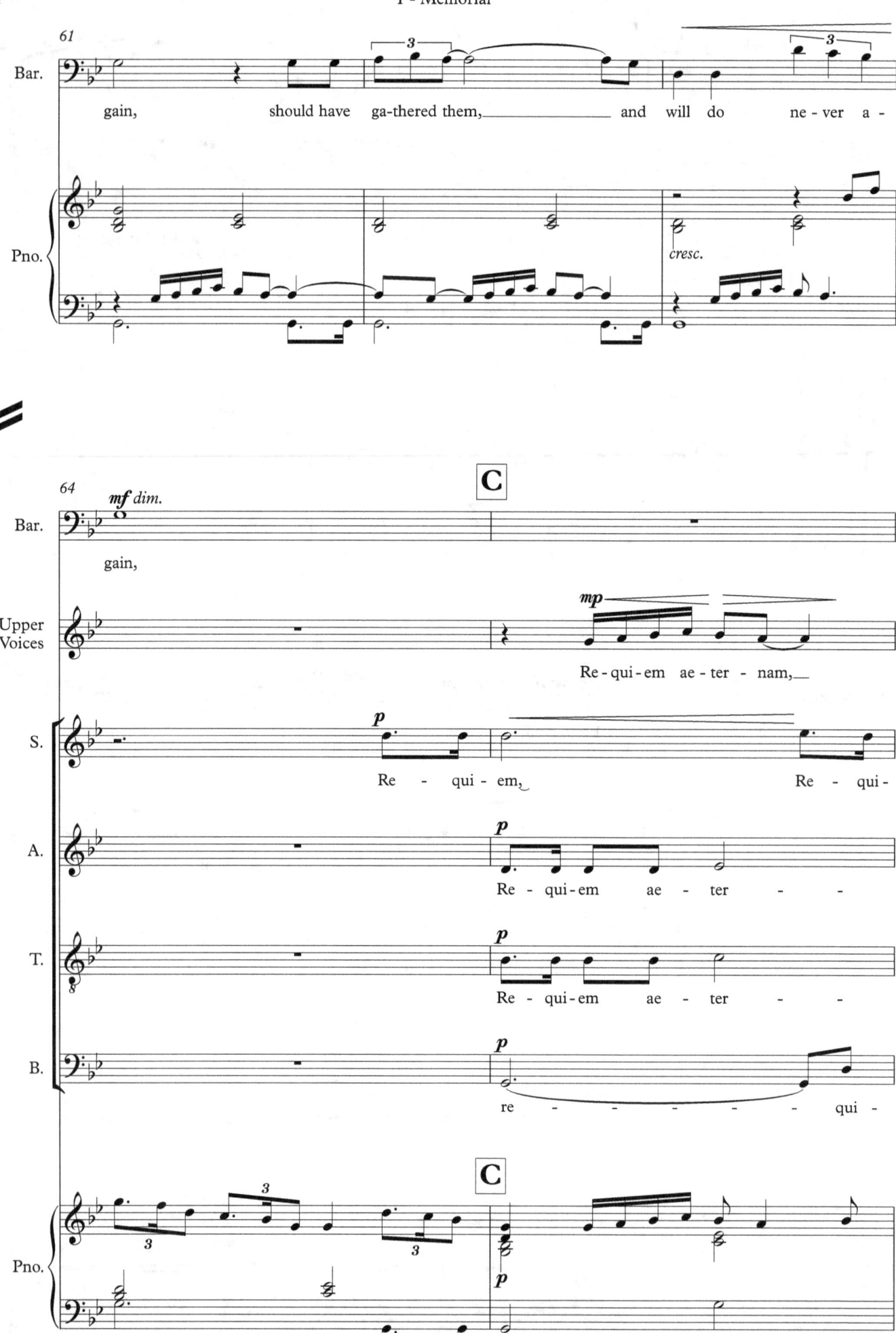

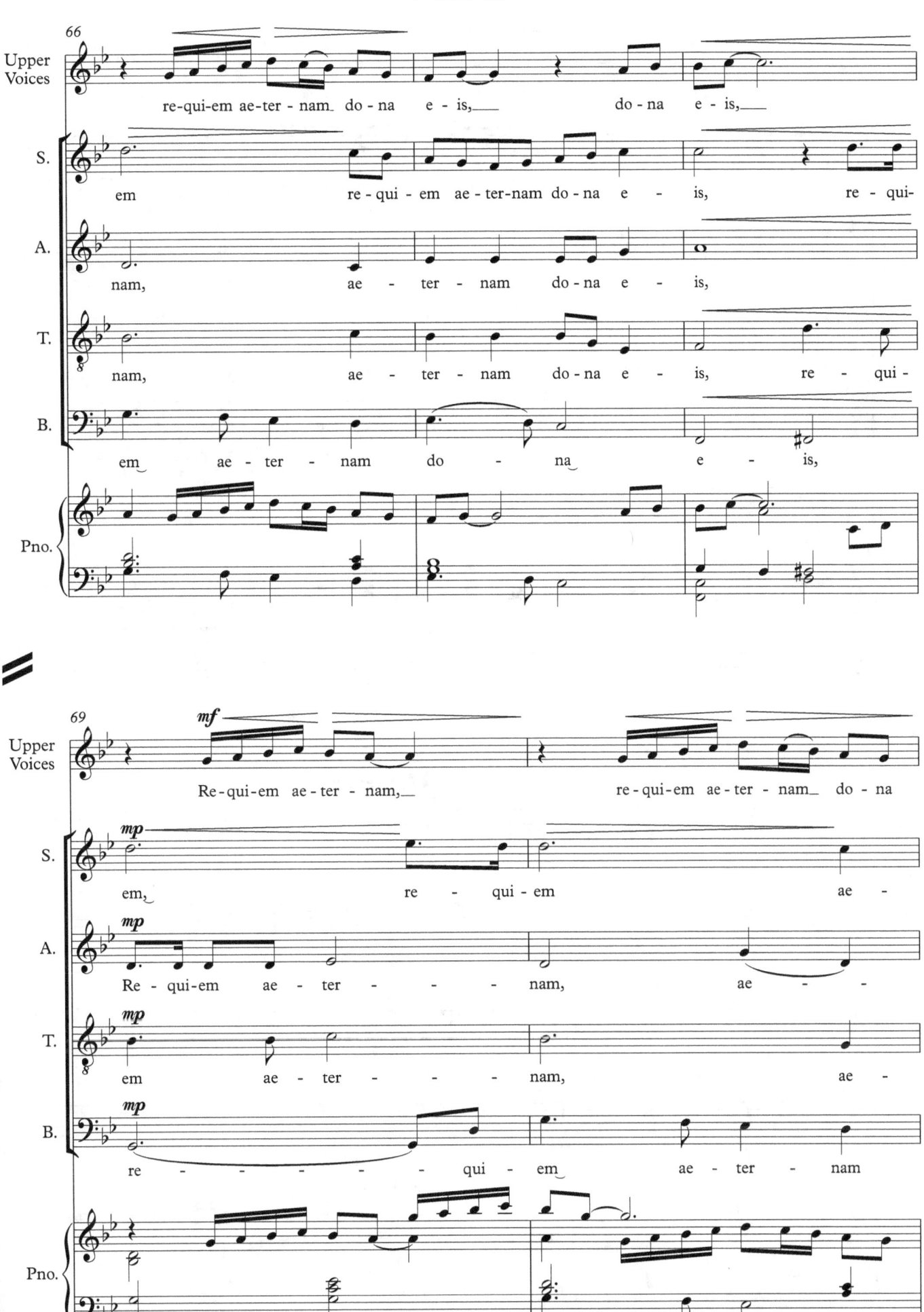

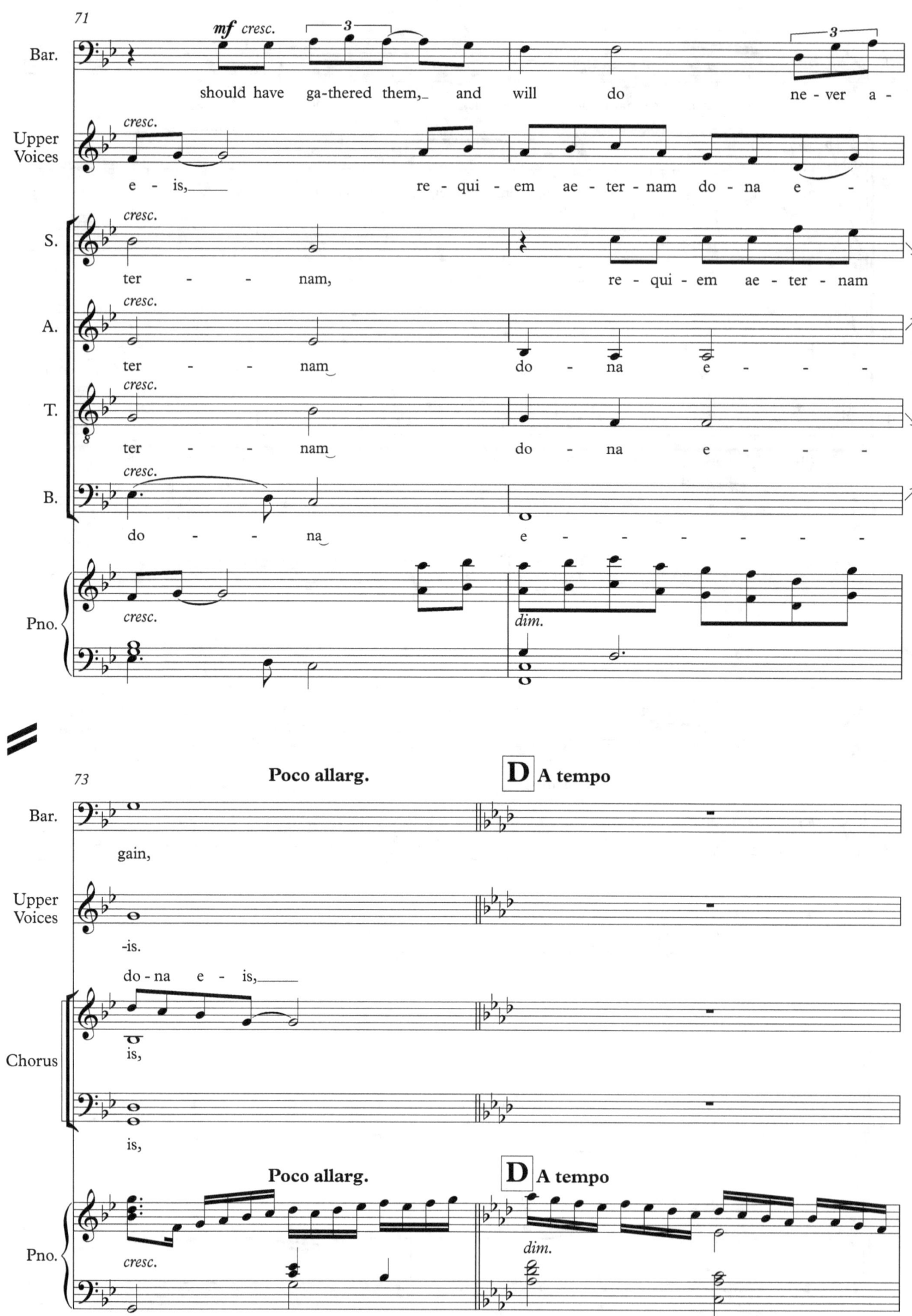

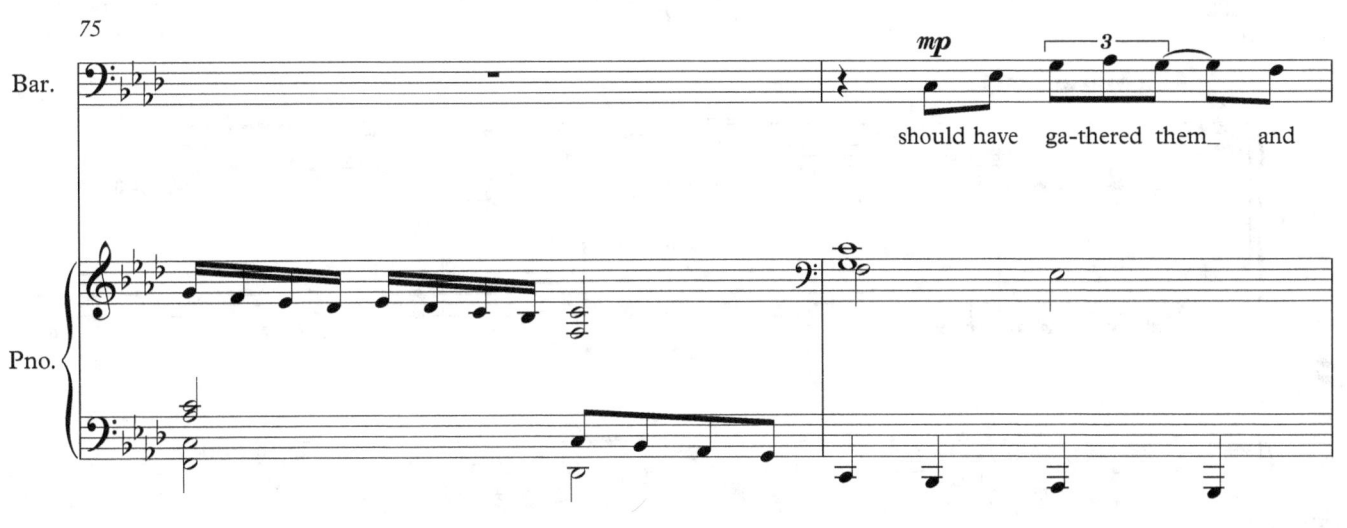

8

For the young Triantafillou Armitages

Soprano solo
SATB chorus
Lower voices

2 - Exhortation

UPPER VOICES SIT
LOWER VOICES STAND

Alla Marcia ♩=112

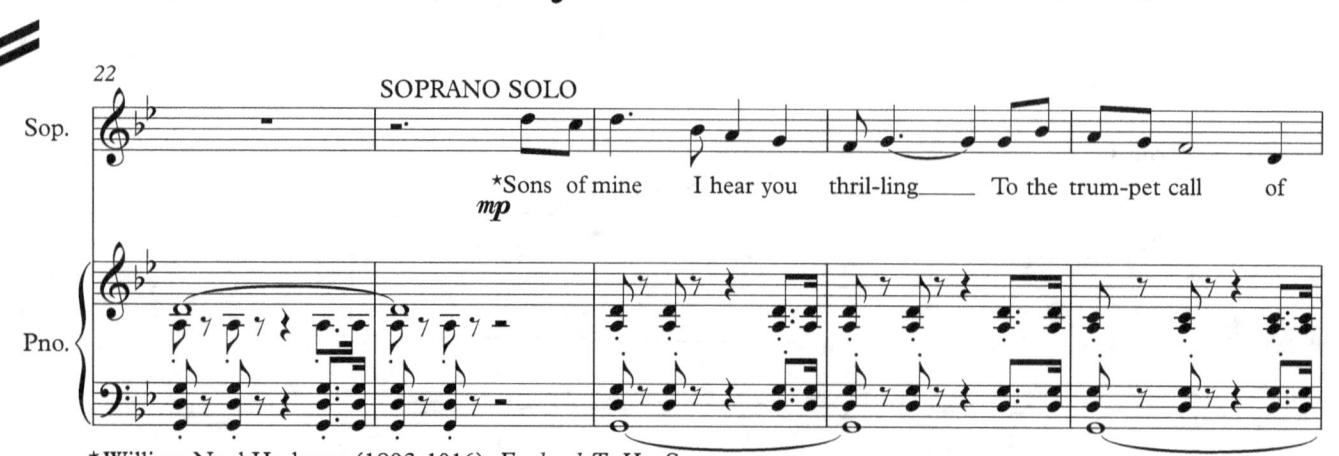

*Sons of mine I hear you thril-ling____ To the trum-pet call of

*William Noel Hodgson (1893-1916): *England, To Her Sons*

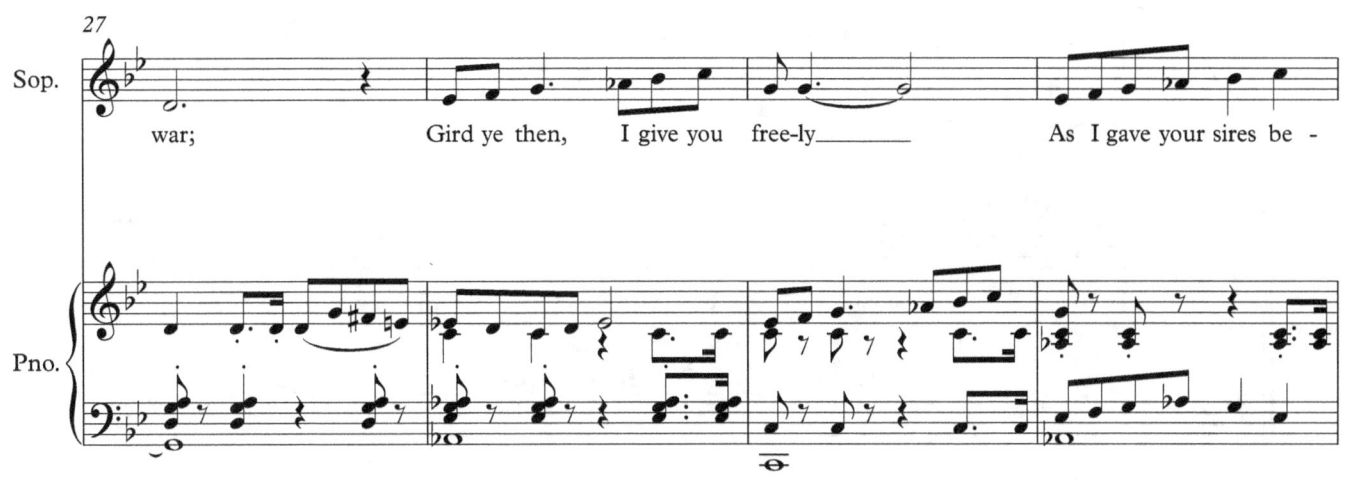
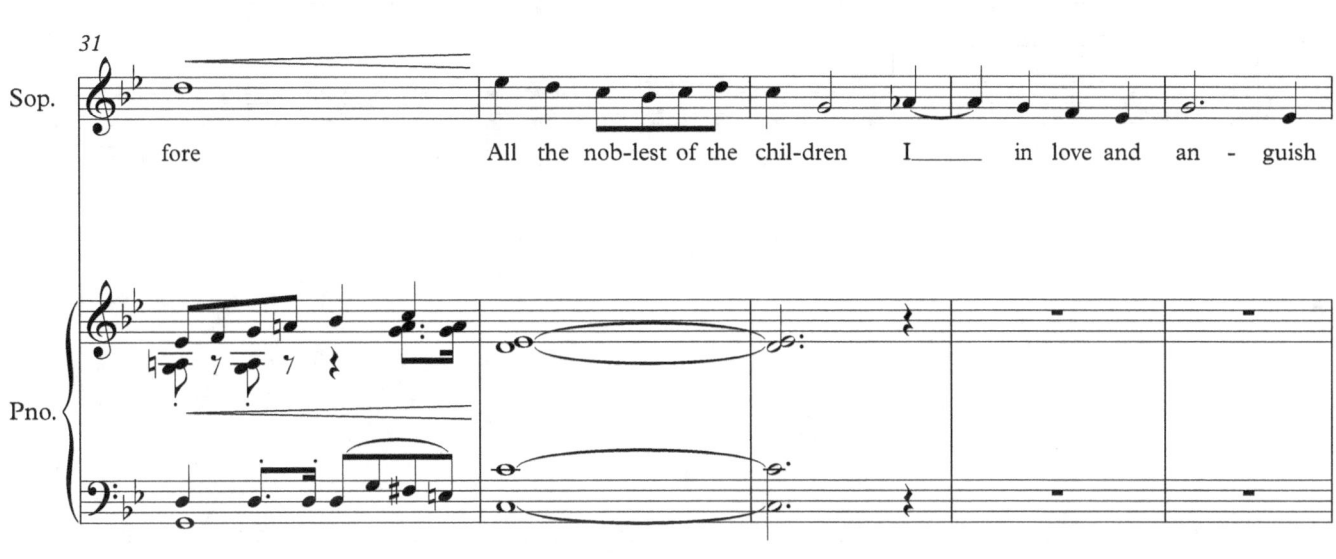

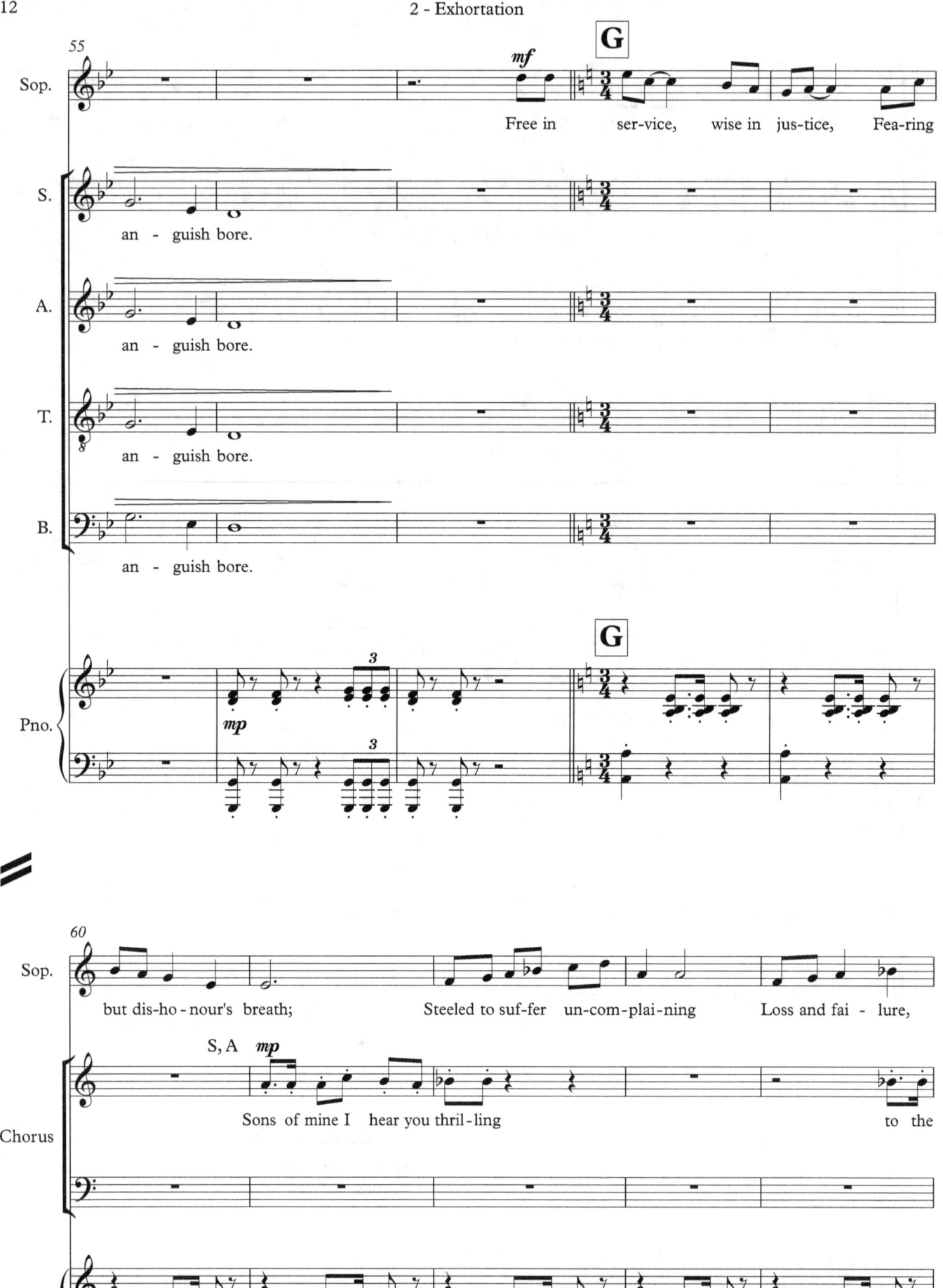

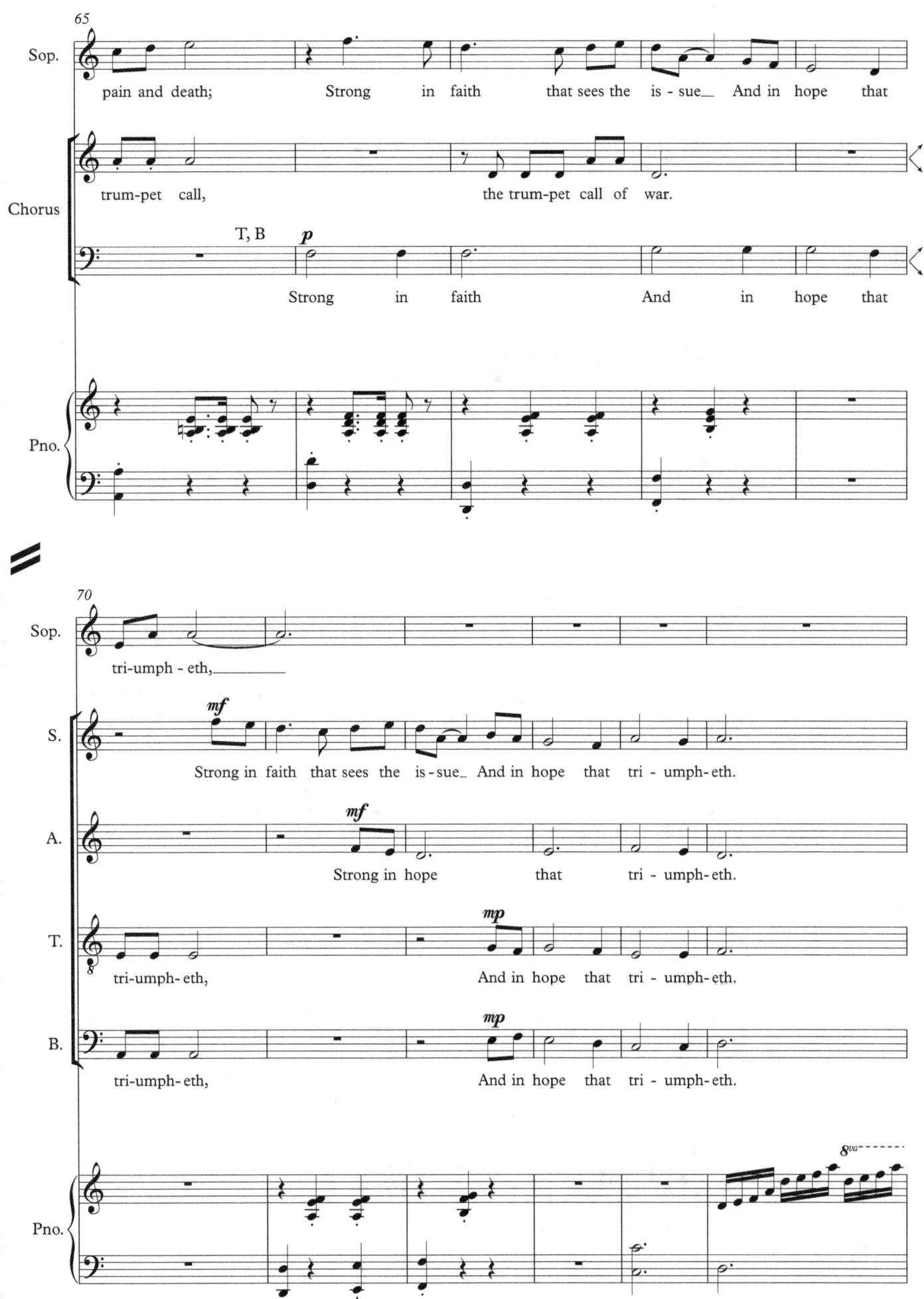

2 - Exhortation

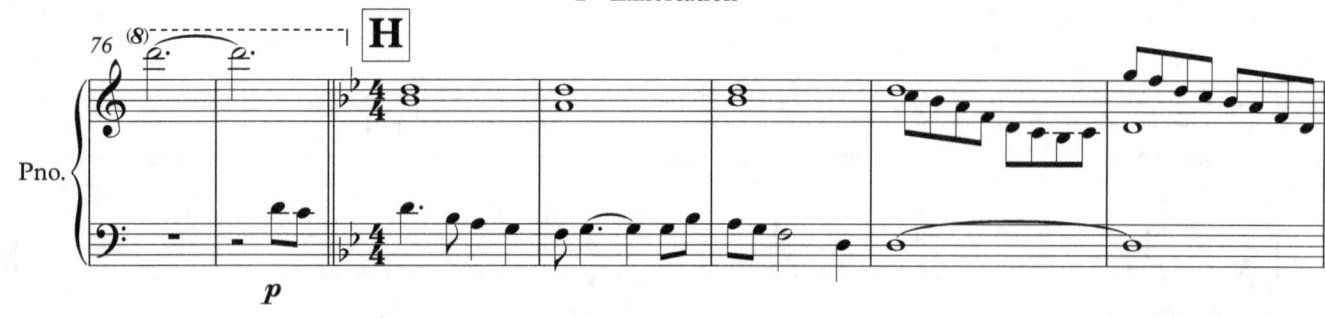
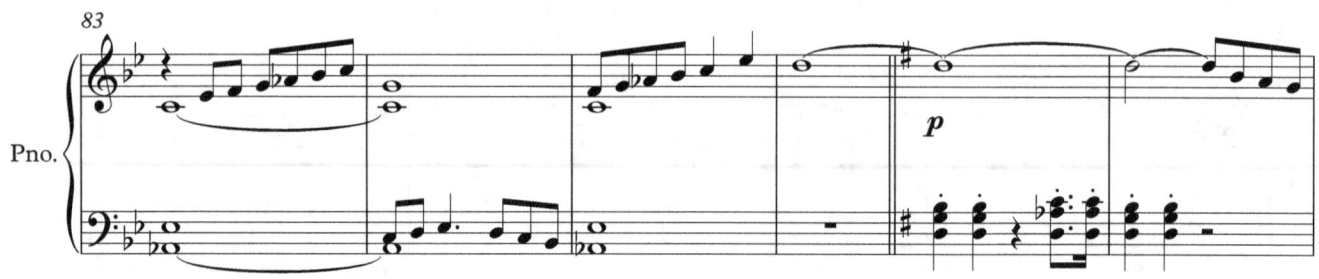
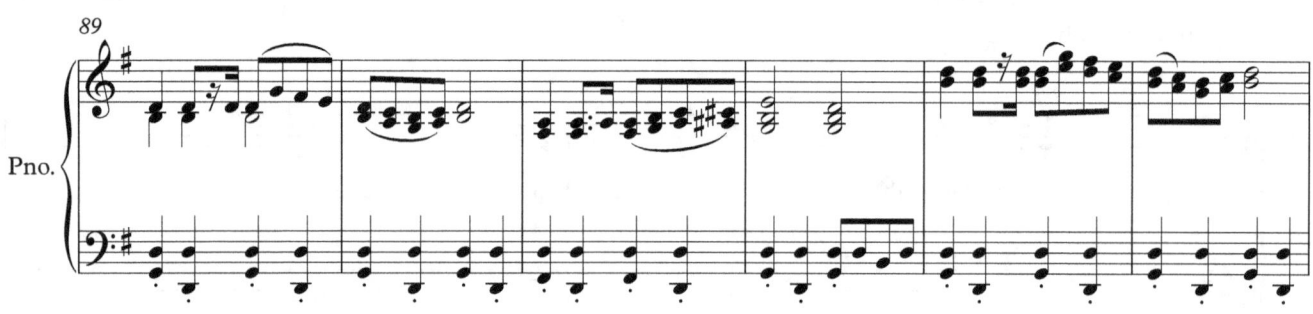
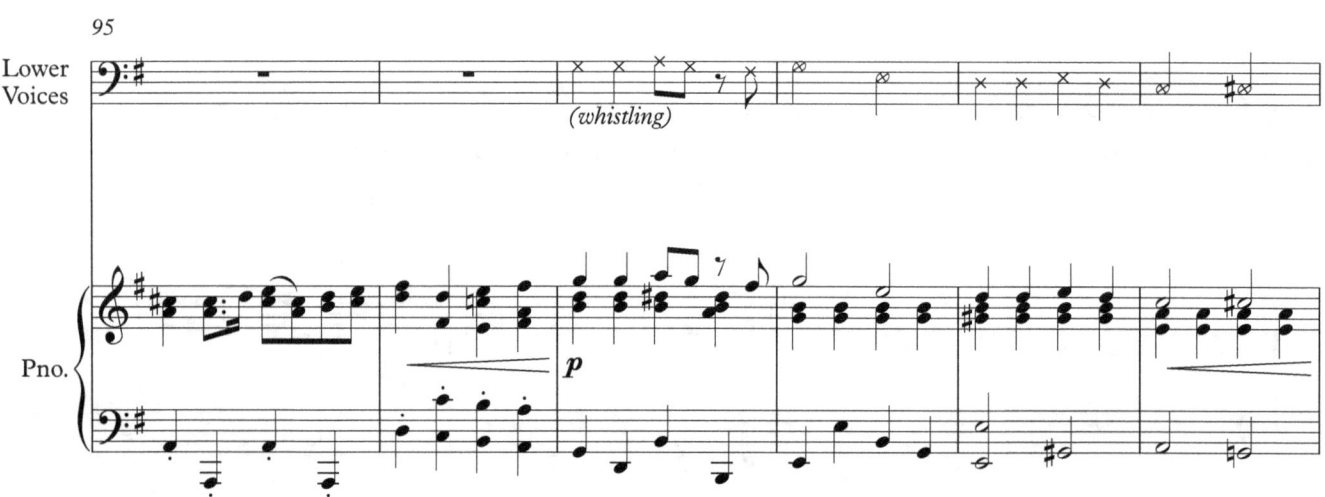

2 - Exhortation

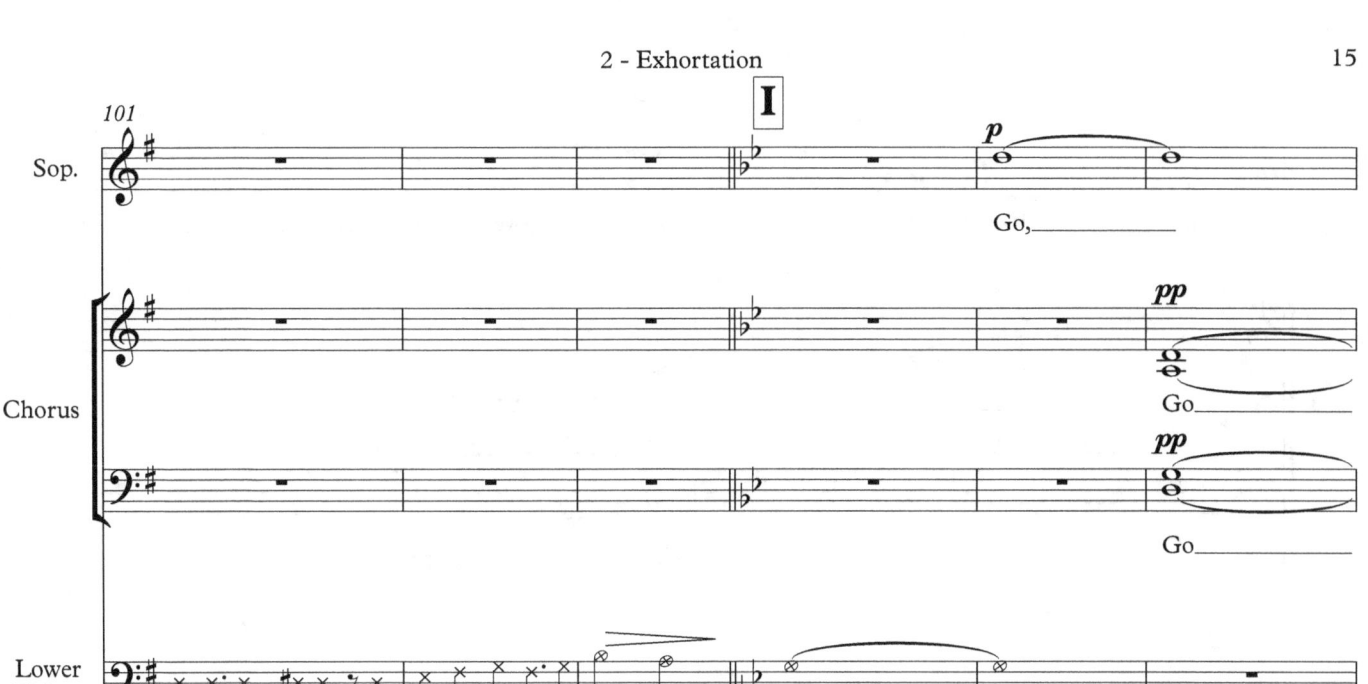

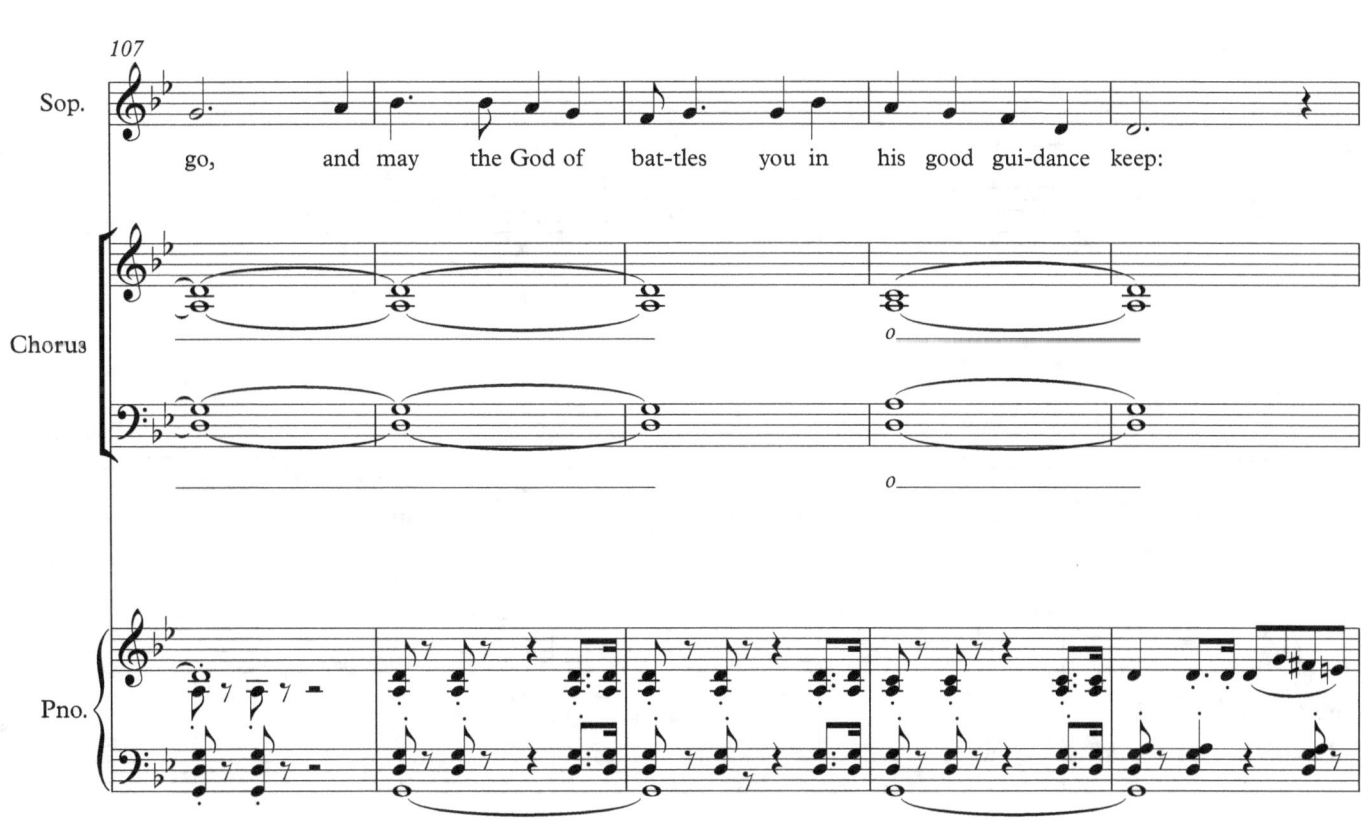

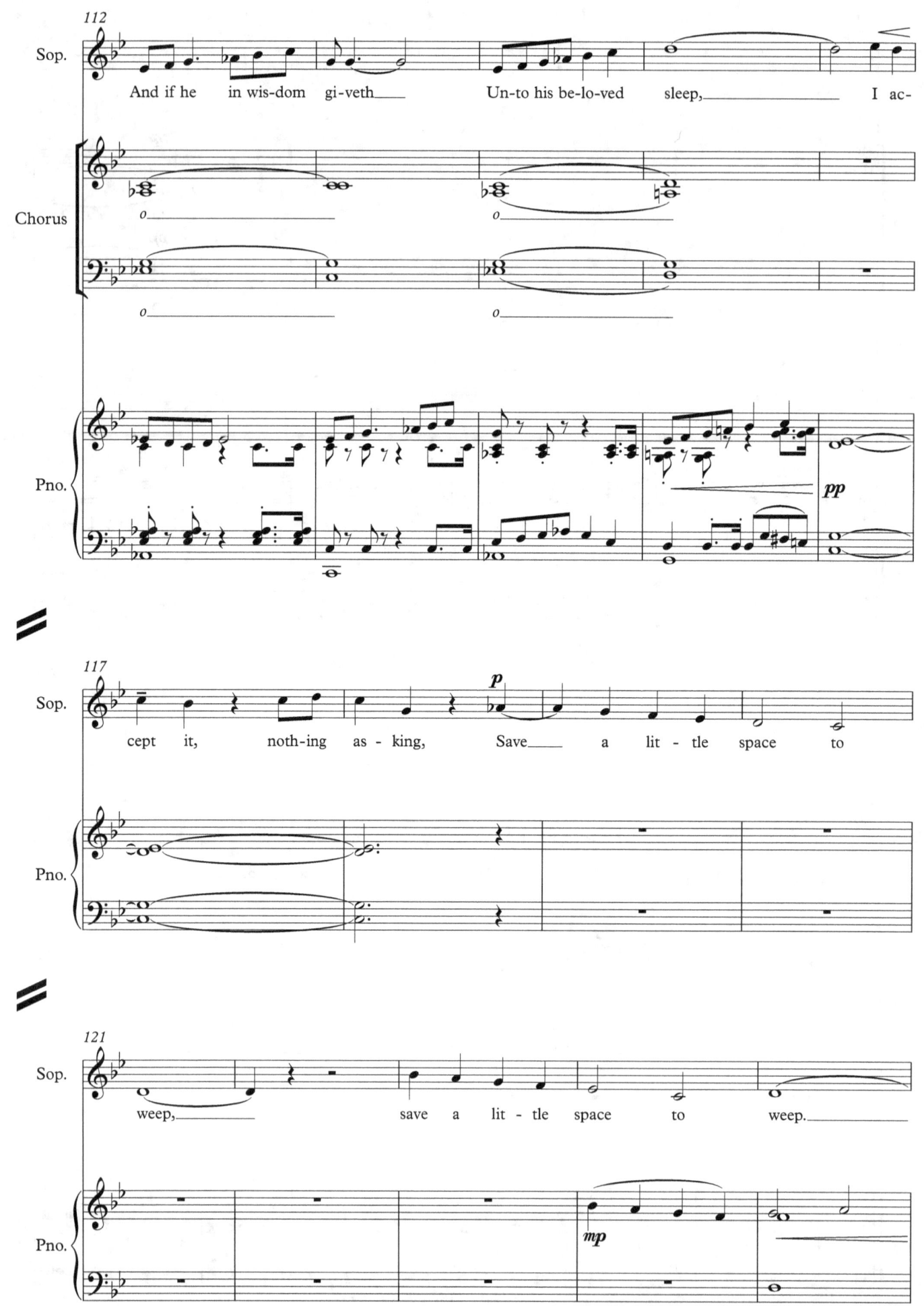

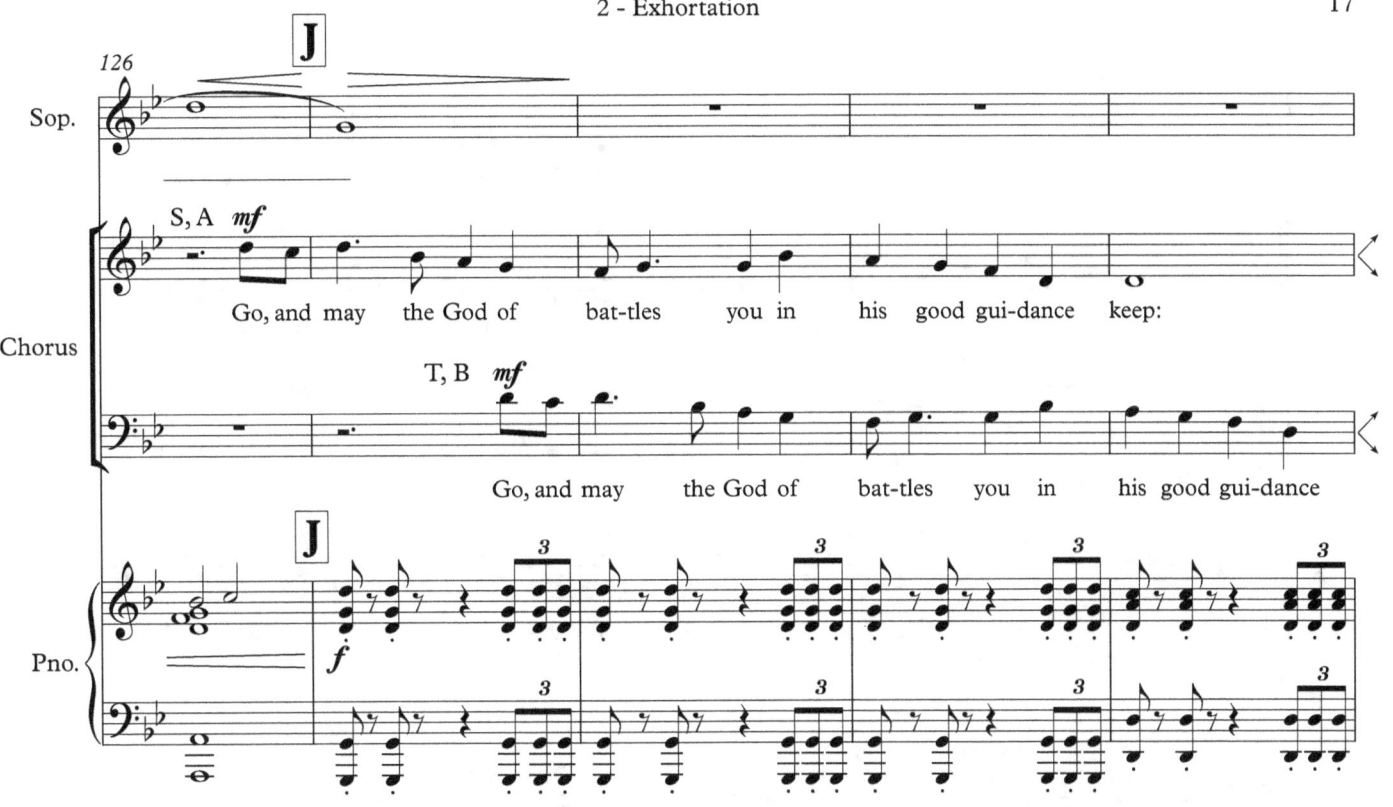

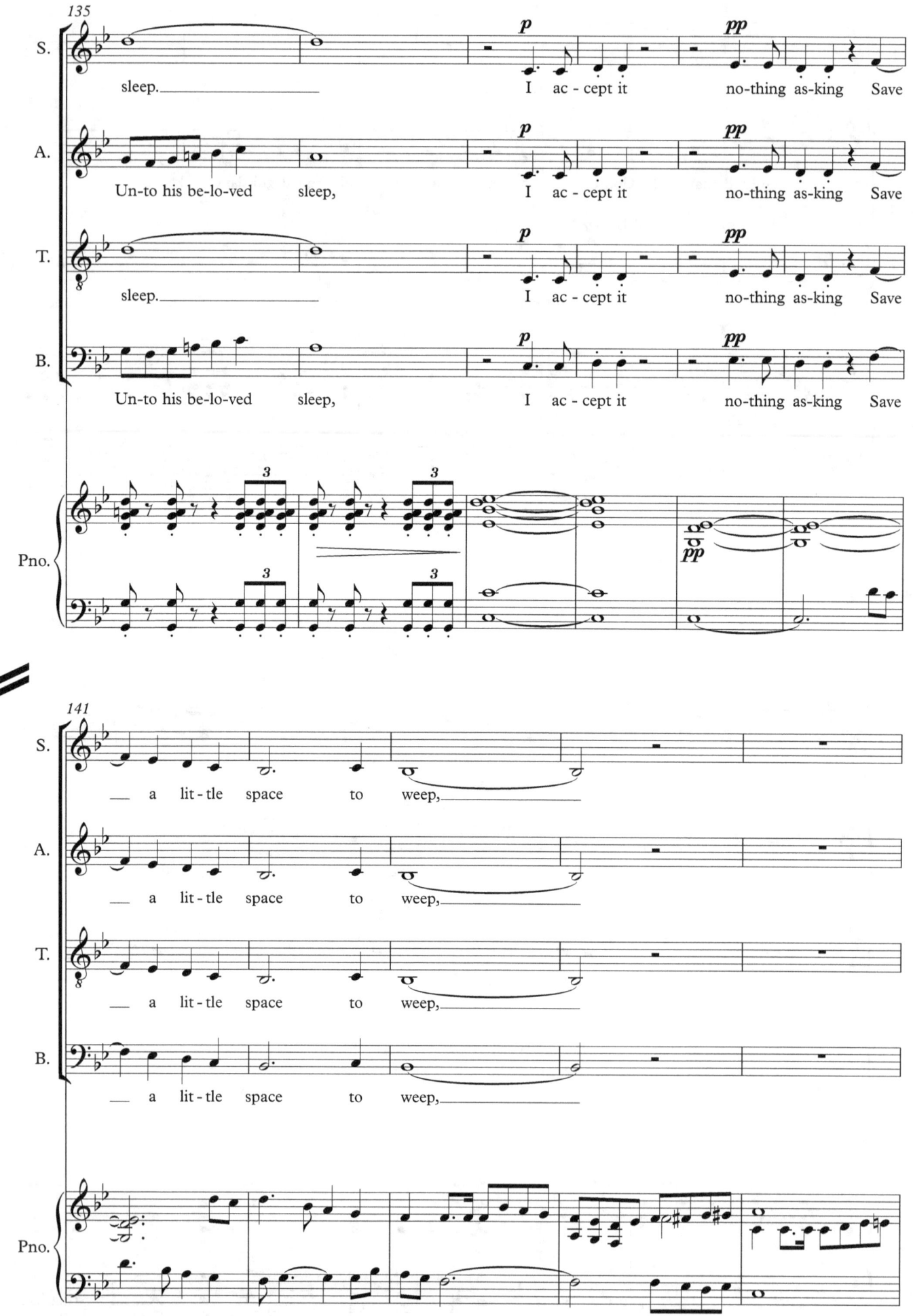

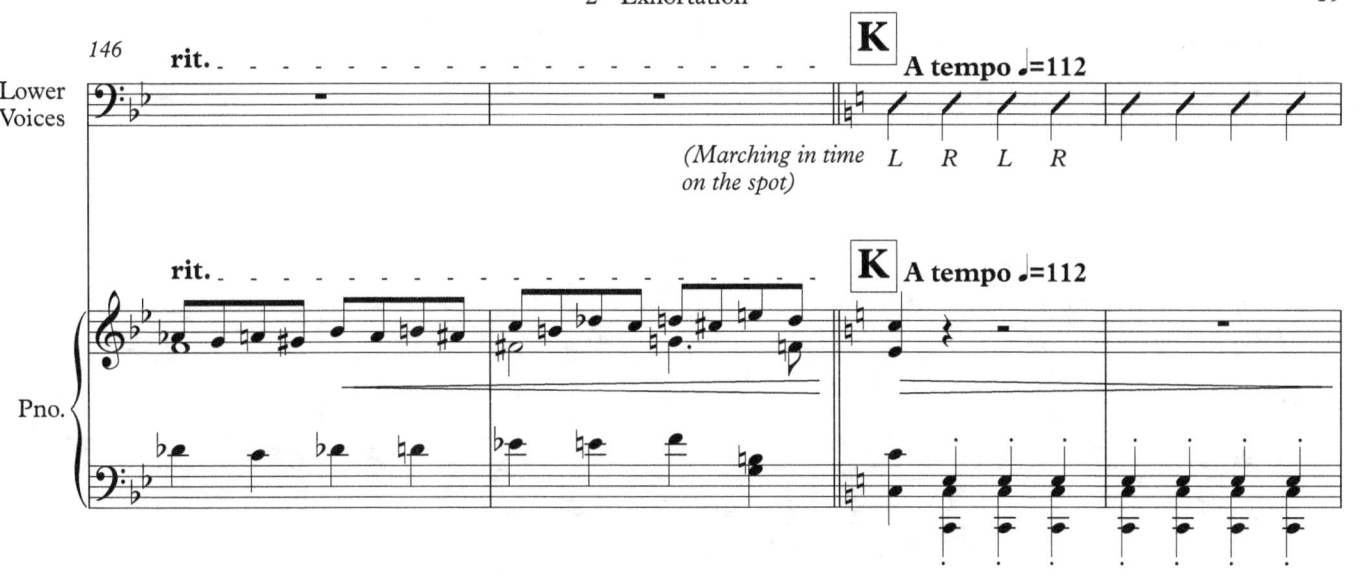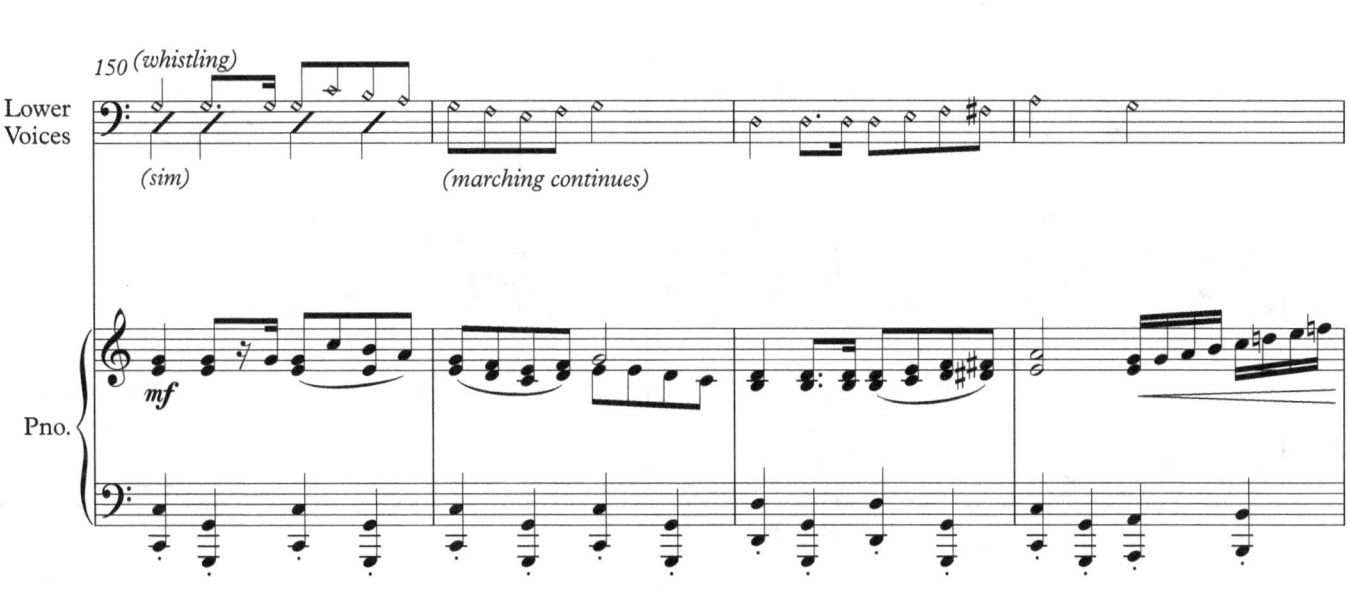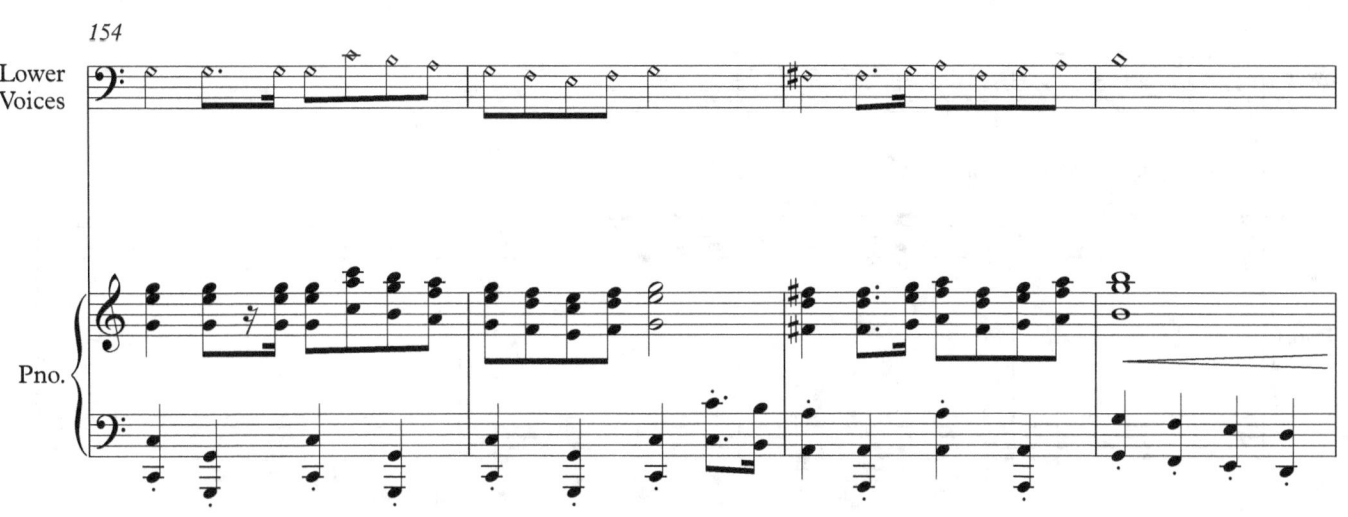

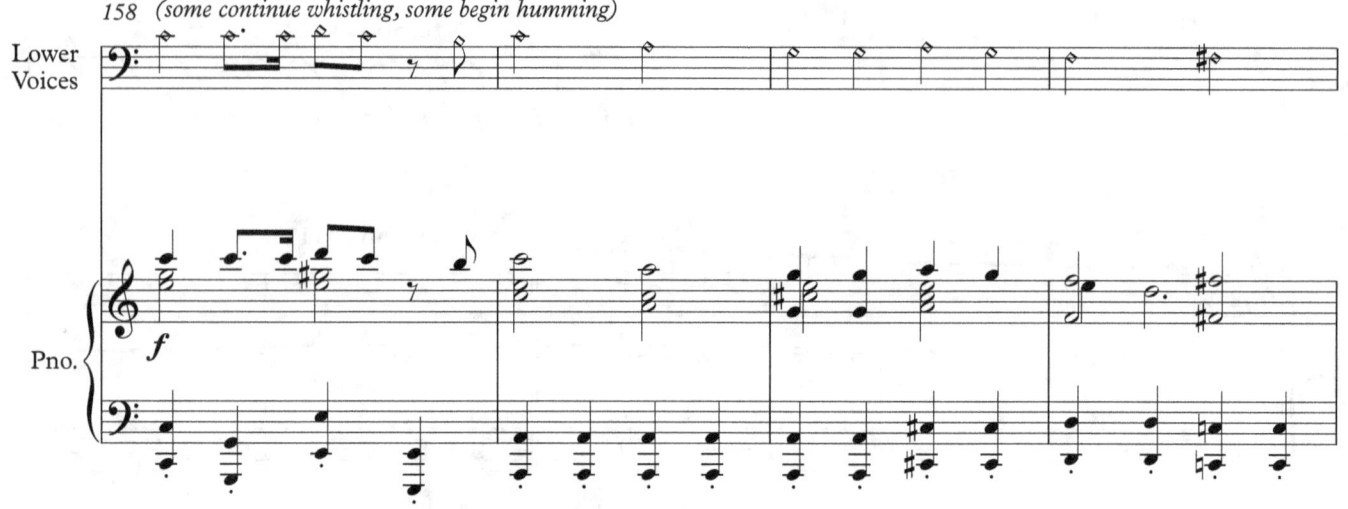

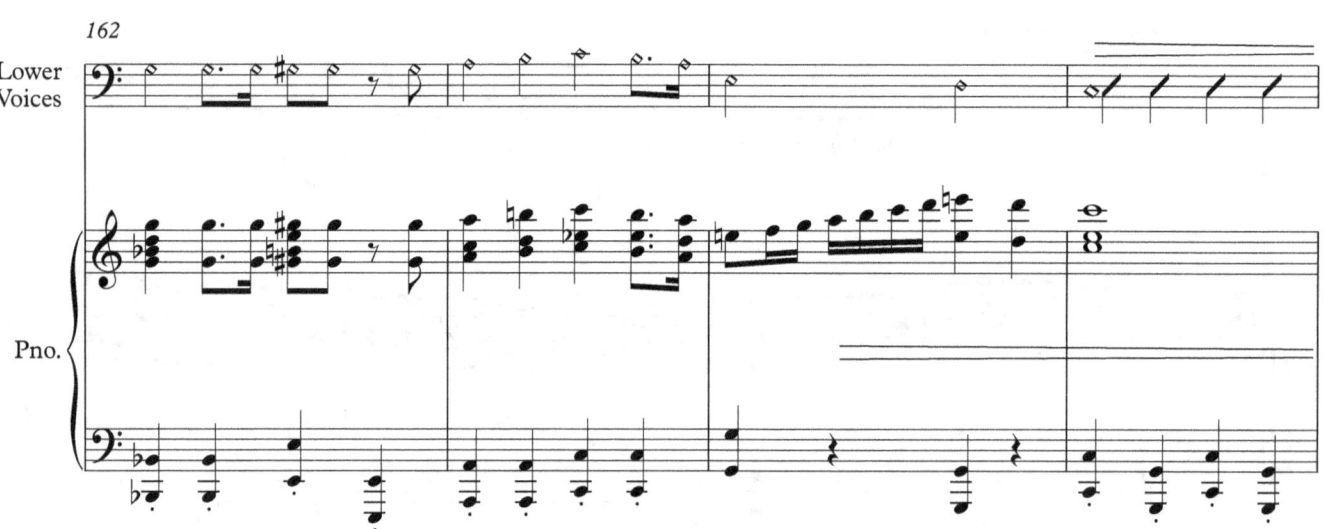
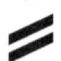

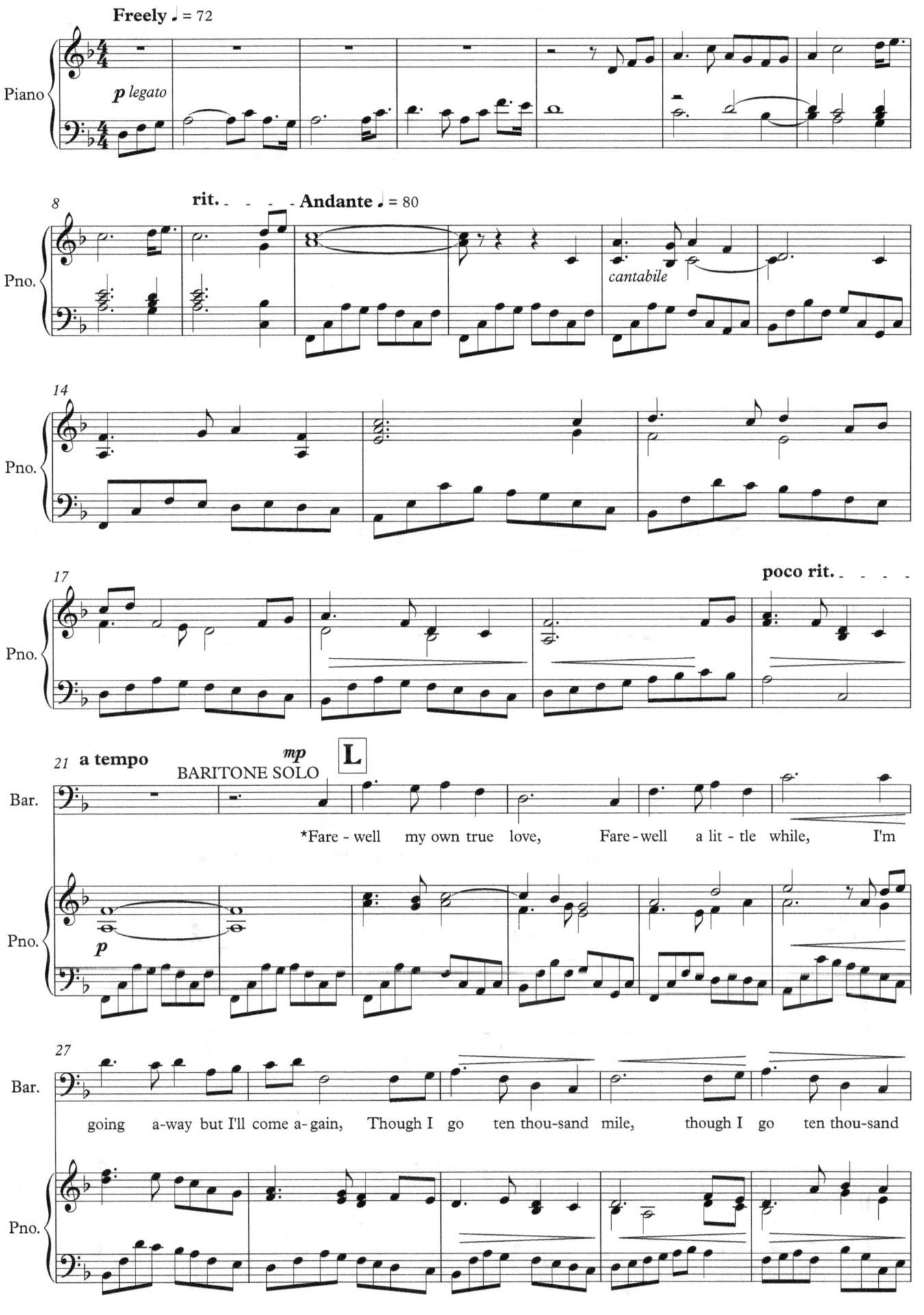

*18th Century folk ballad

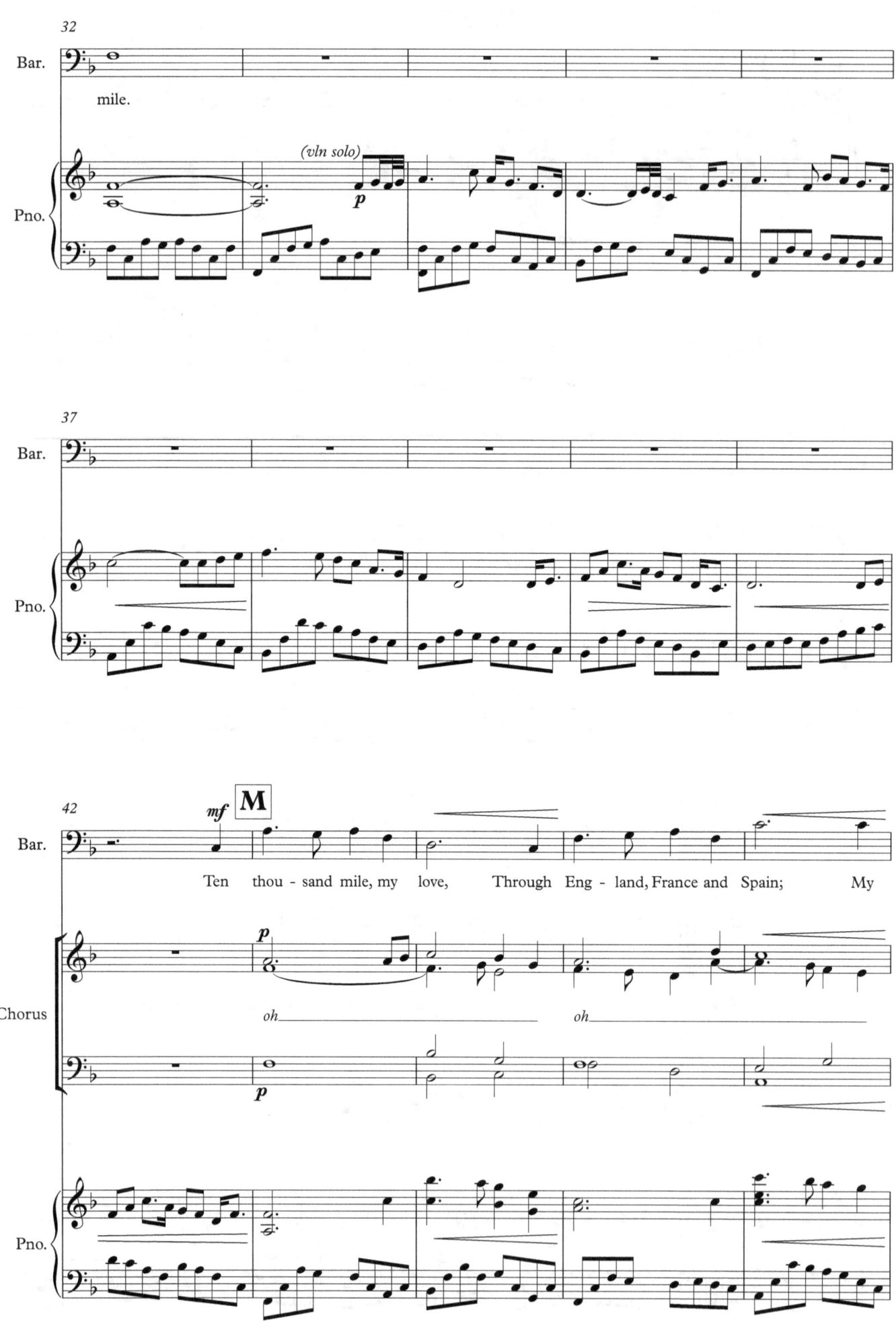

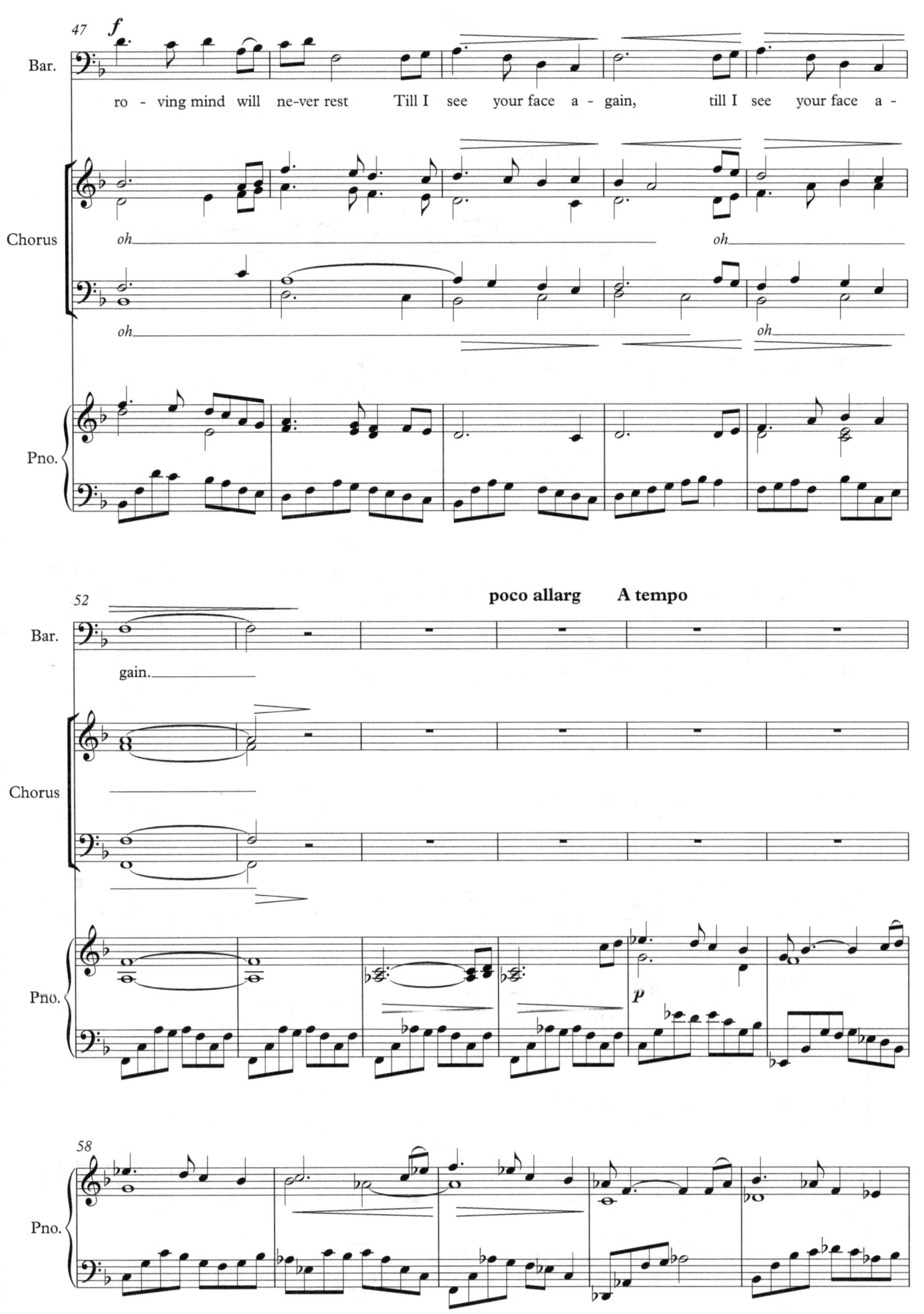

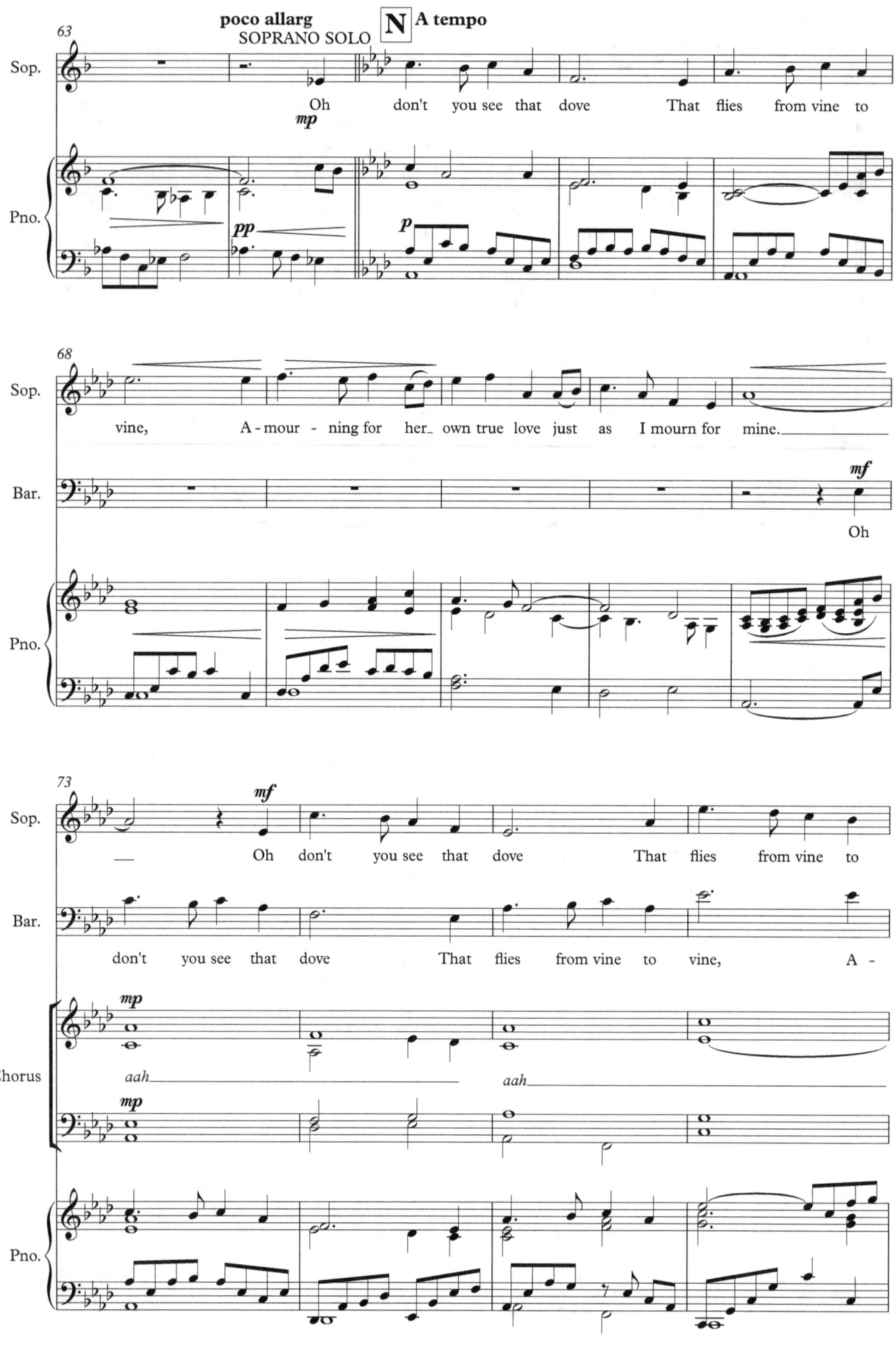

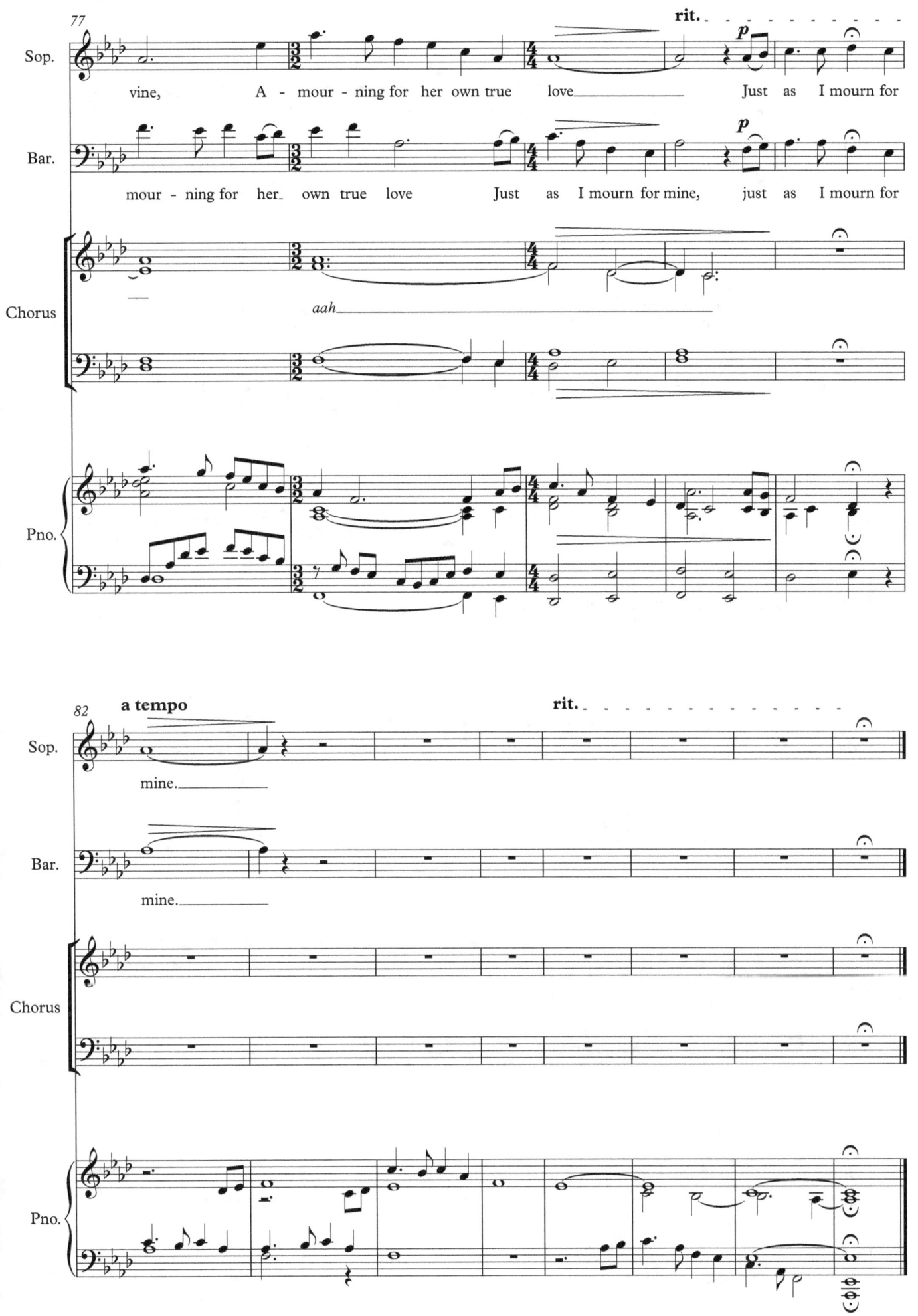

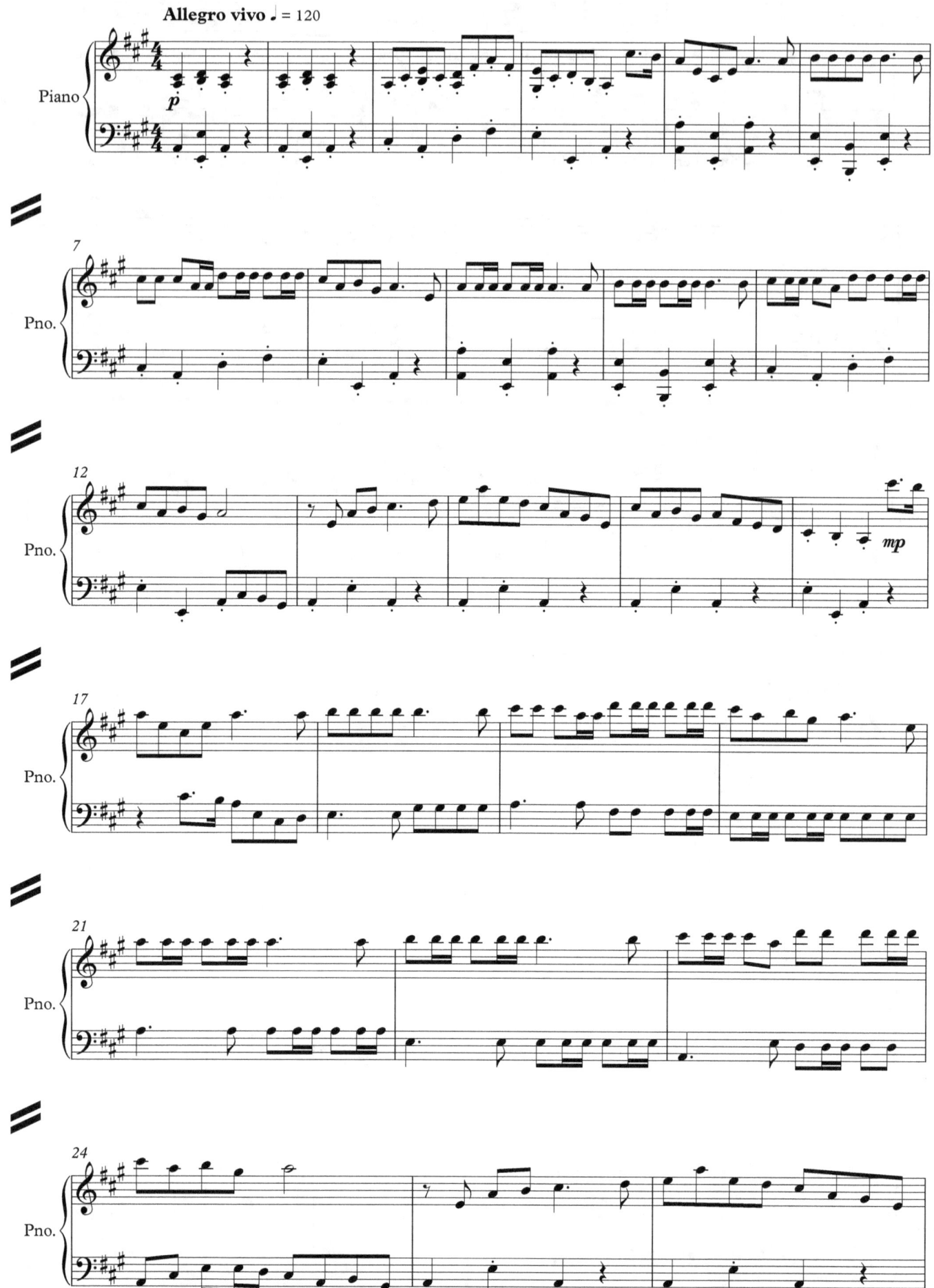

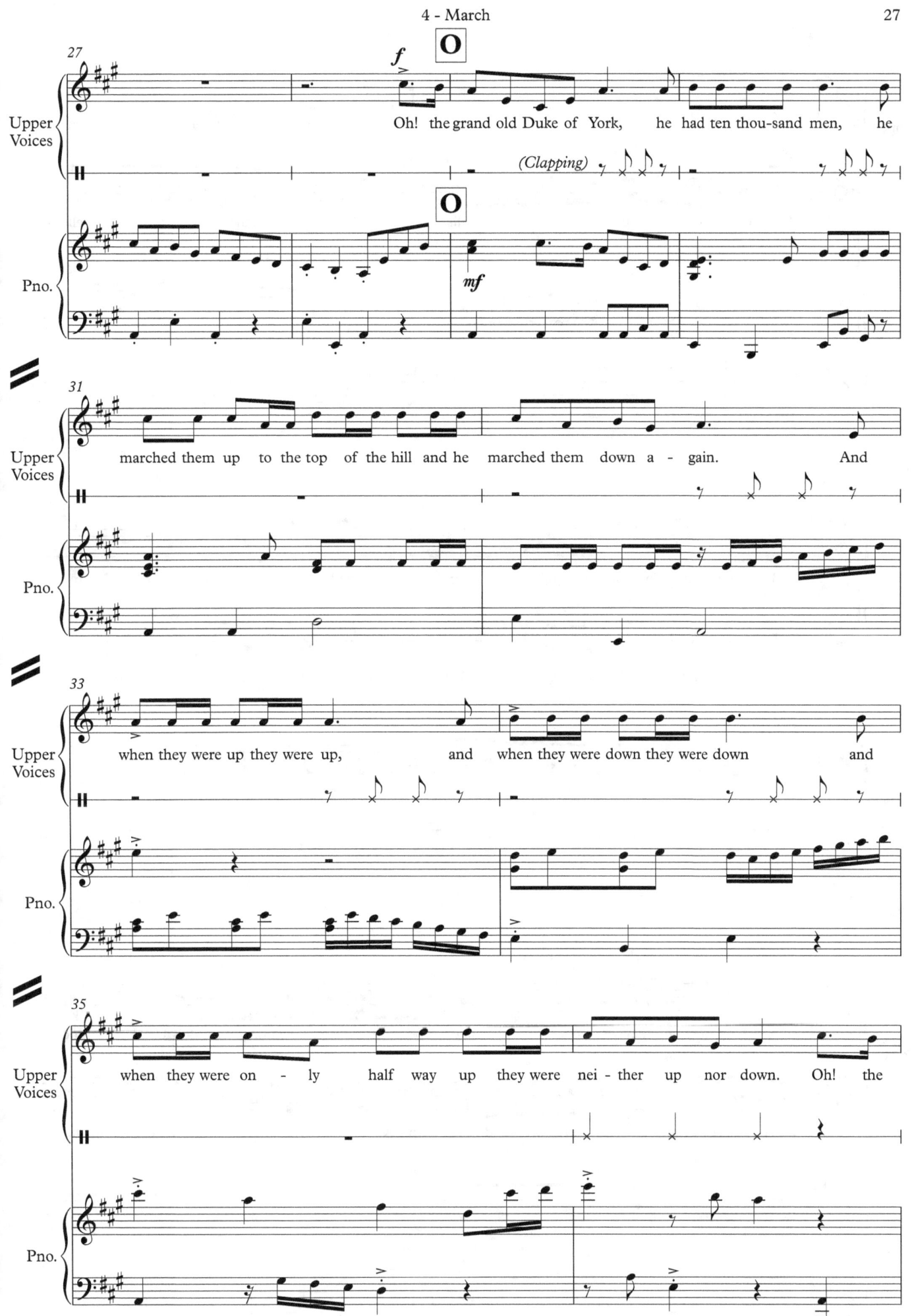

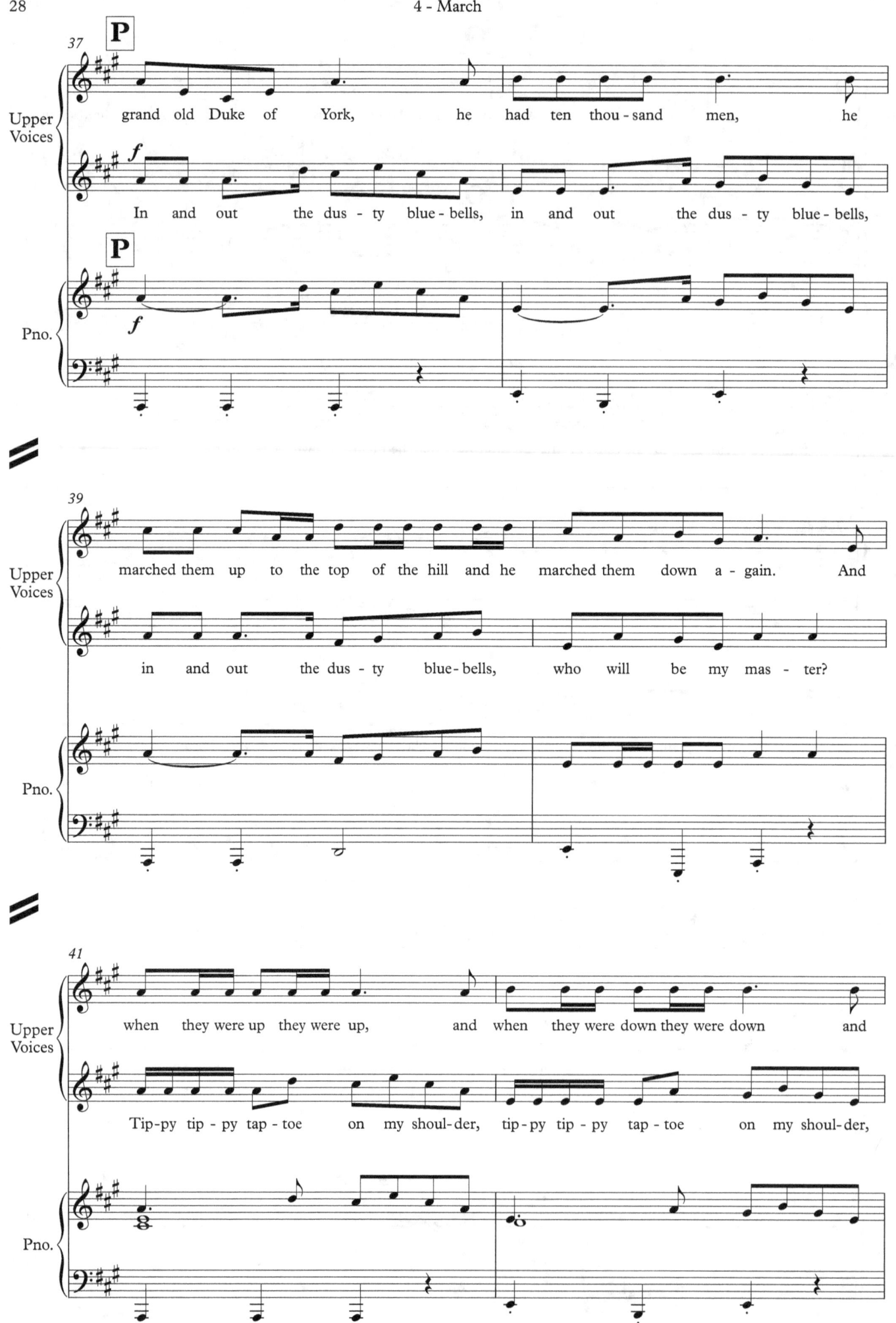

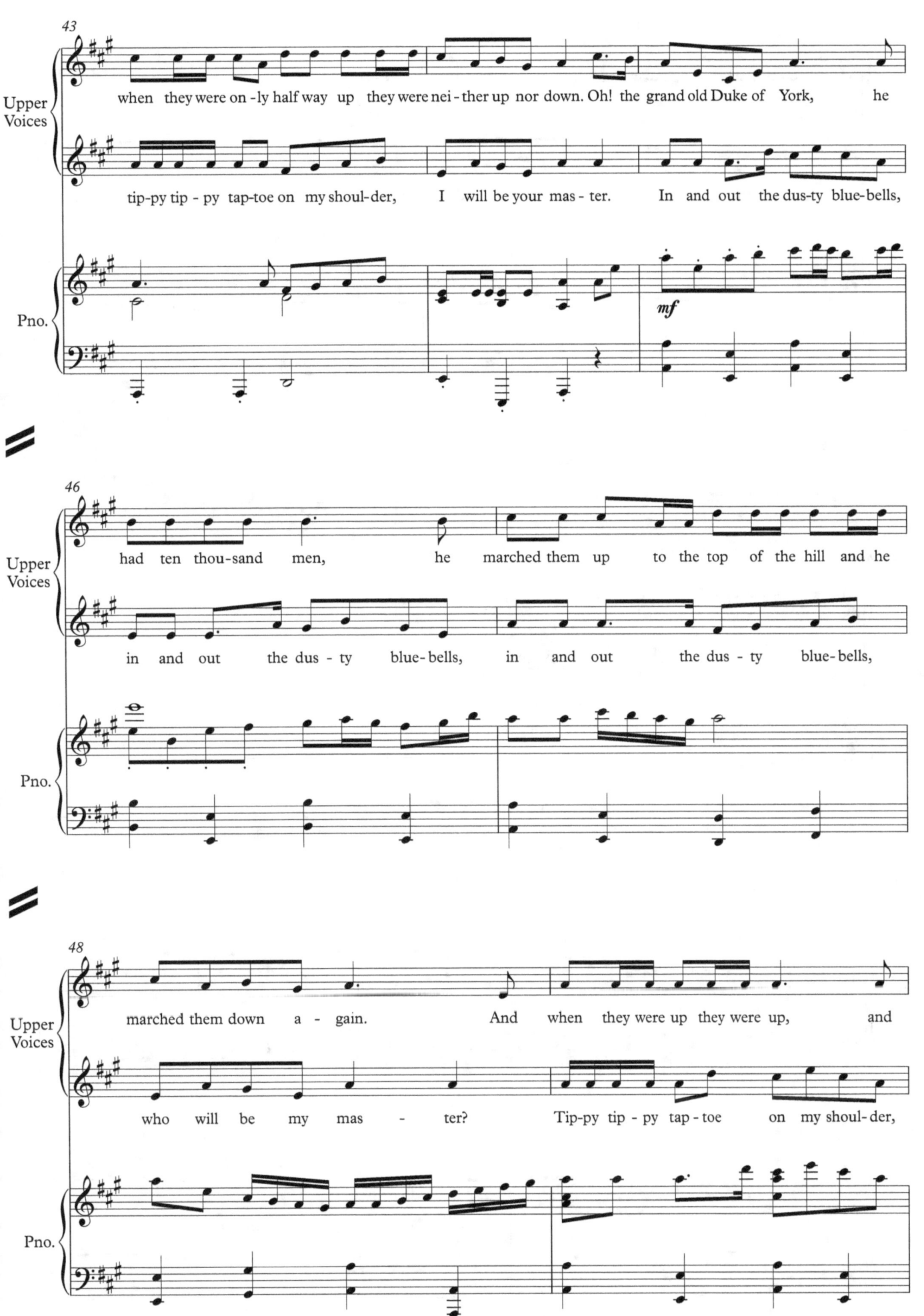

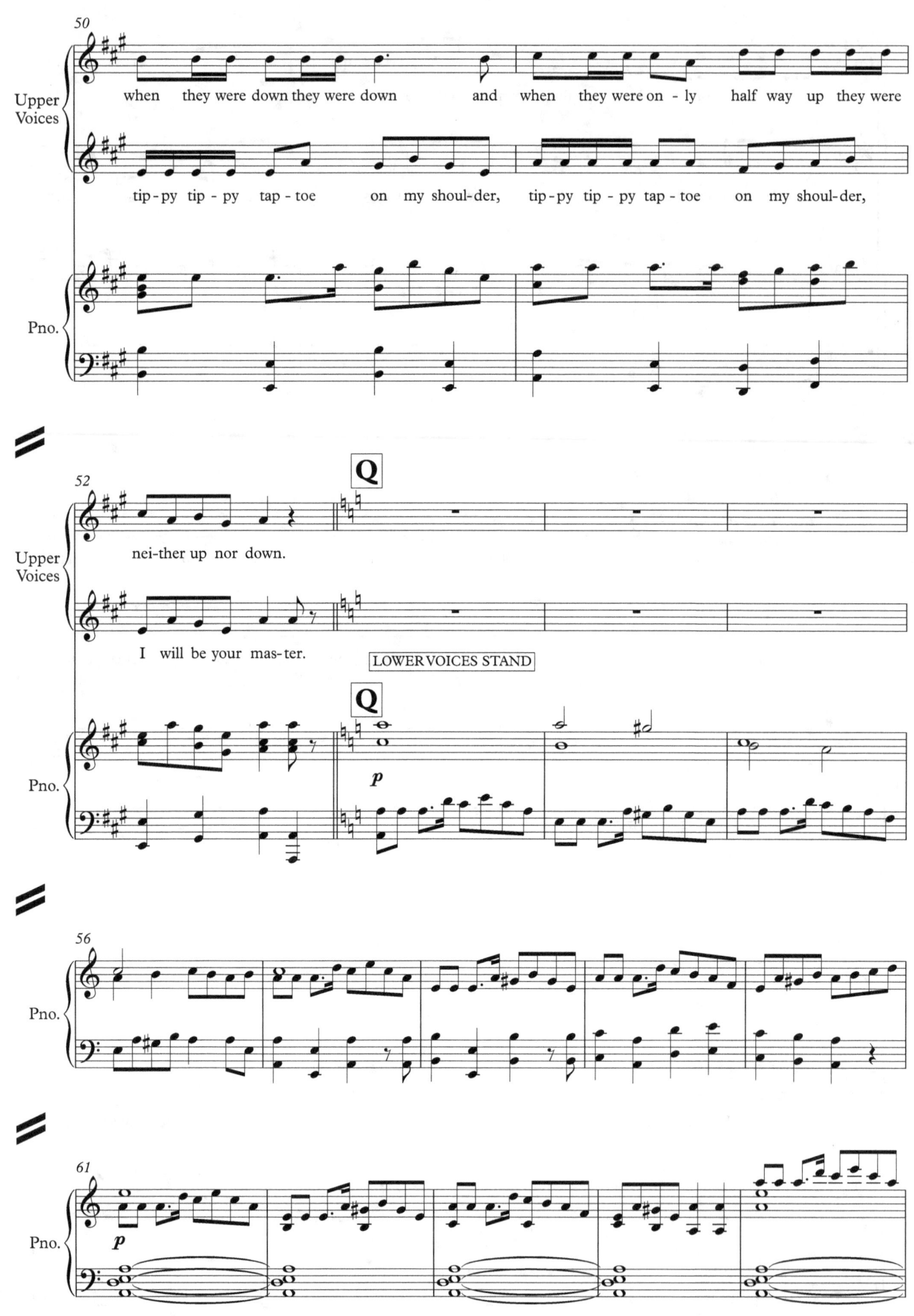

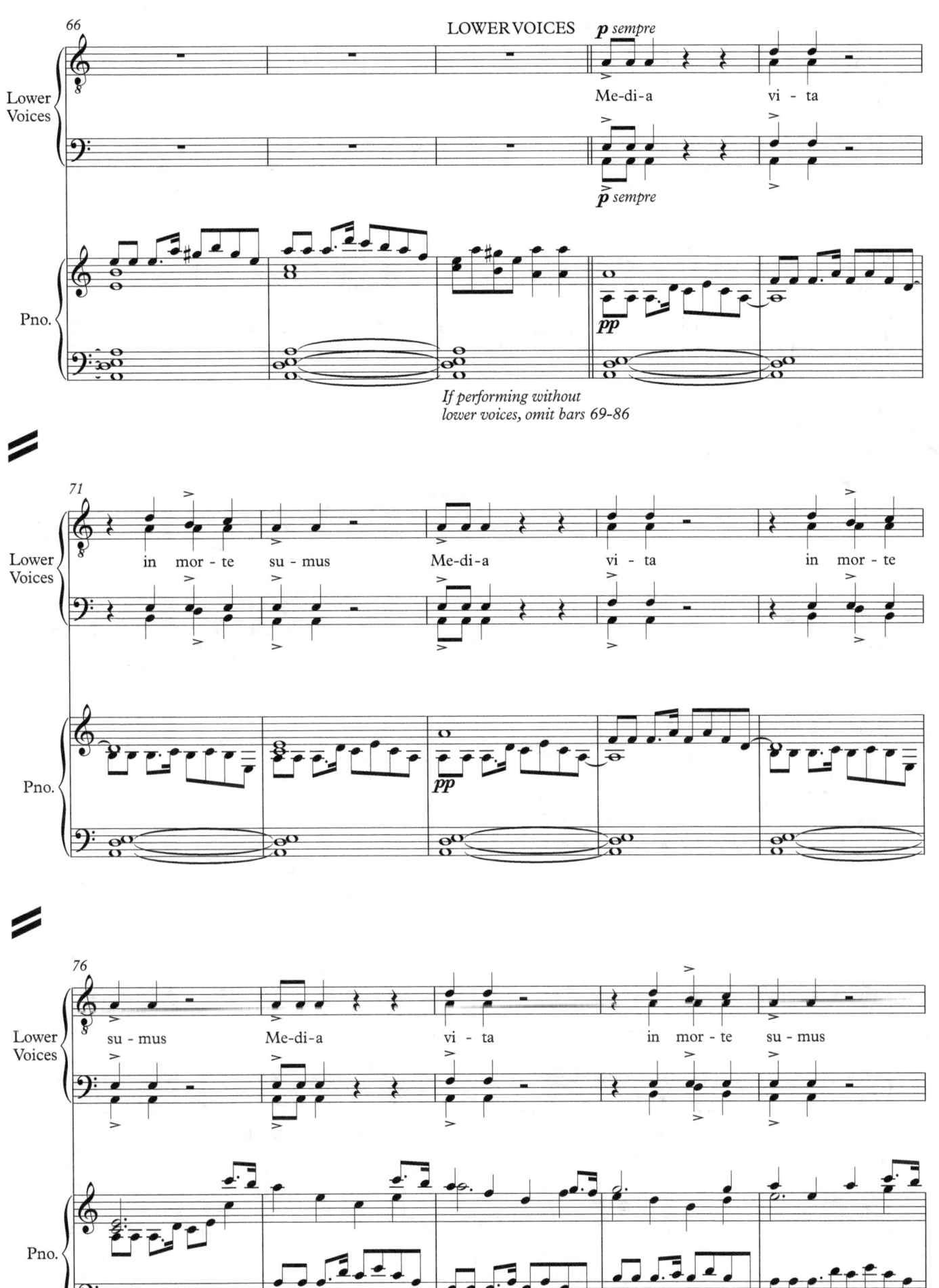

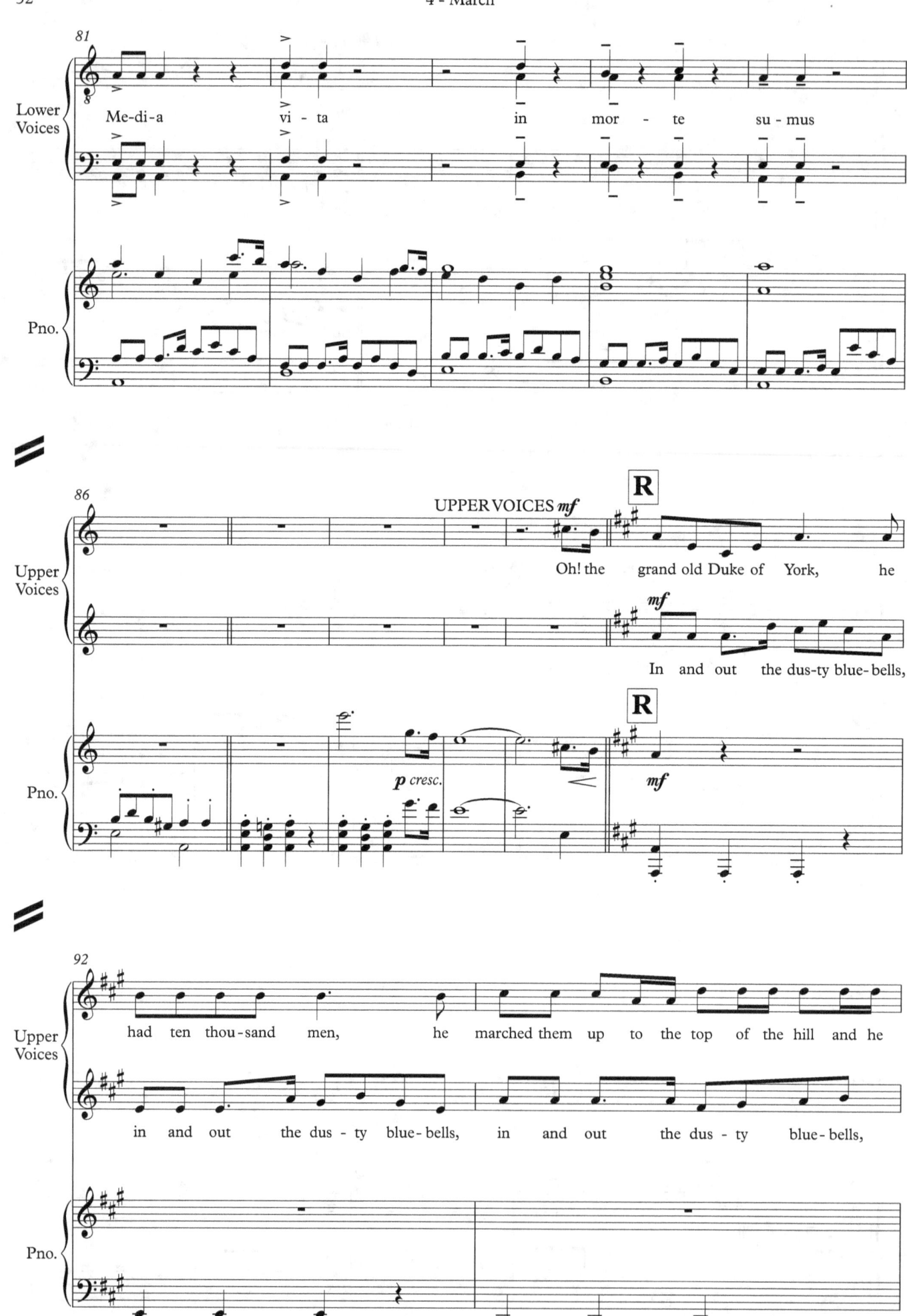

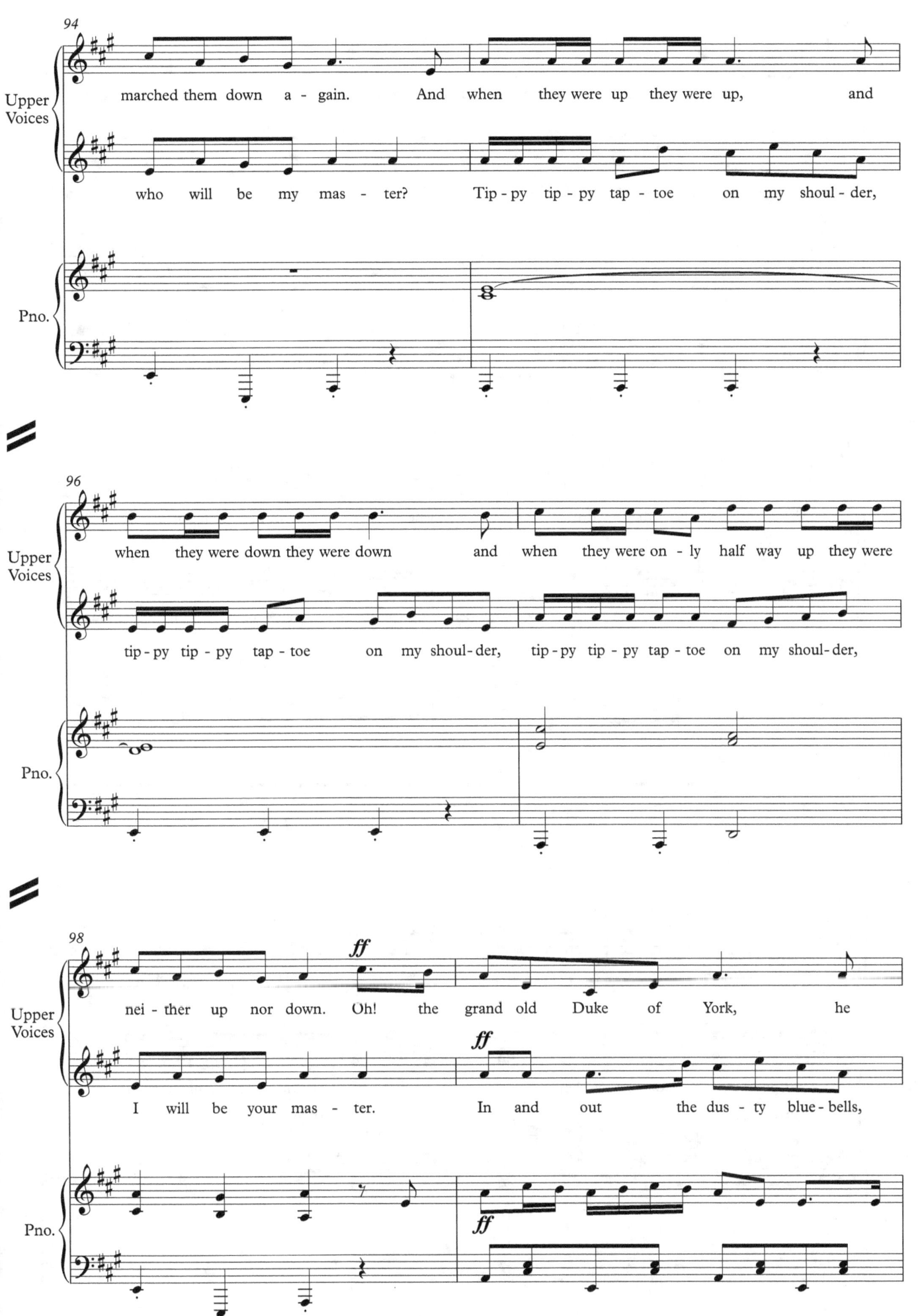

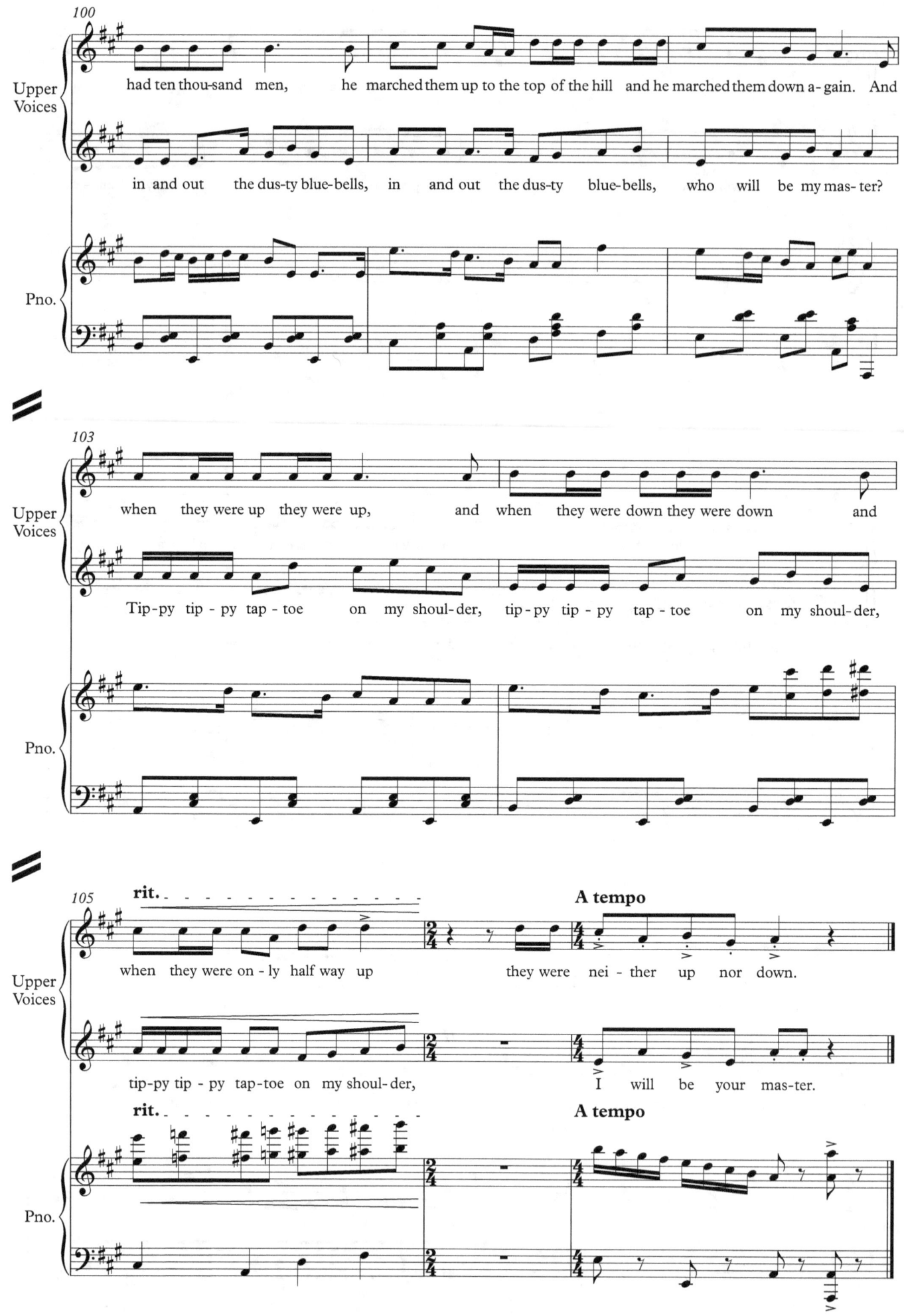

Baritone solo
Lower voices

In memory of Marcelle Rowe.
"Great Inspiration. Brilliant pianist and singer. We will remember you always."

35

5 - Invocation

UPPER VOICES SIT

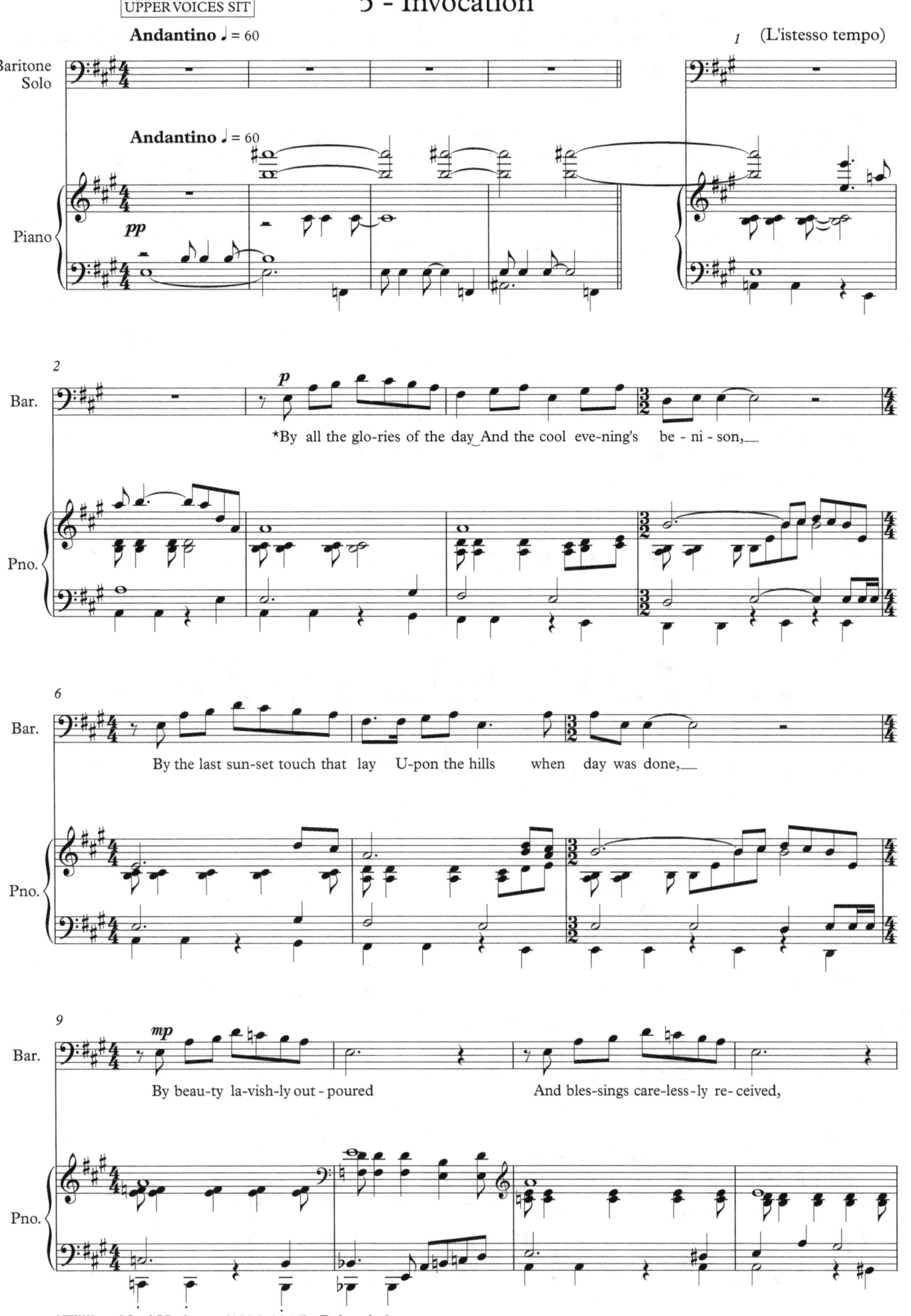

*William Noel Hodgson (1893-1916): *Before Action*

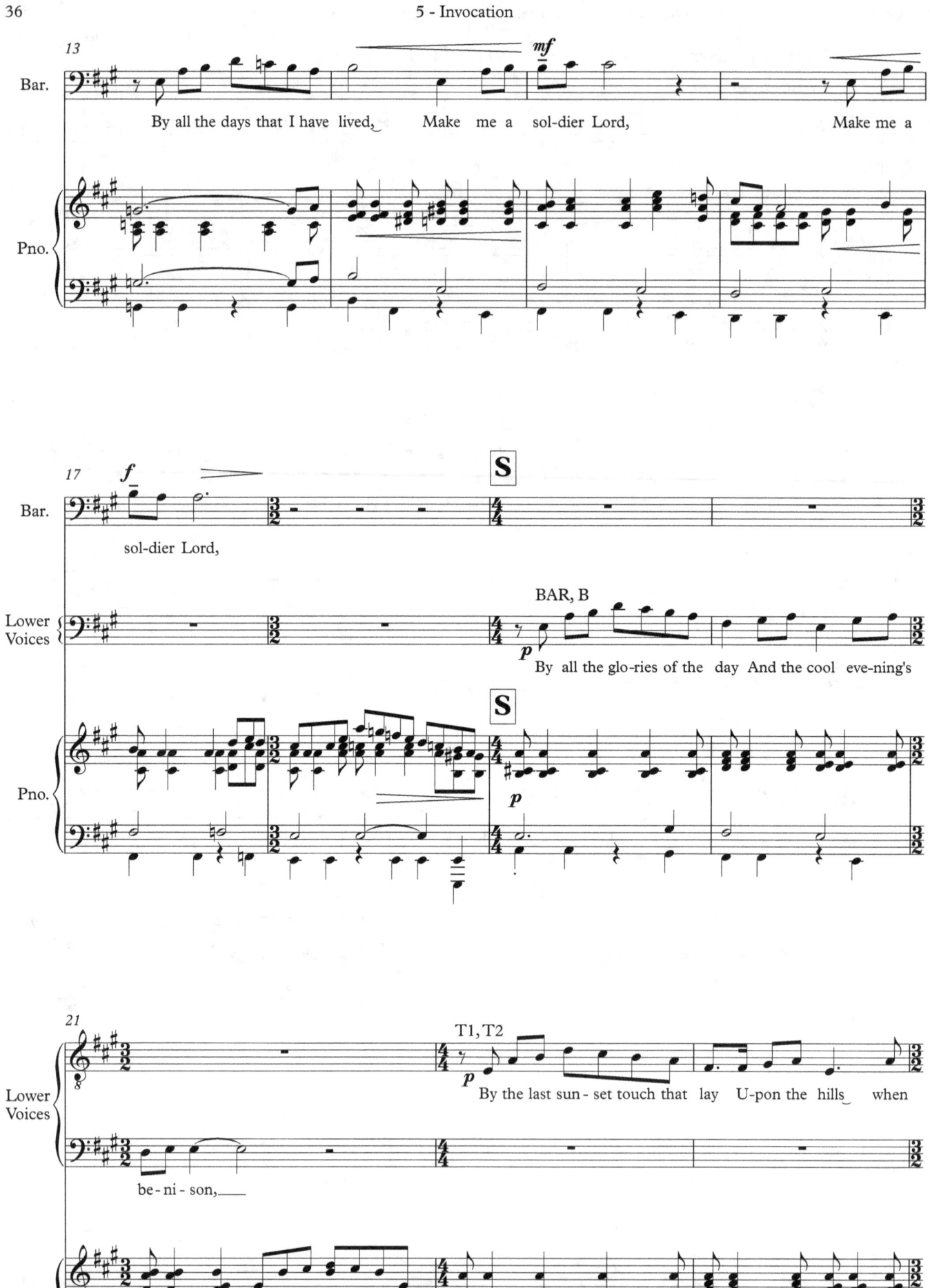

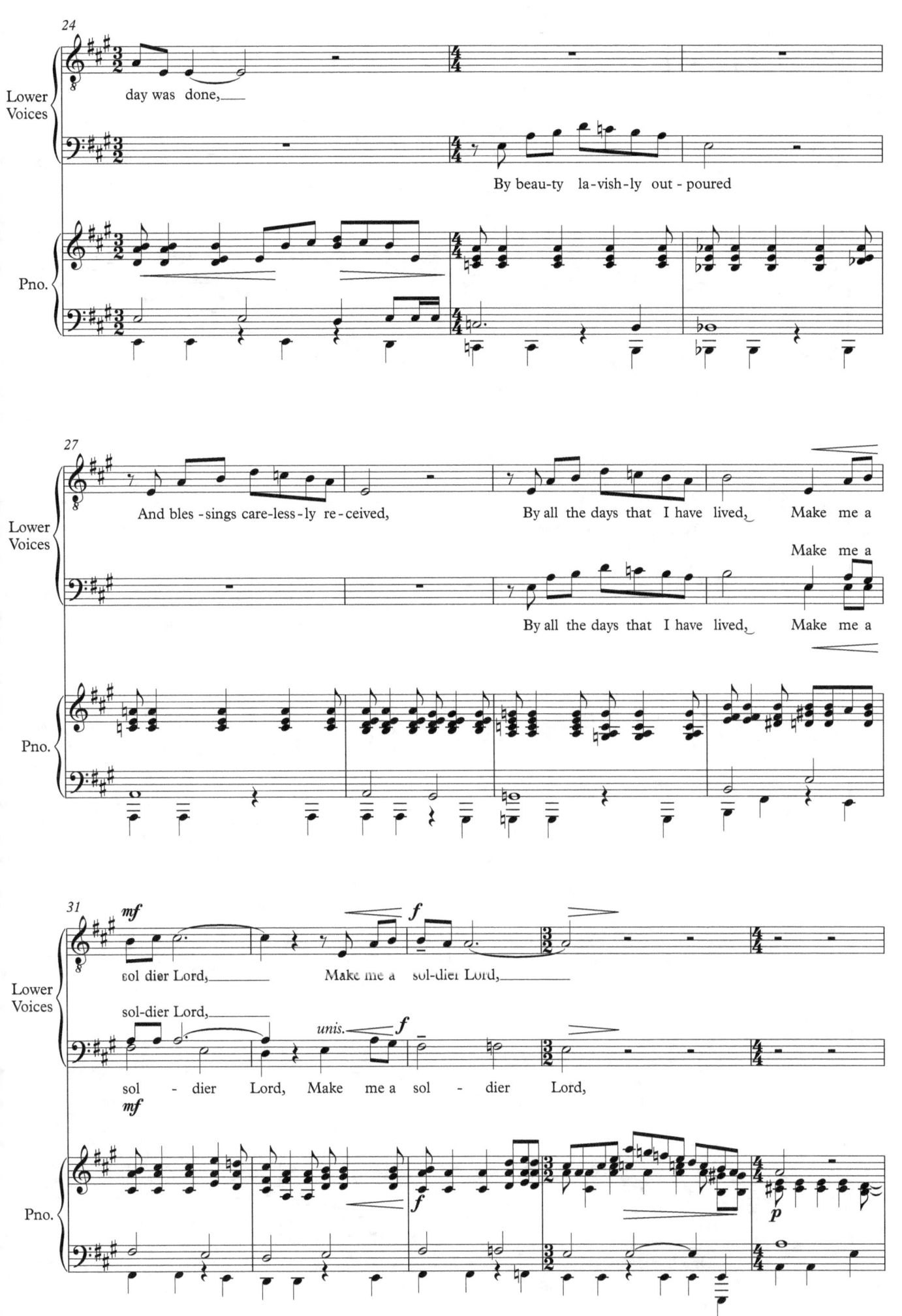

38

5 - Invocation

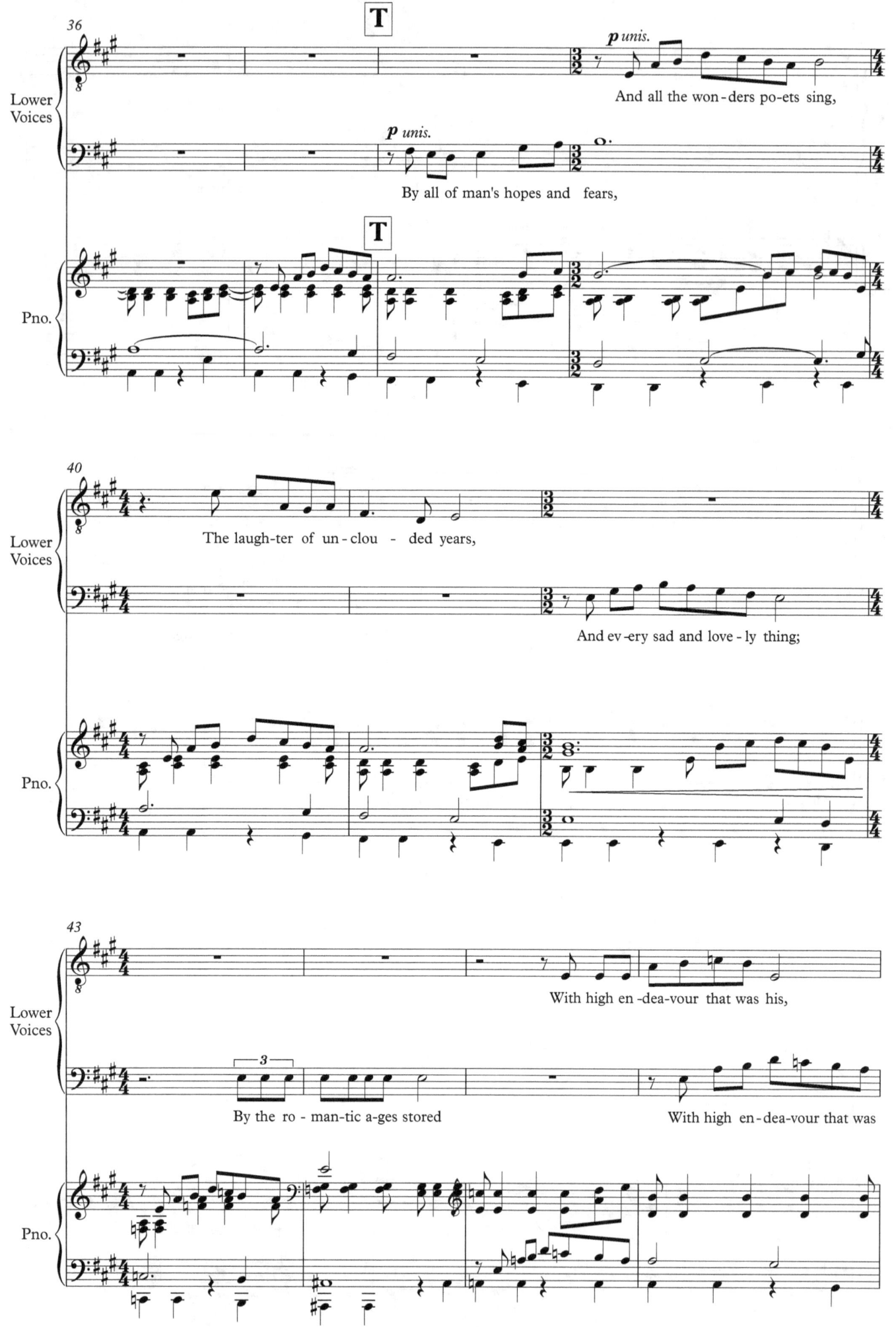

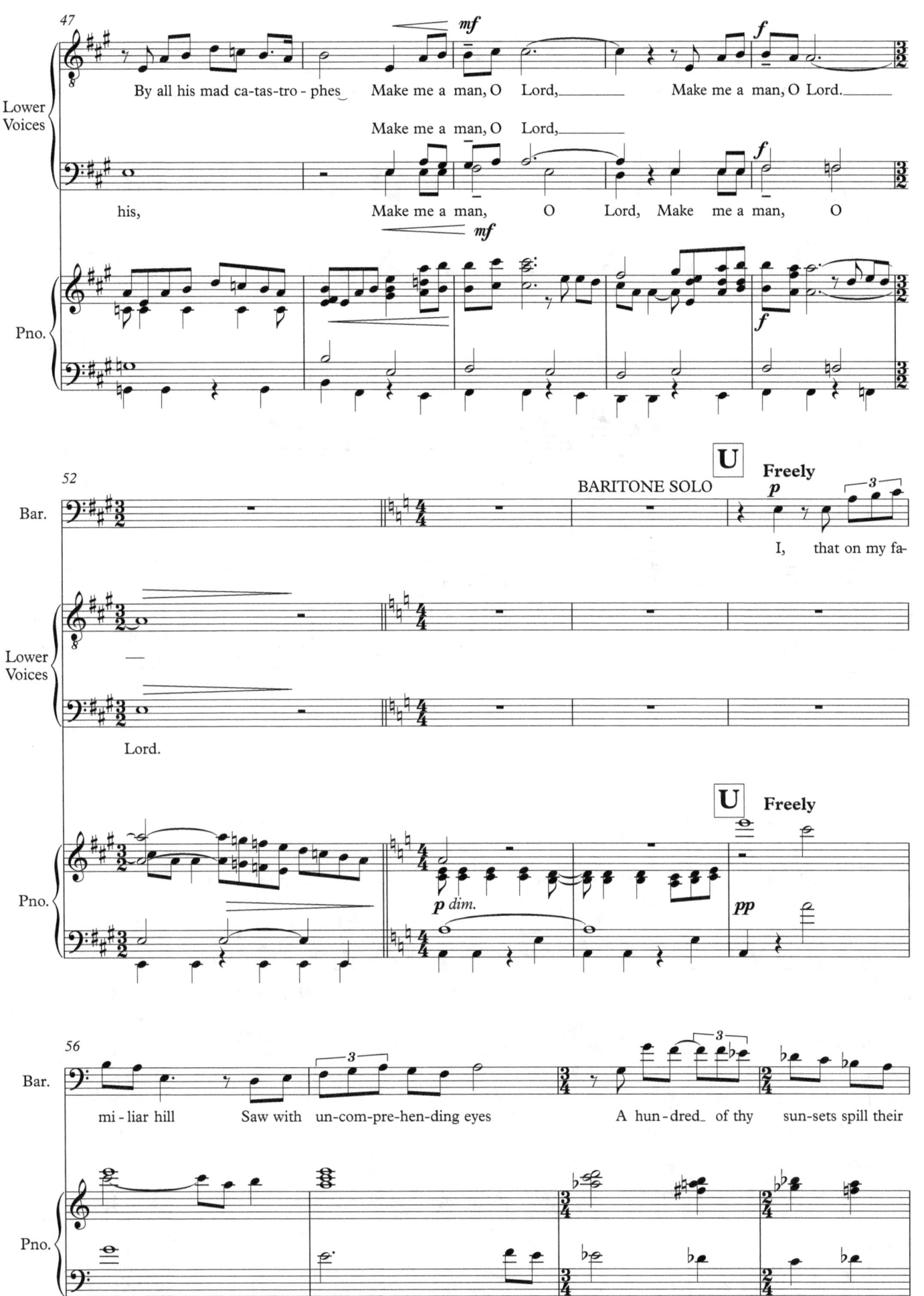

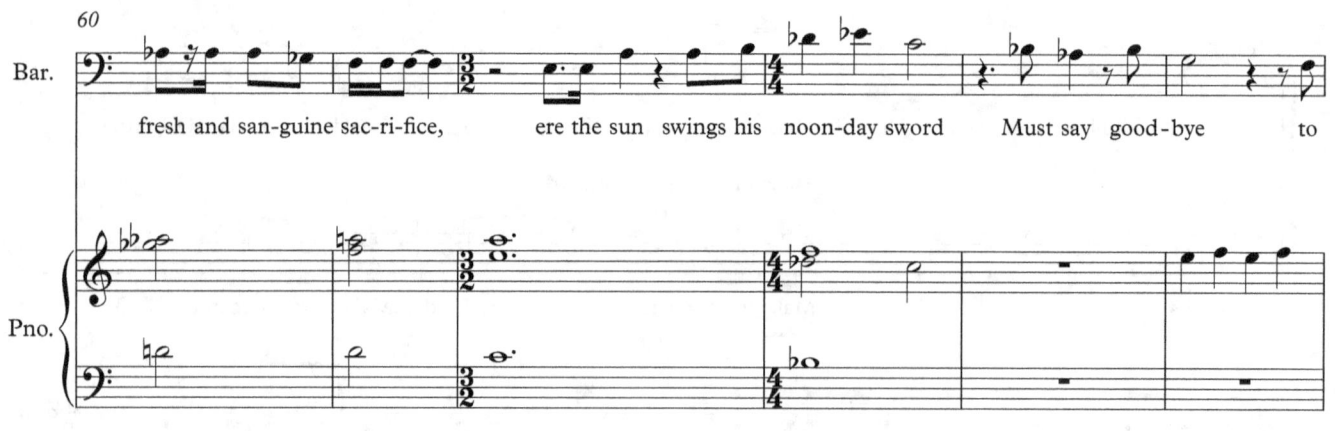
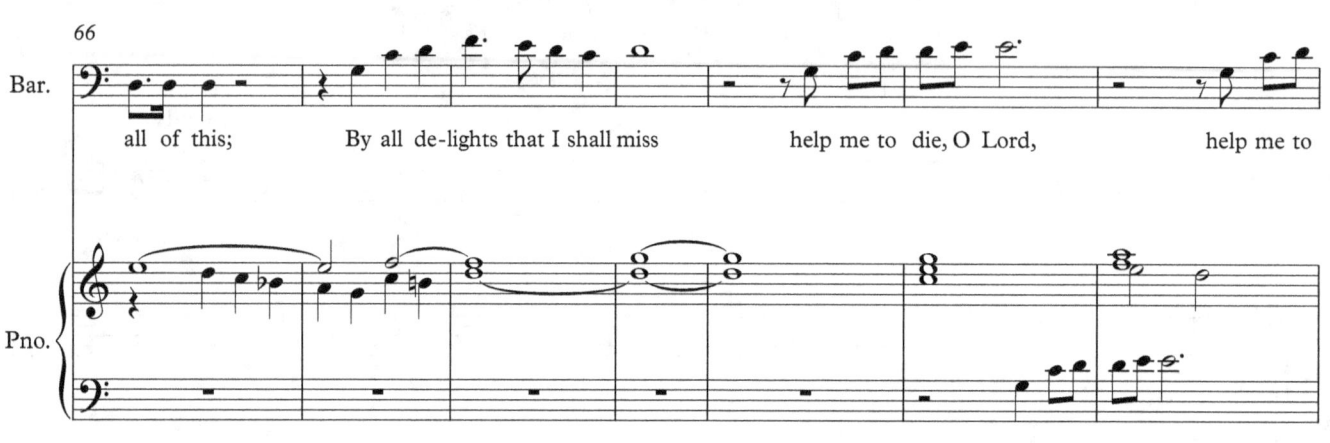

Soprano & baritone solos
Upper voices
SATB chorus
Lower voices (optional)

In memory of Owen and Victor Whitaker, killed in the First World War

6 - Hymn

CHORUS STAND
UPPER VOICES STAND

*In the midst of earth-ly life Snares of death sur-round us;

Who shall help us in the strife Lest the foe con-found us? Save us lest we

pe-rish In the bit-ter pangs of death. Have mer-cy, have mer-cy O Lord.

*Martin Luther (1483-1546): *In the midst of earthly life*

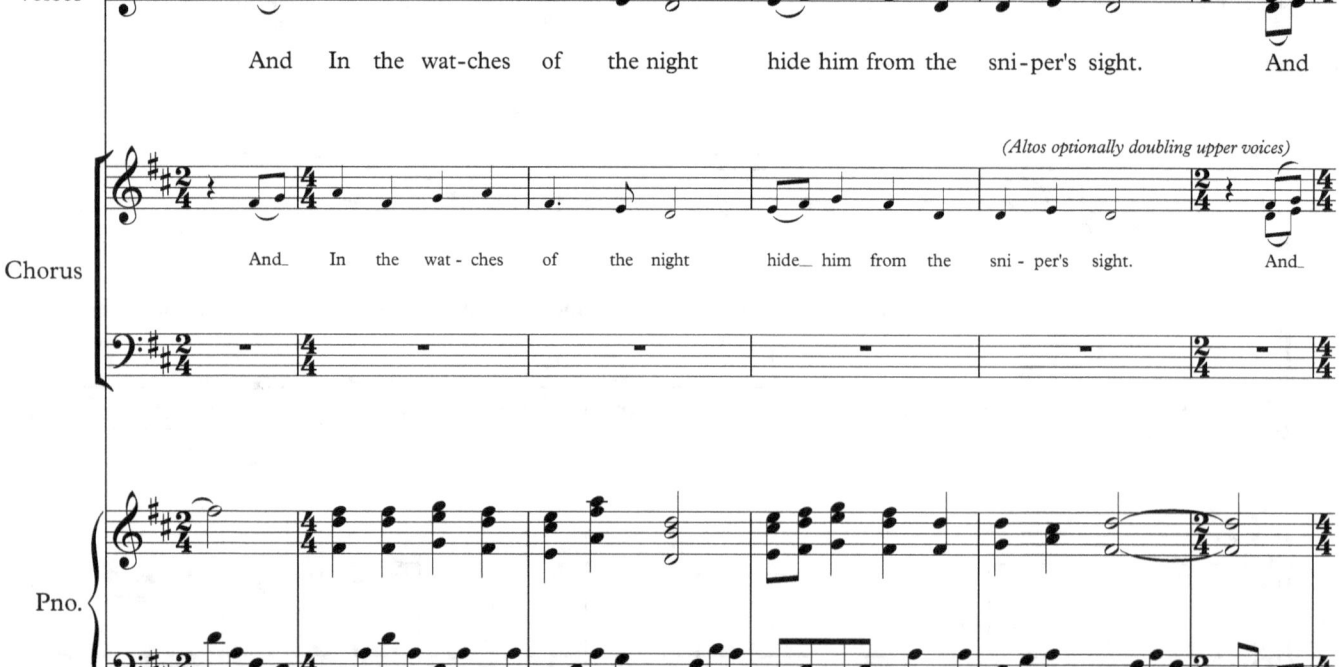

*Additional text interpolated by the composer

6 - Hymn

if his cou-rage starts to fail 'mid the dread-ful can-non's roar, Have mer-cy, have mer-cy O Lord.

With the strength of thy pro-

(1st altos and 1st sopranos could sing the Upper Voice part instead)

mer-cy O Lord.

oo

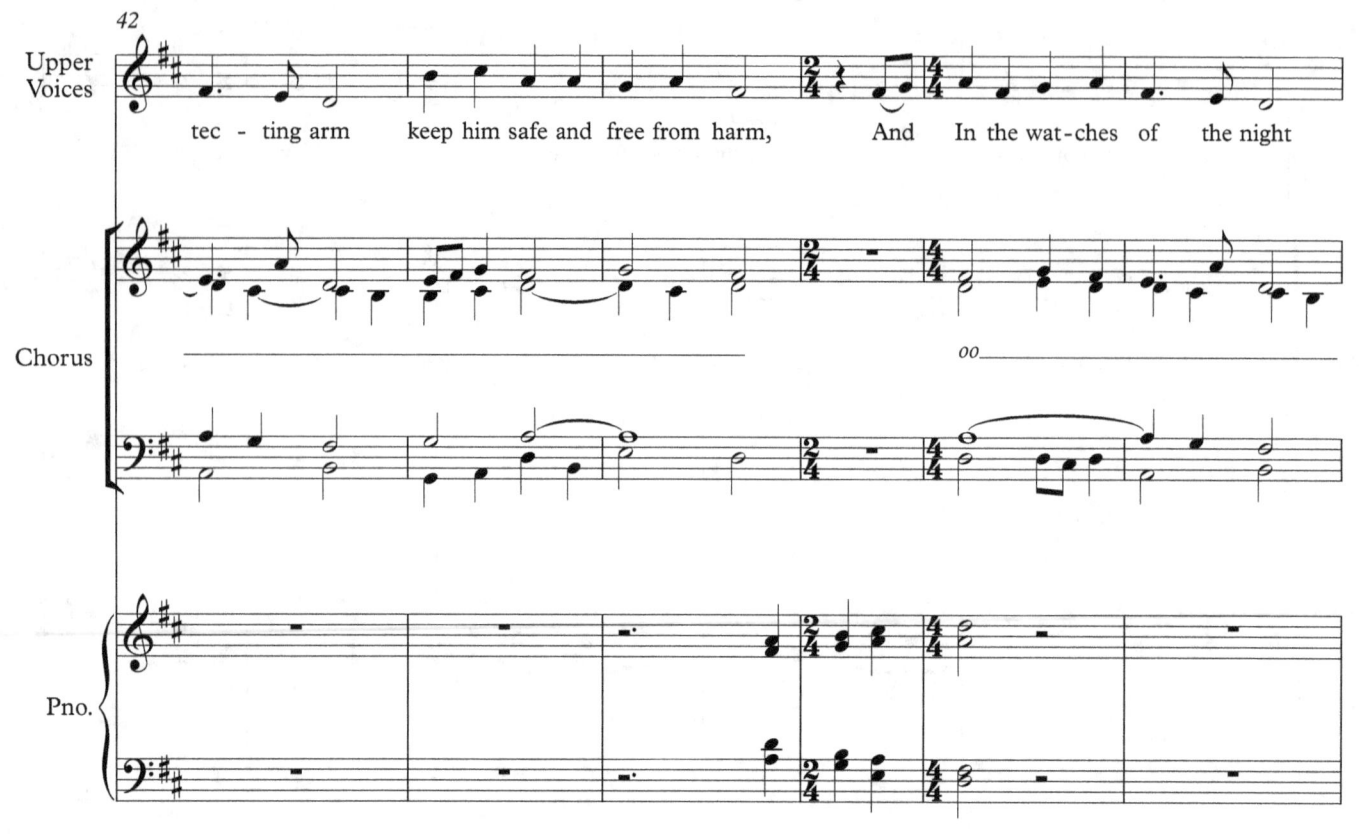
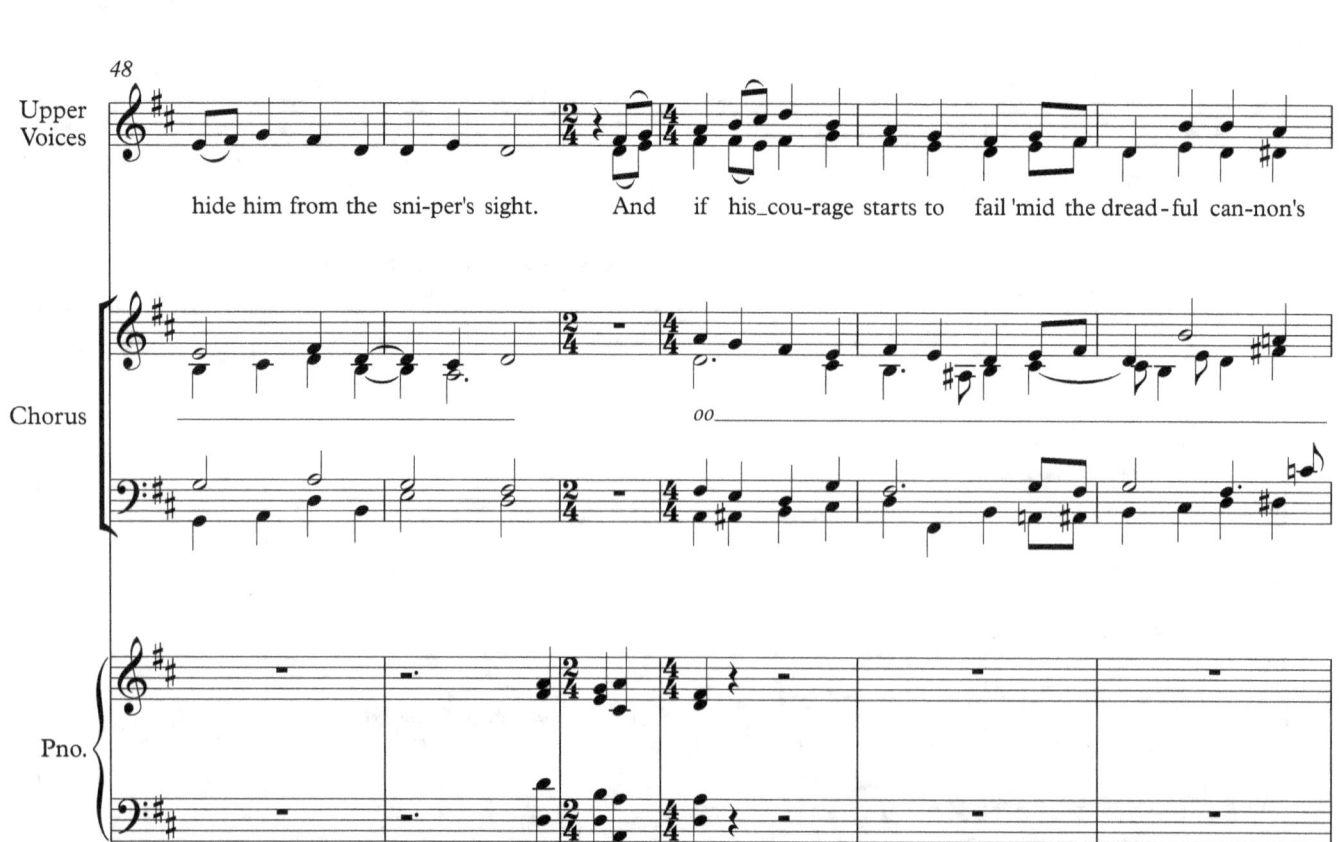

6 - Hymn

54

Sop. SOPRANO SOLO *f*
With the strength of thy pro-

Bar. BARITONE SOLO *f*
In the midst of

Upper Voices
roar, Have mer-cy, have mer-cy O Lord.

Chorus
f
In the midst of

Lower Voices
mf
In the midst of

Pno.

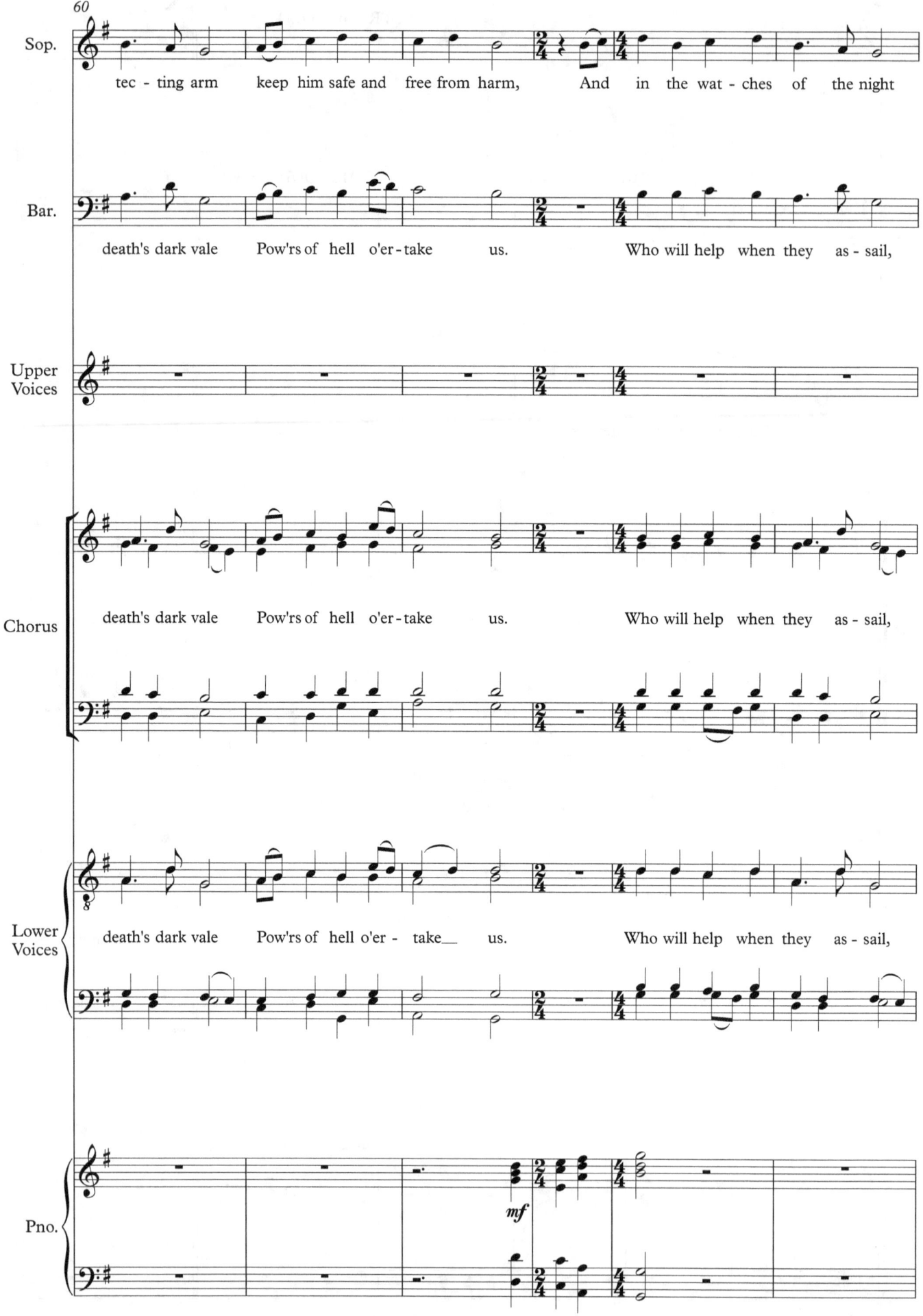

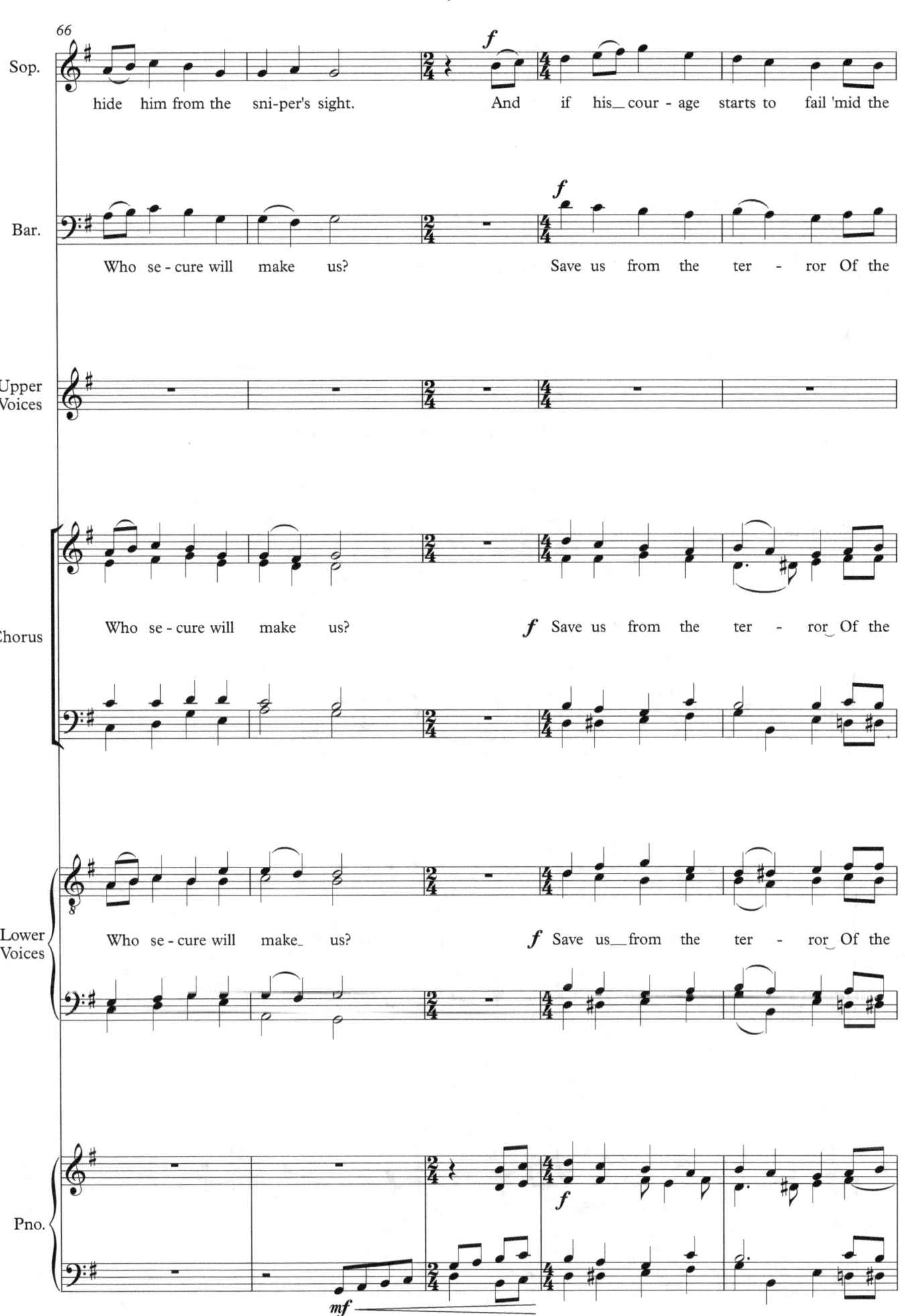

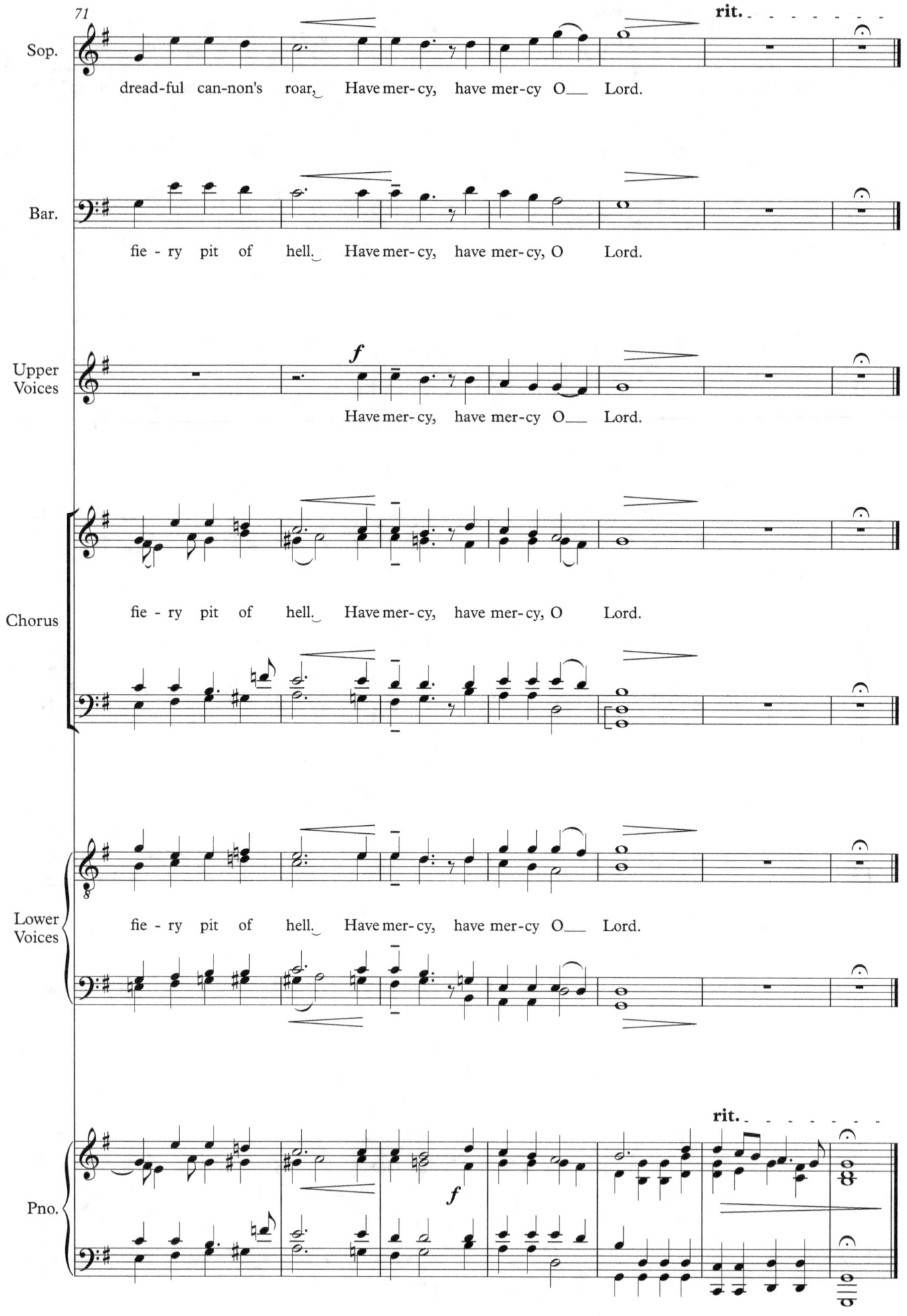

Dedicated with love to Maya and Lucas Alcantara Holme

7 - Foreboding

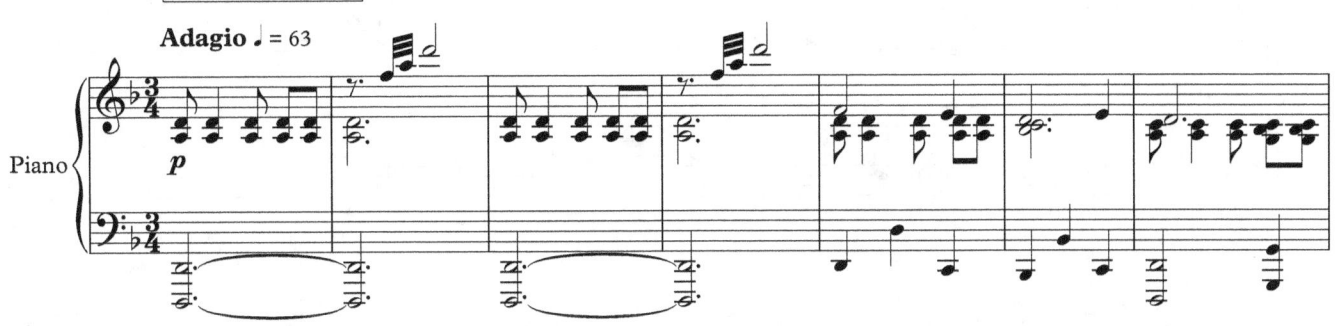
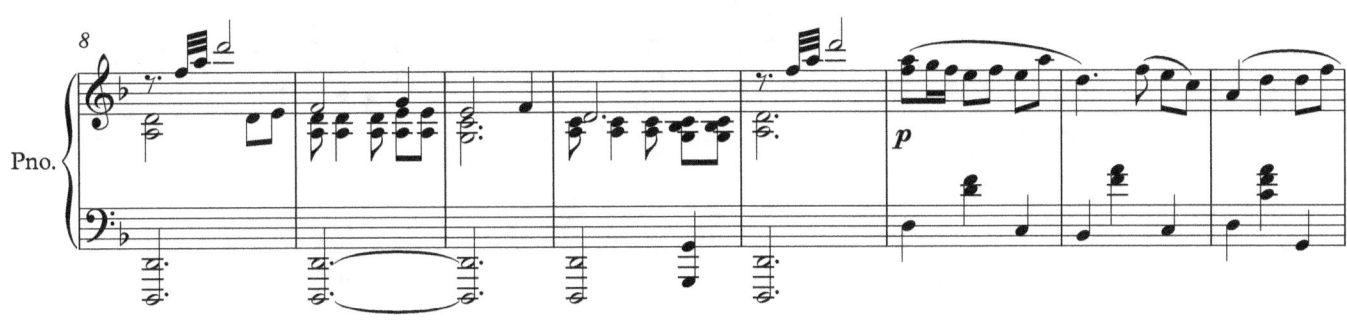

50

7 - Foreboding

*Alan Seeger (1888–1916): *I have a rendezvous with Death*

7 - Foreboding

Bar. (m. 49, *dolce*): When spring comes back with rust-ling shade_____ And ap-ple blos-soms fill the air;

Bar. (m. 53): I have a ren-dez-vous with Death_____ When spring brings back blue days and fair.

Lower Voices (m. 56, **CC**, *p tenderly*): Ky - ri - e e - le - i - son, Ky - ri - e e -

54 7 - Foreboding

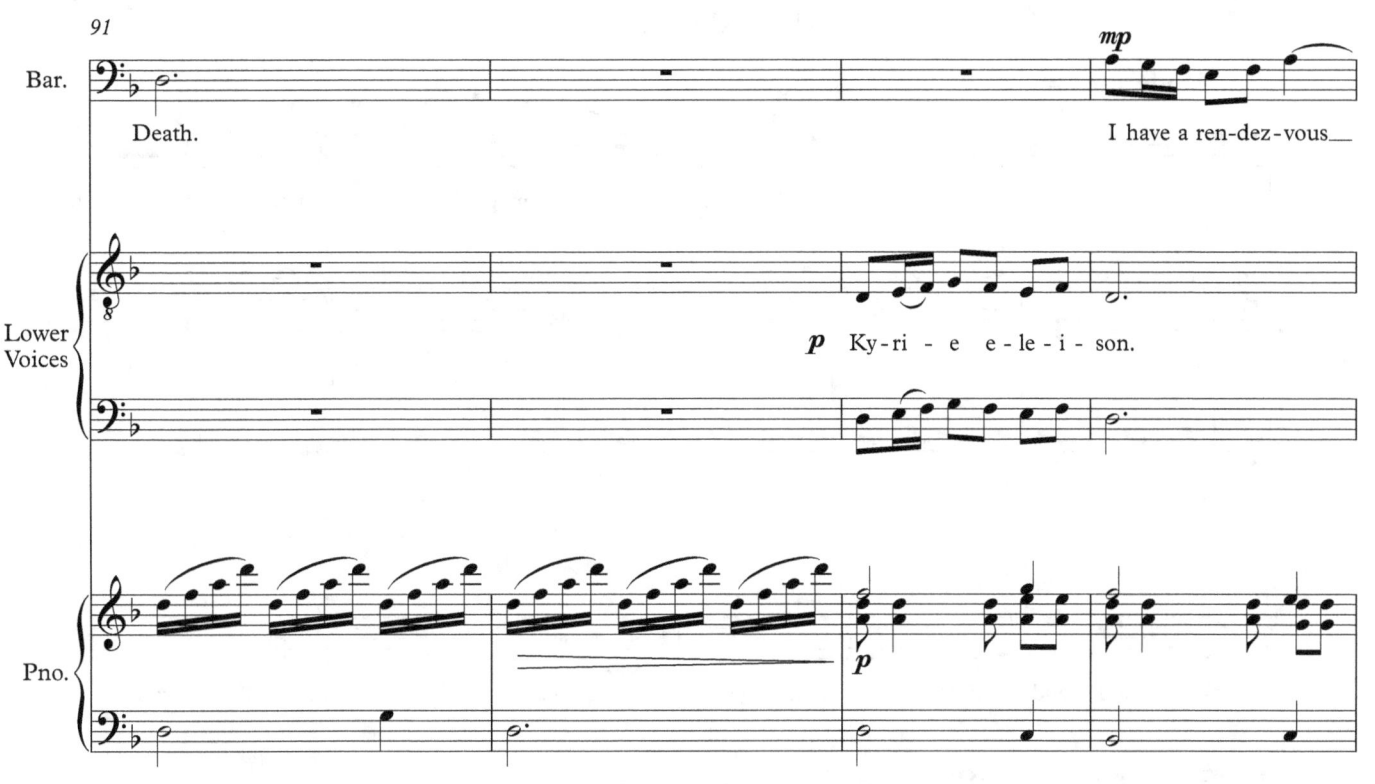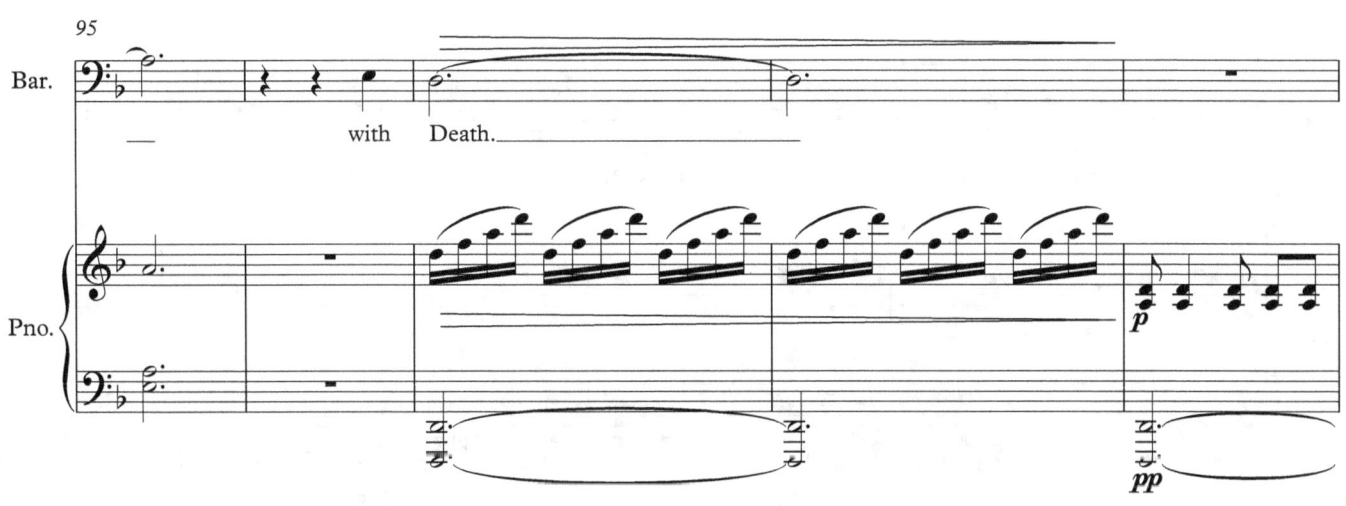

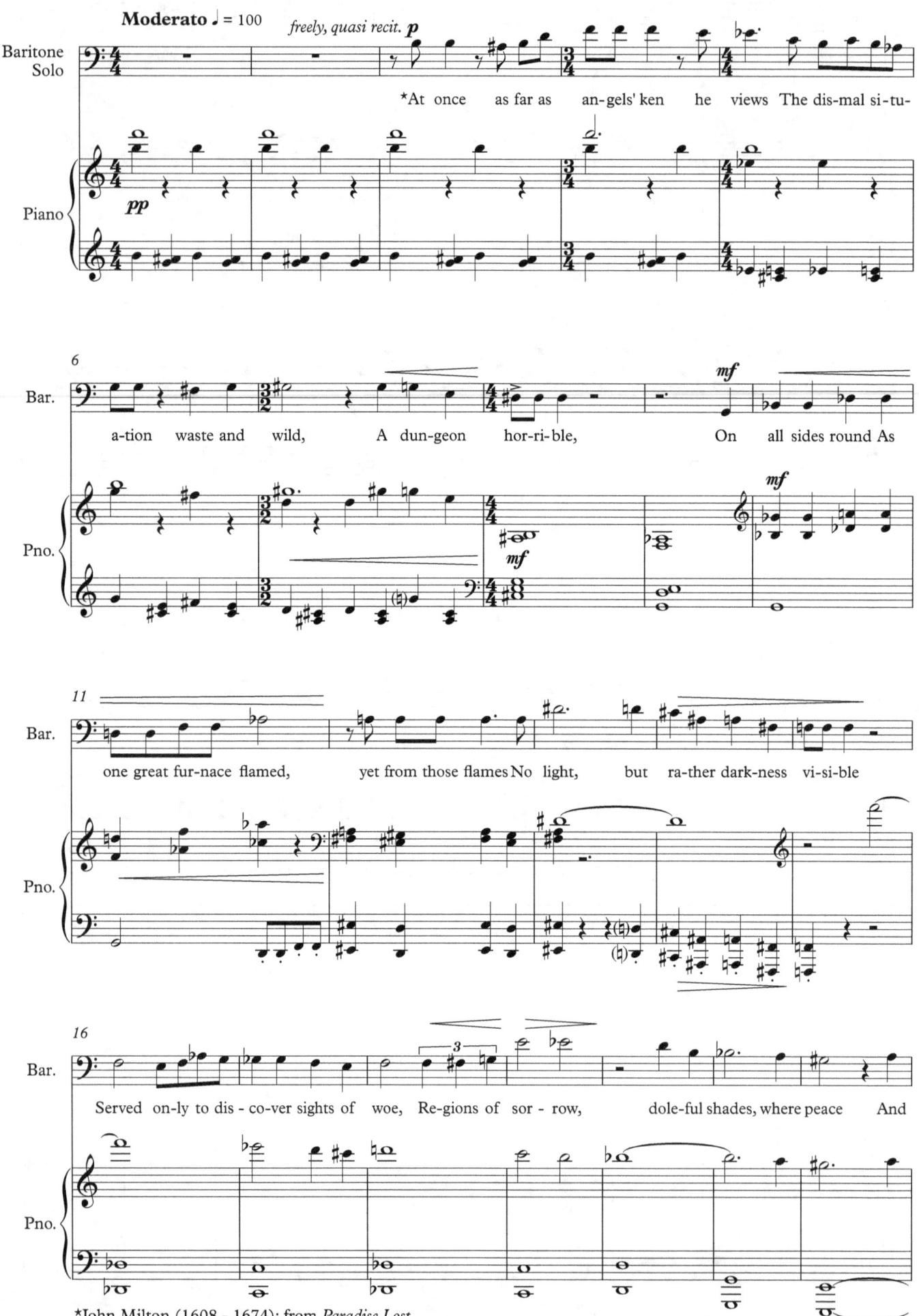

*John Milton (1608 - 1674): from *Paradise Lost*

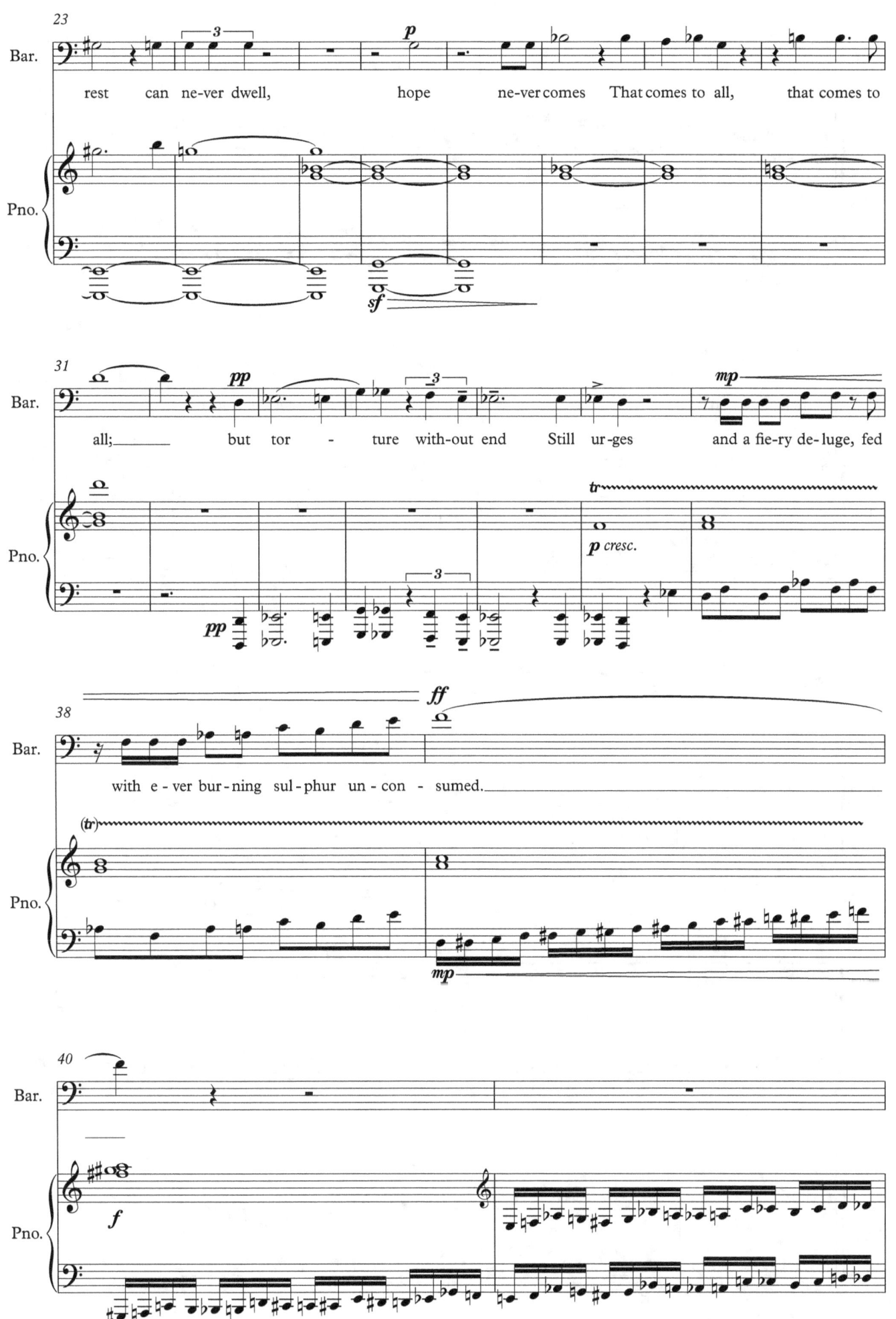

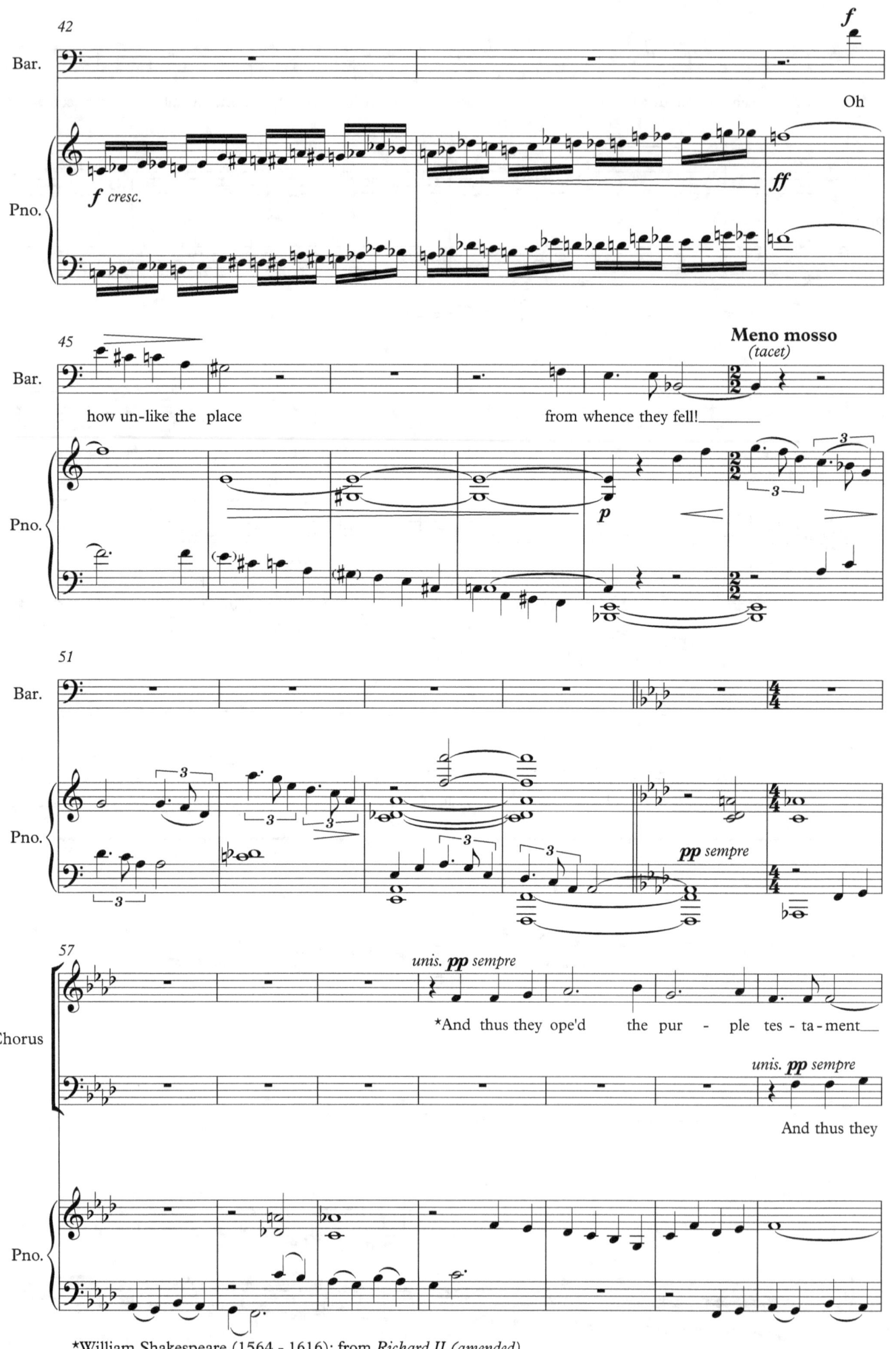

*William Shakespeare (1564 - 1616): from *Richard II* (amended)

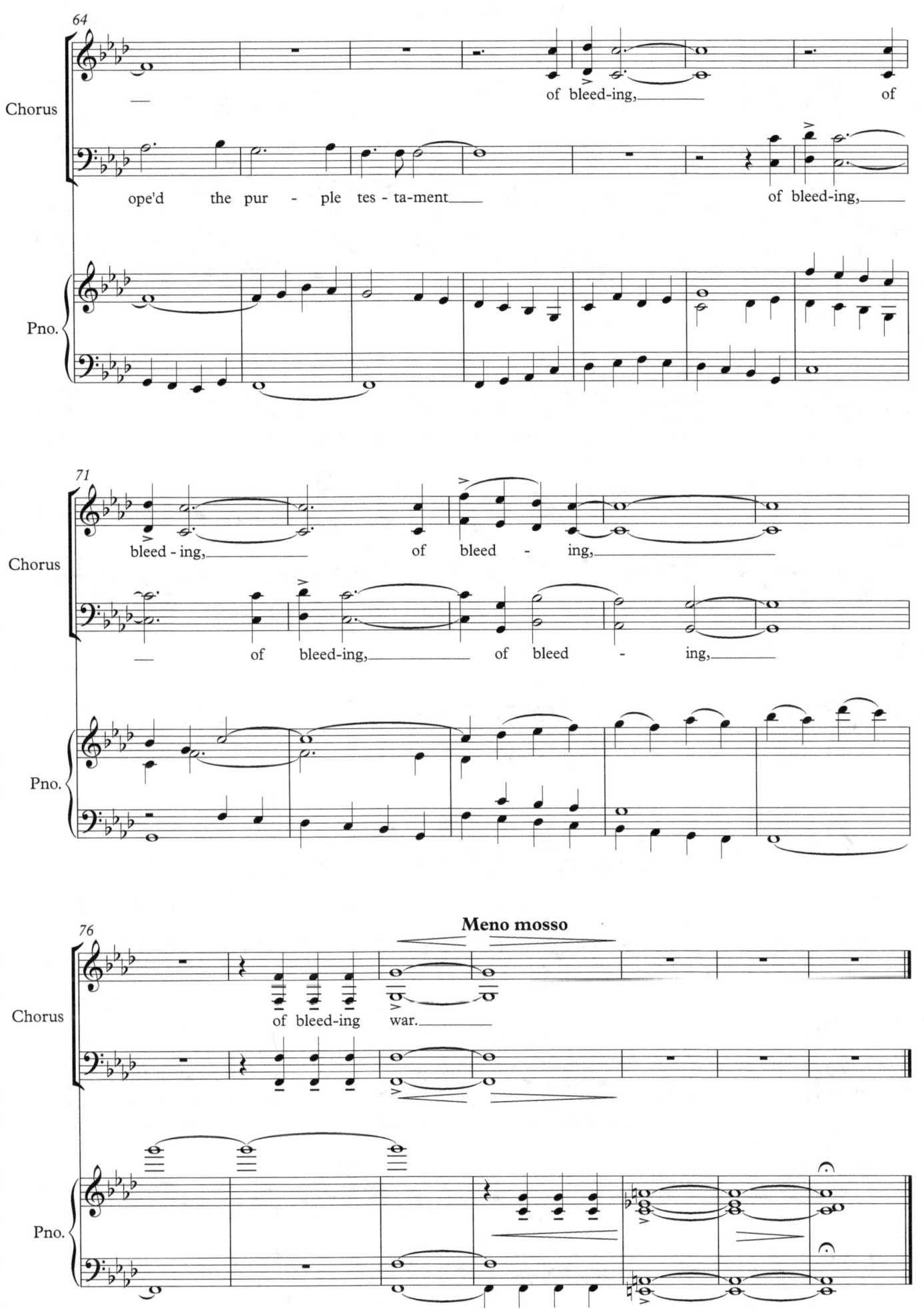

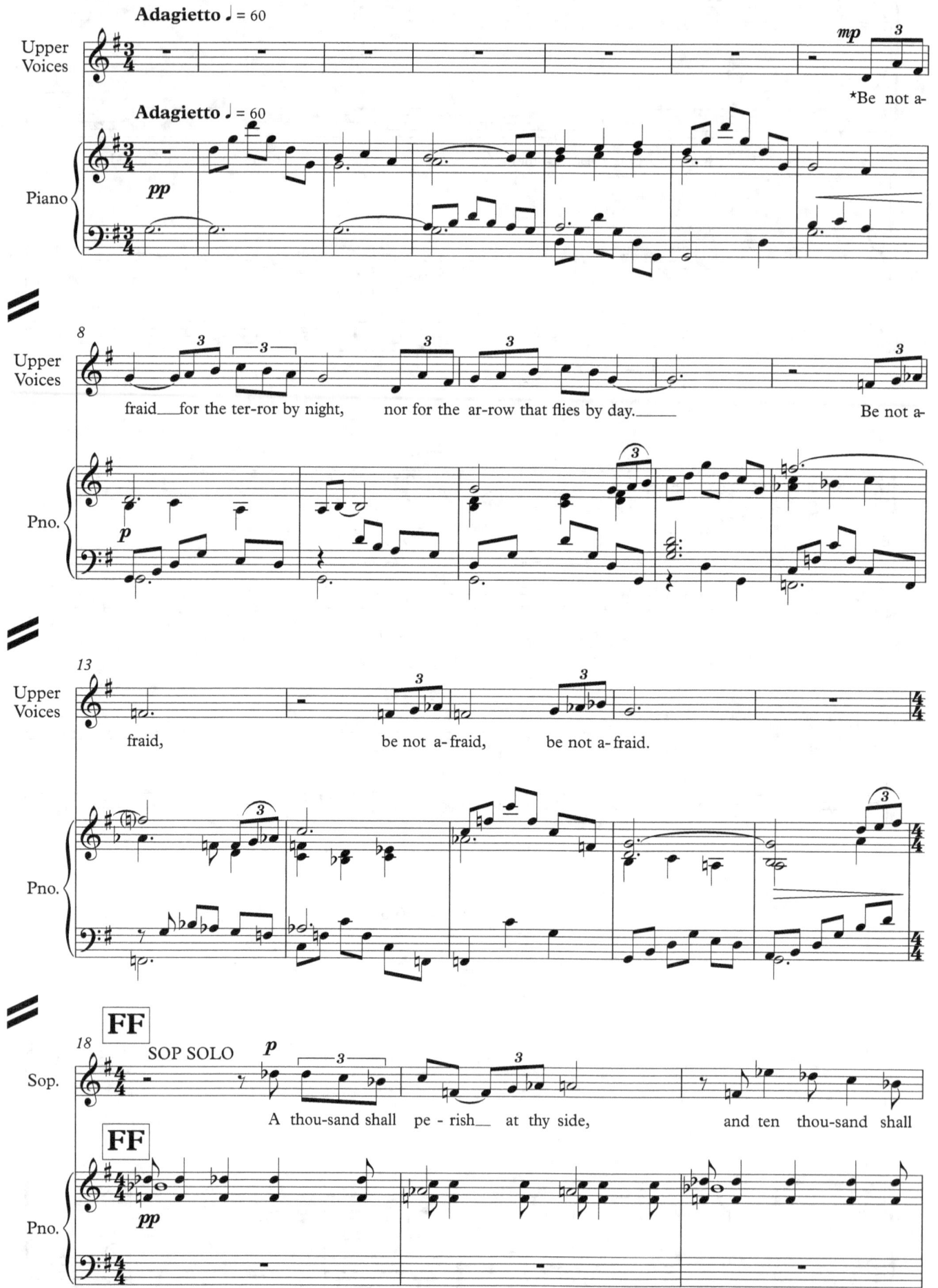

*Psalm 91 (adapted)

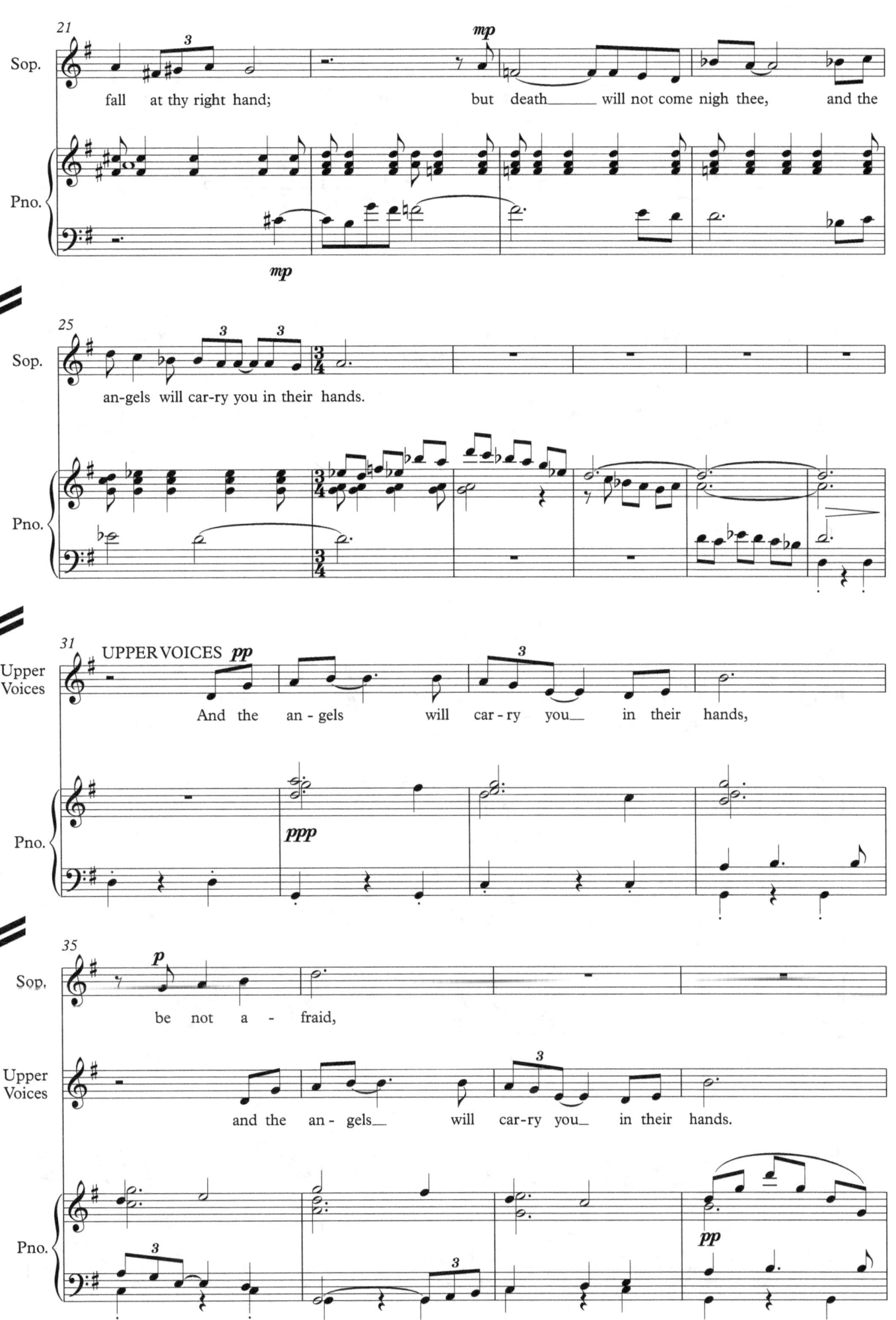

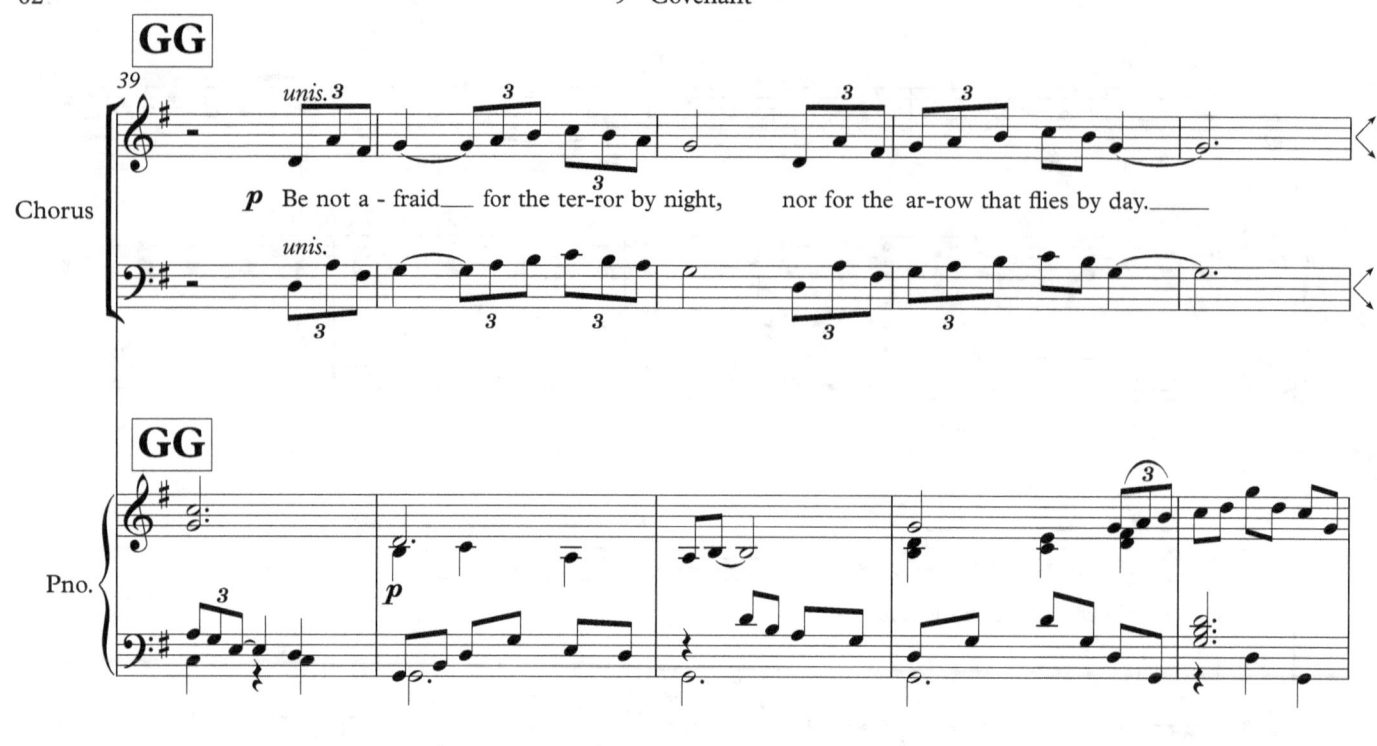

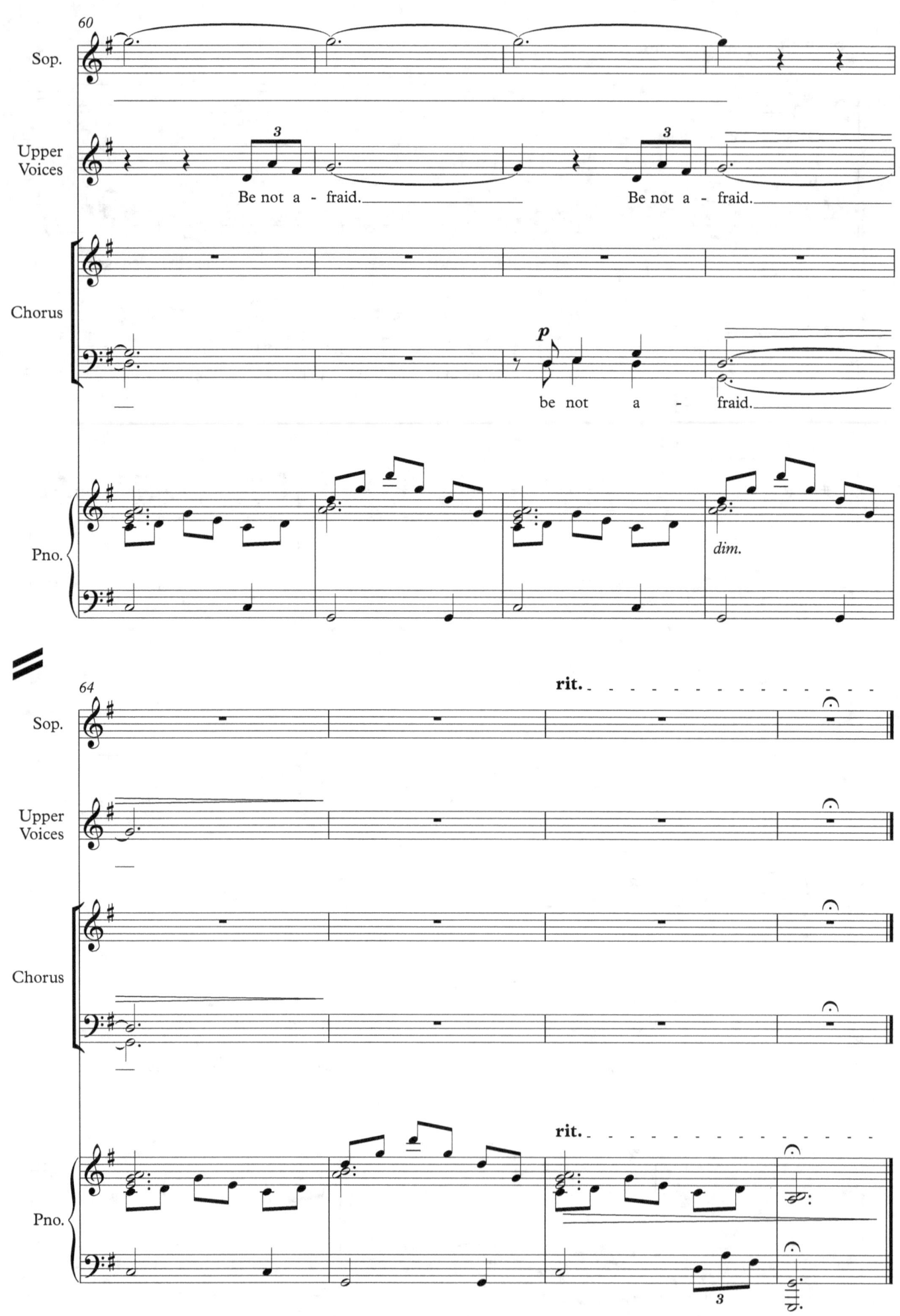

SATB Chorus
Lower Voices

UPPER VOICES SIT
LOWER VOICES STAND

*In fond and loving memory of Charles Tanner and John Stevenson,
both wounded in action in the Great War.*

10 - Battle

*Before the movement begins, about 4 or 5 members of the Lower Voice choir should
give loud blasts on whistles, (ideally the long "police-type" without peas in.)*

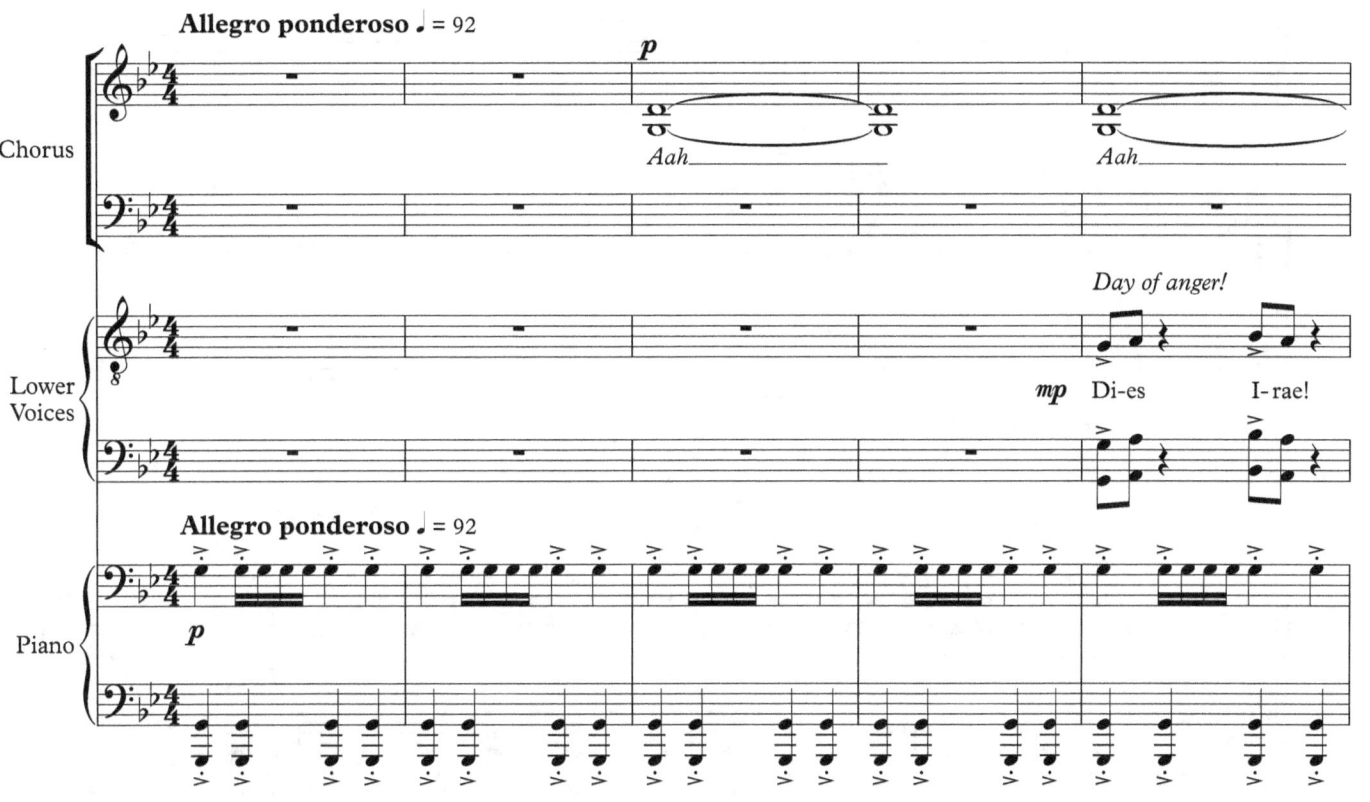

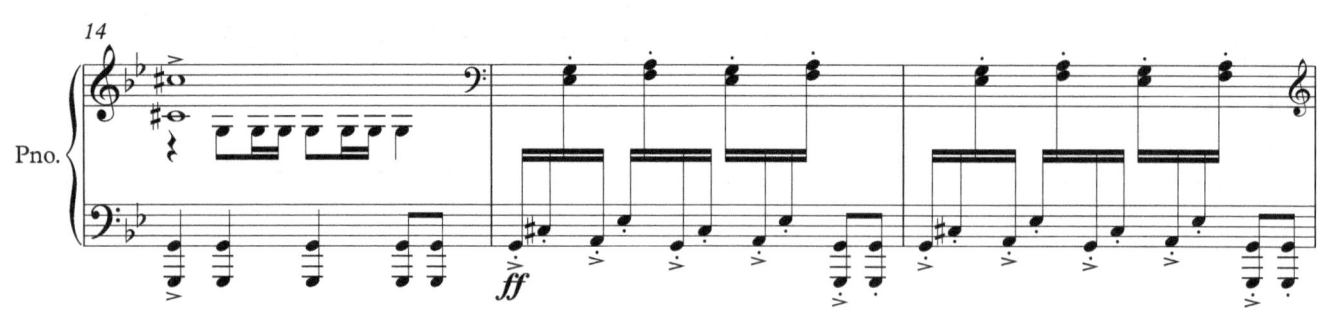
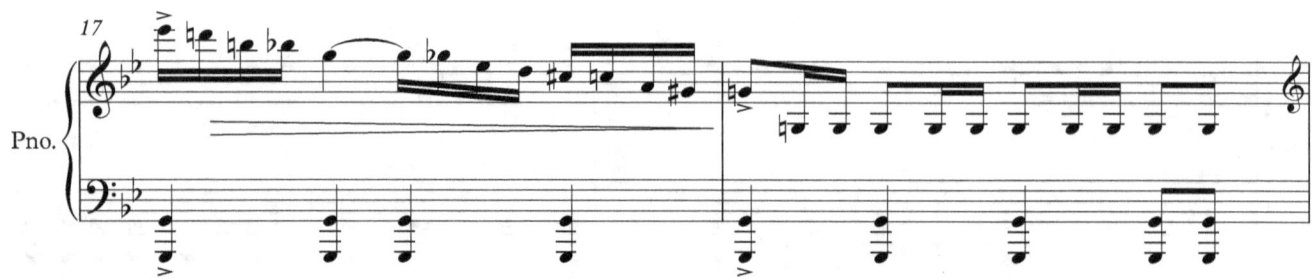

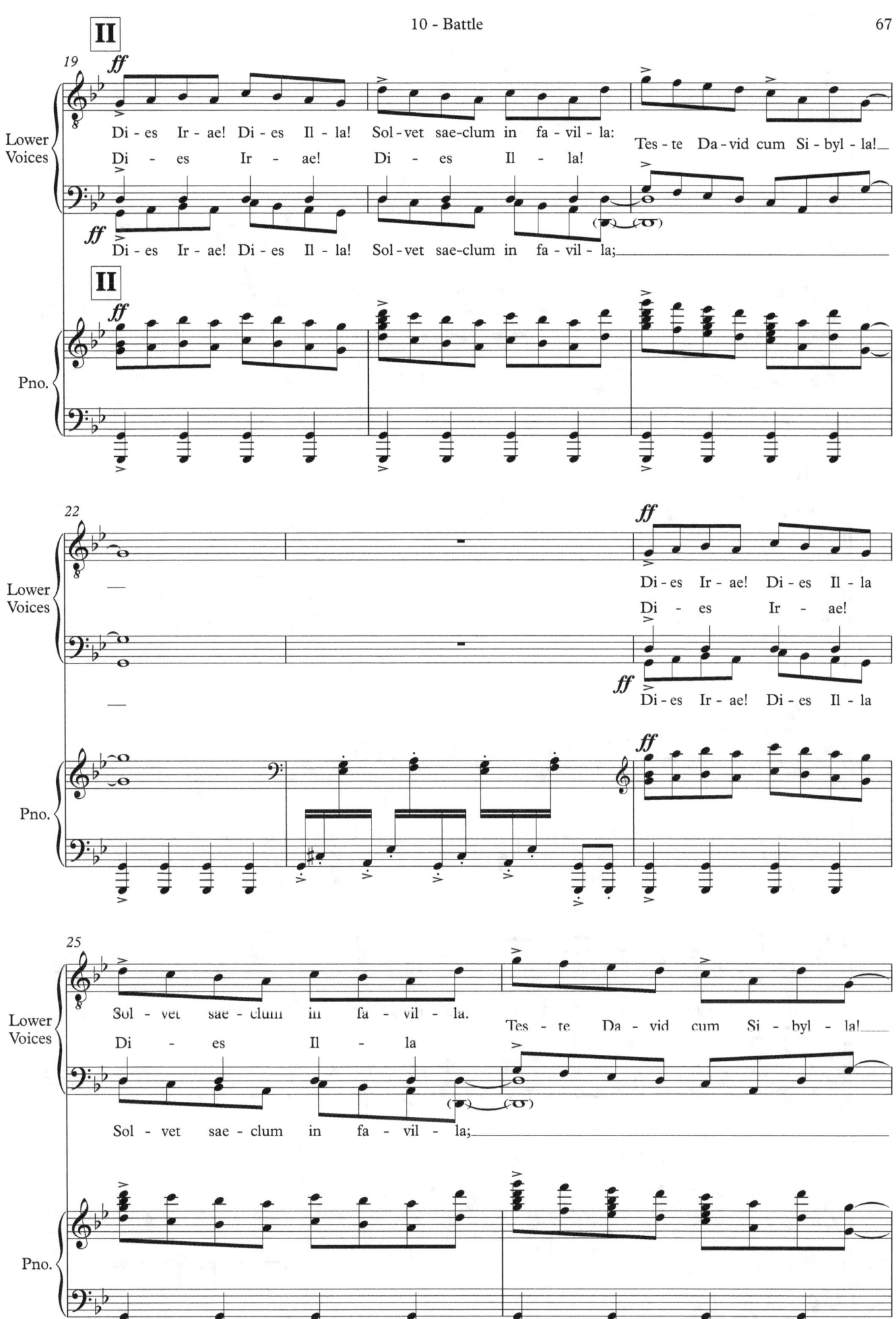

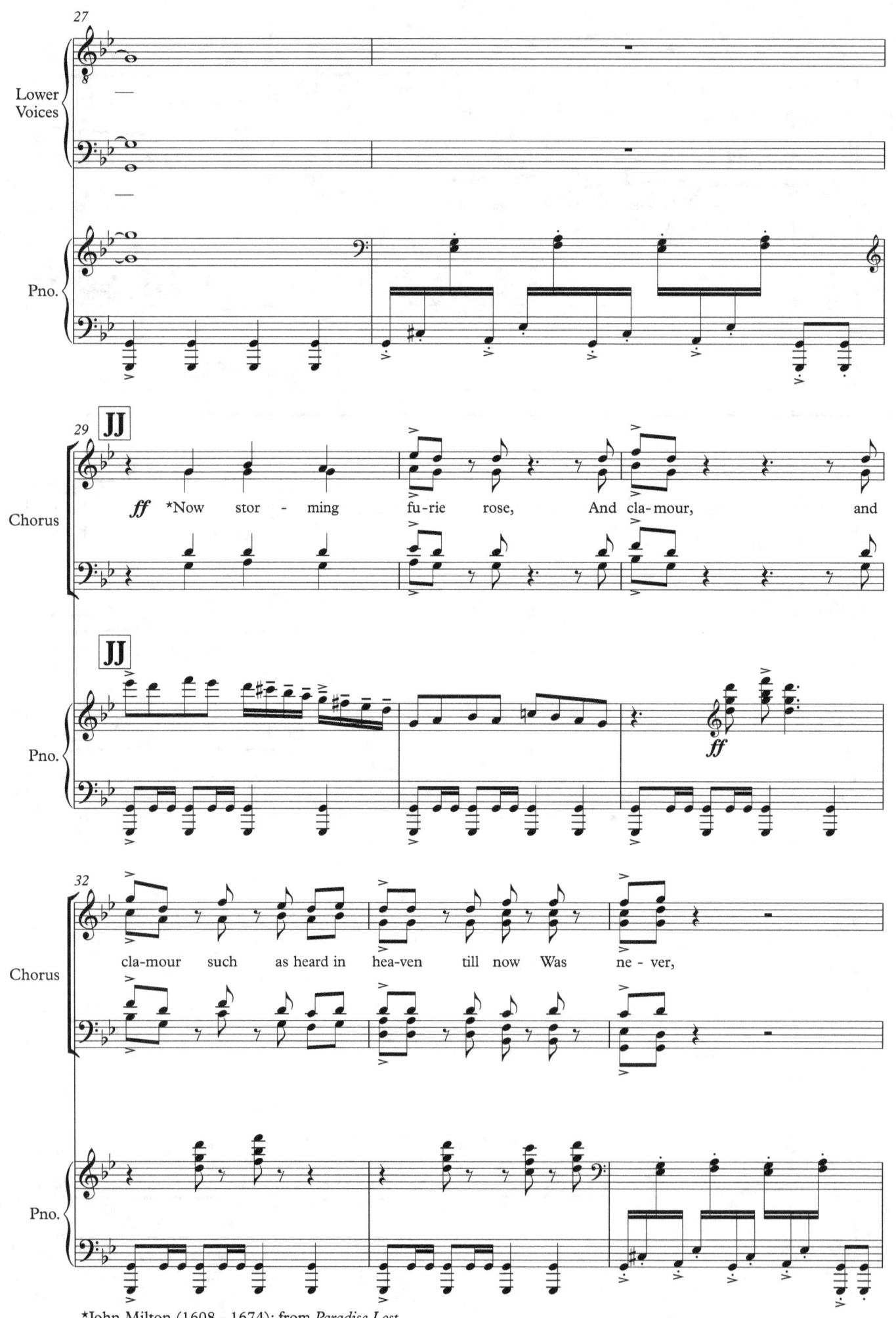

*John Milton (1608 - 1674): from *Paradise Lost*

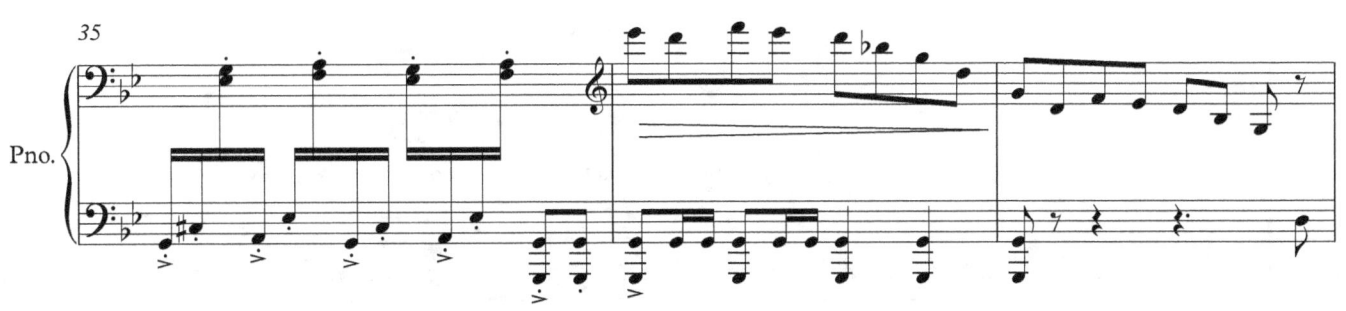
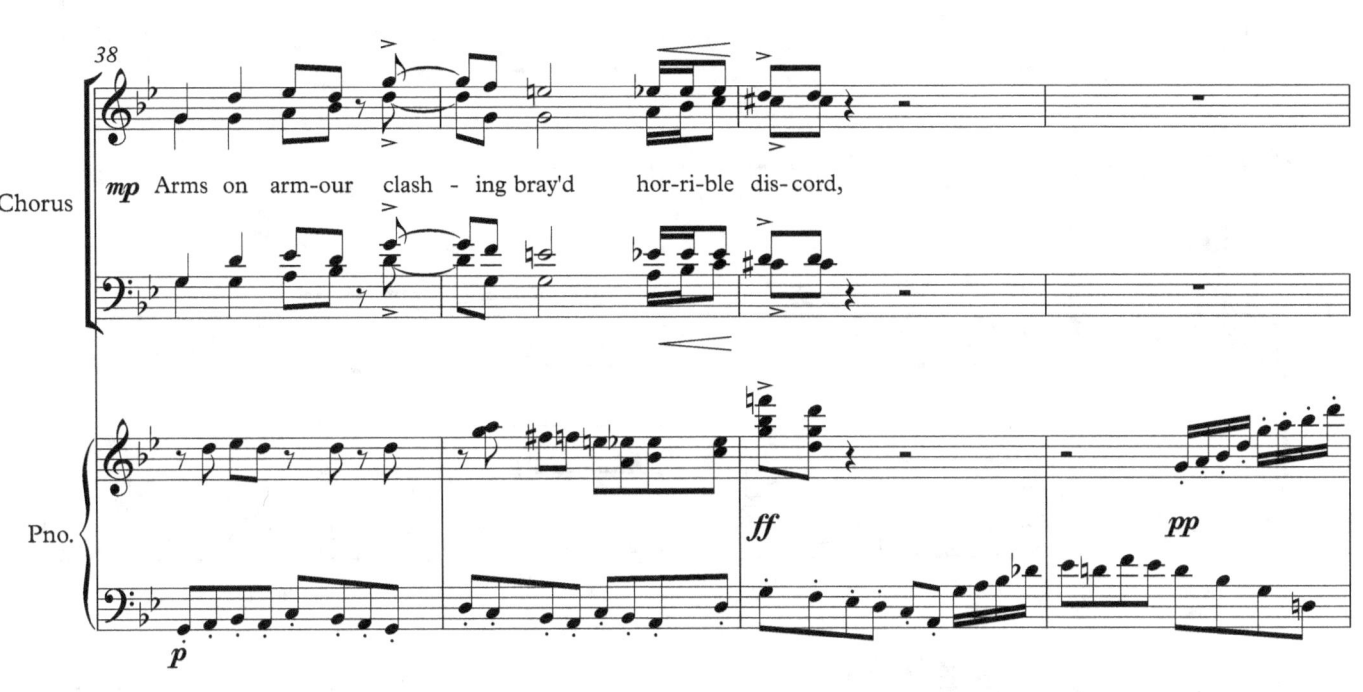
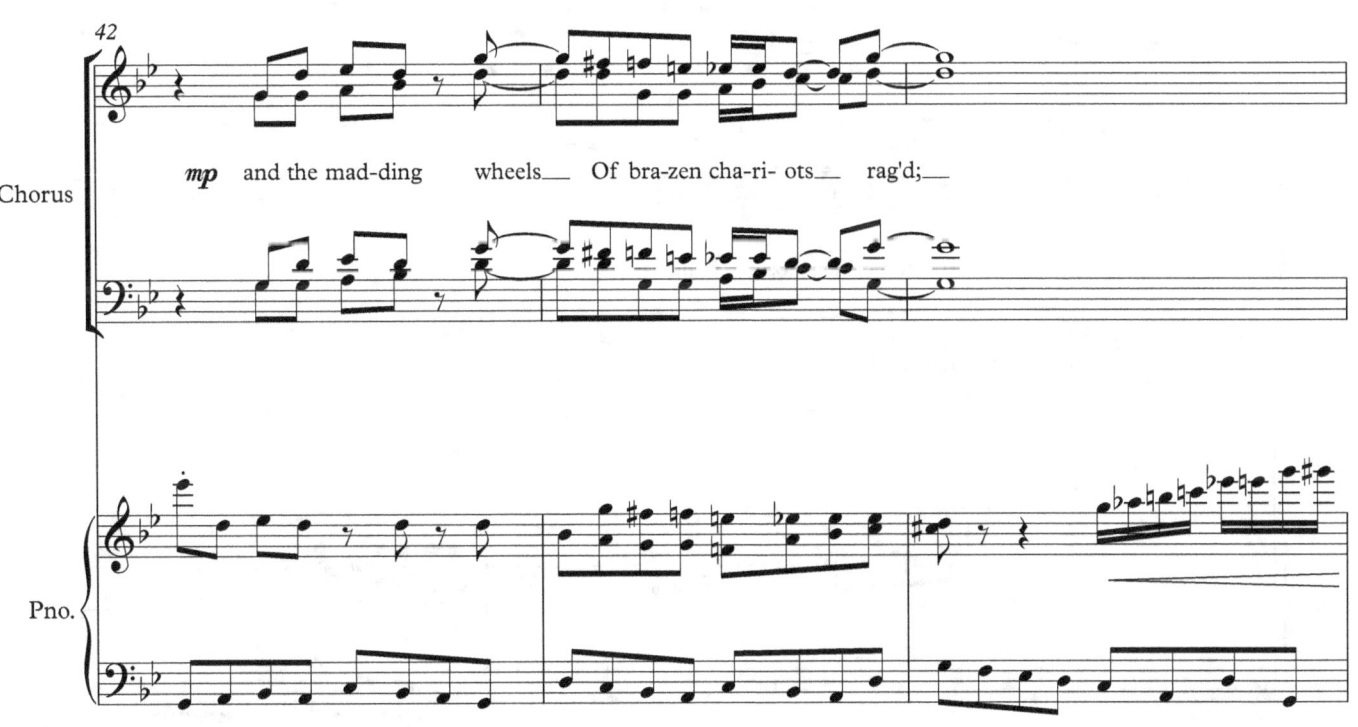

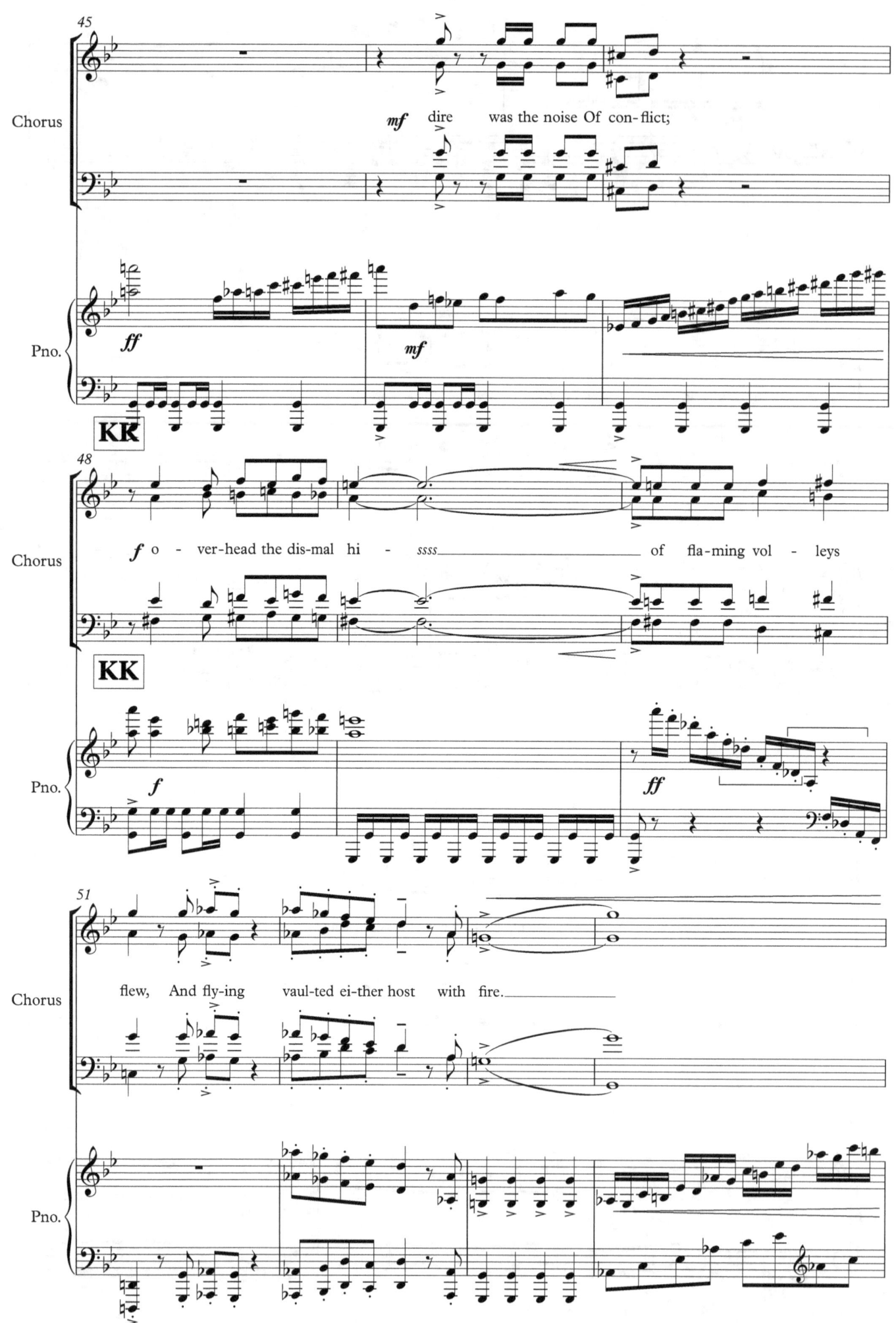

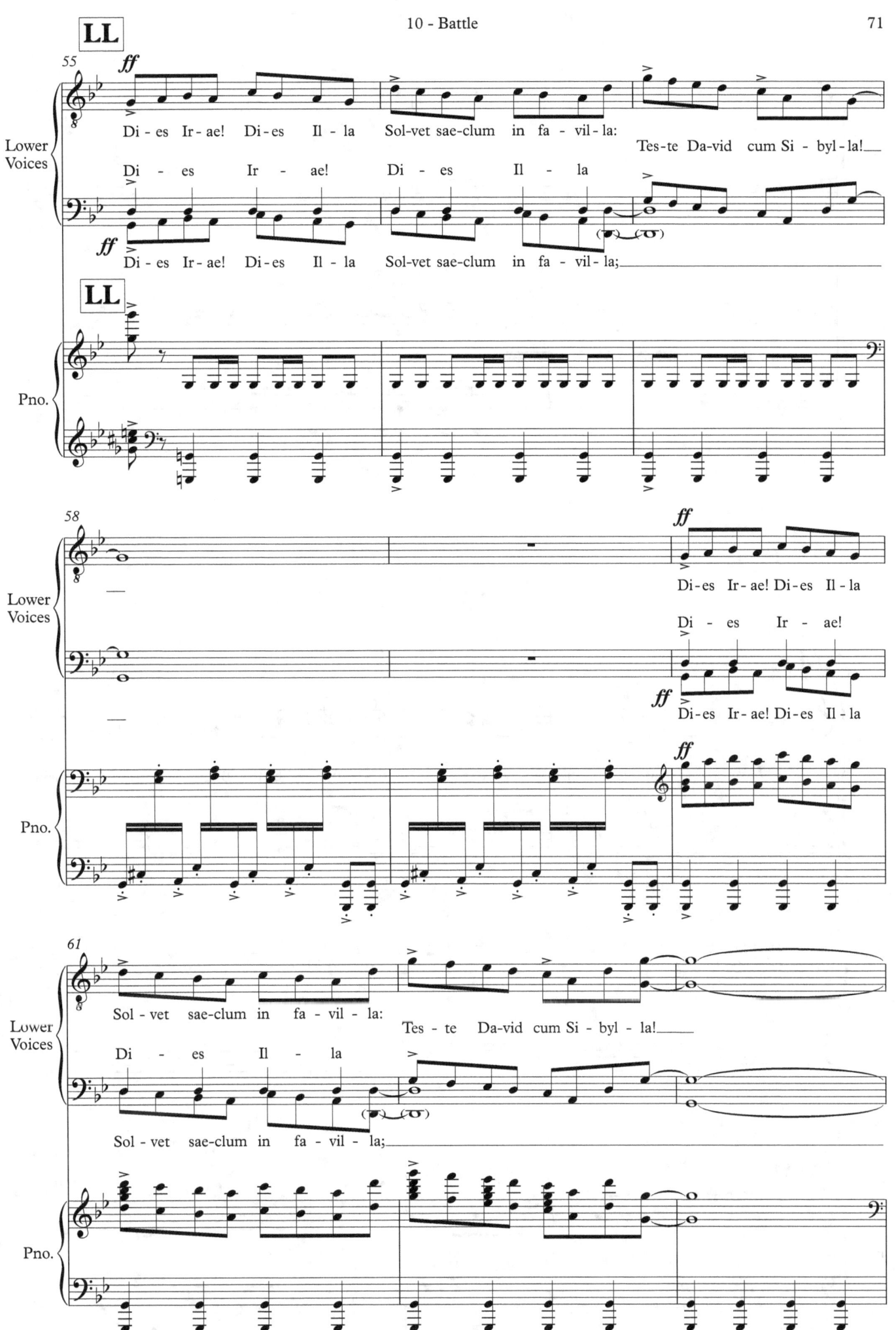

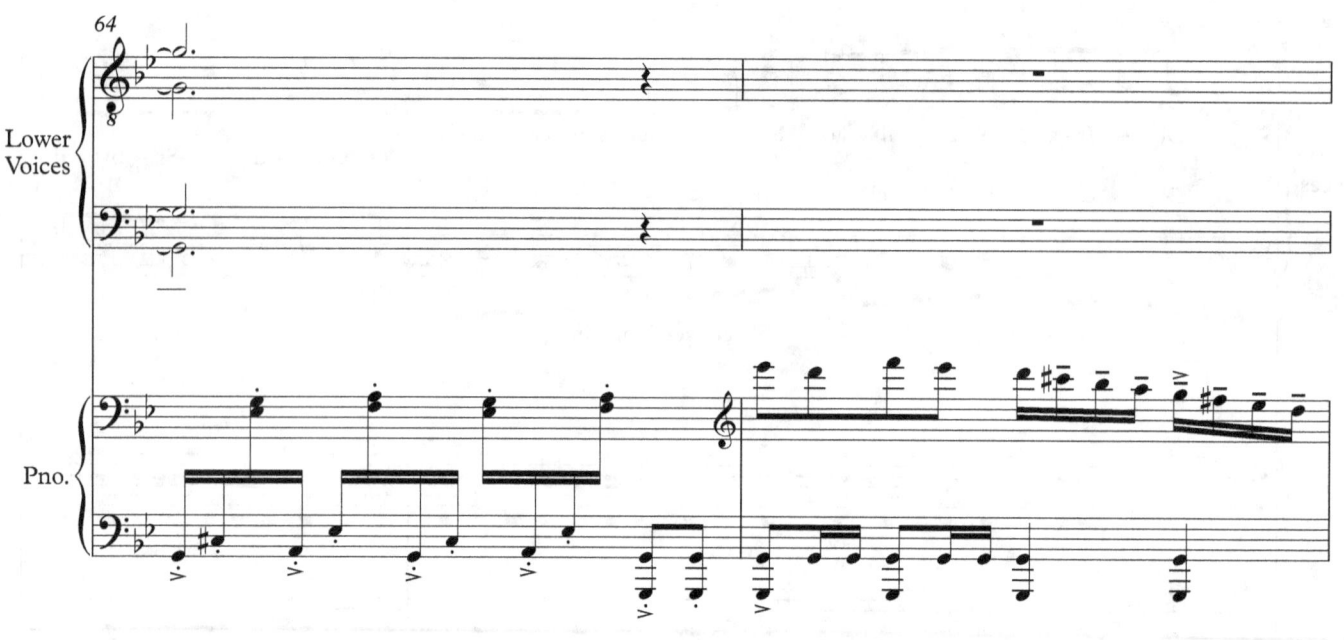

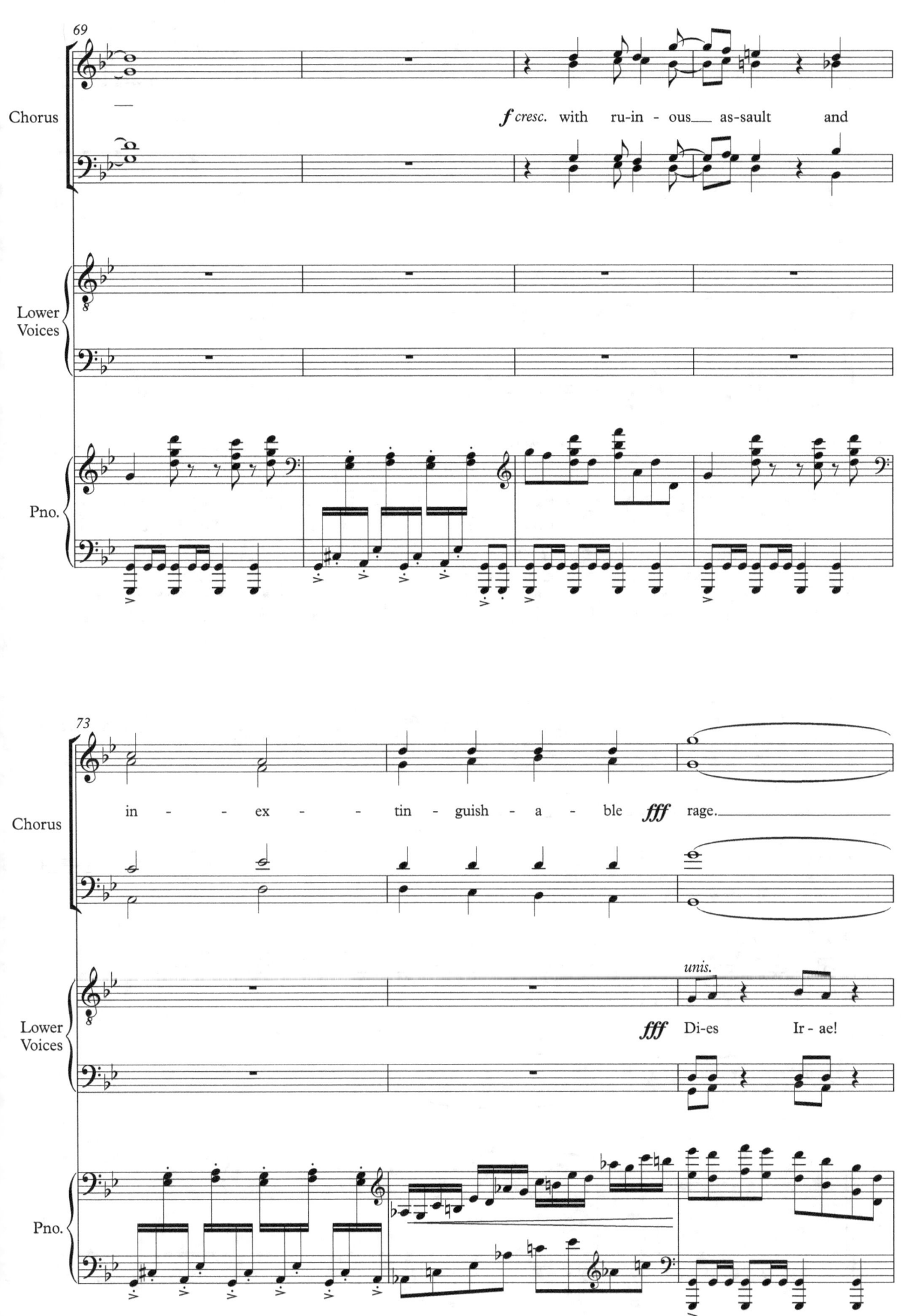

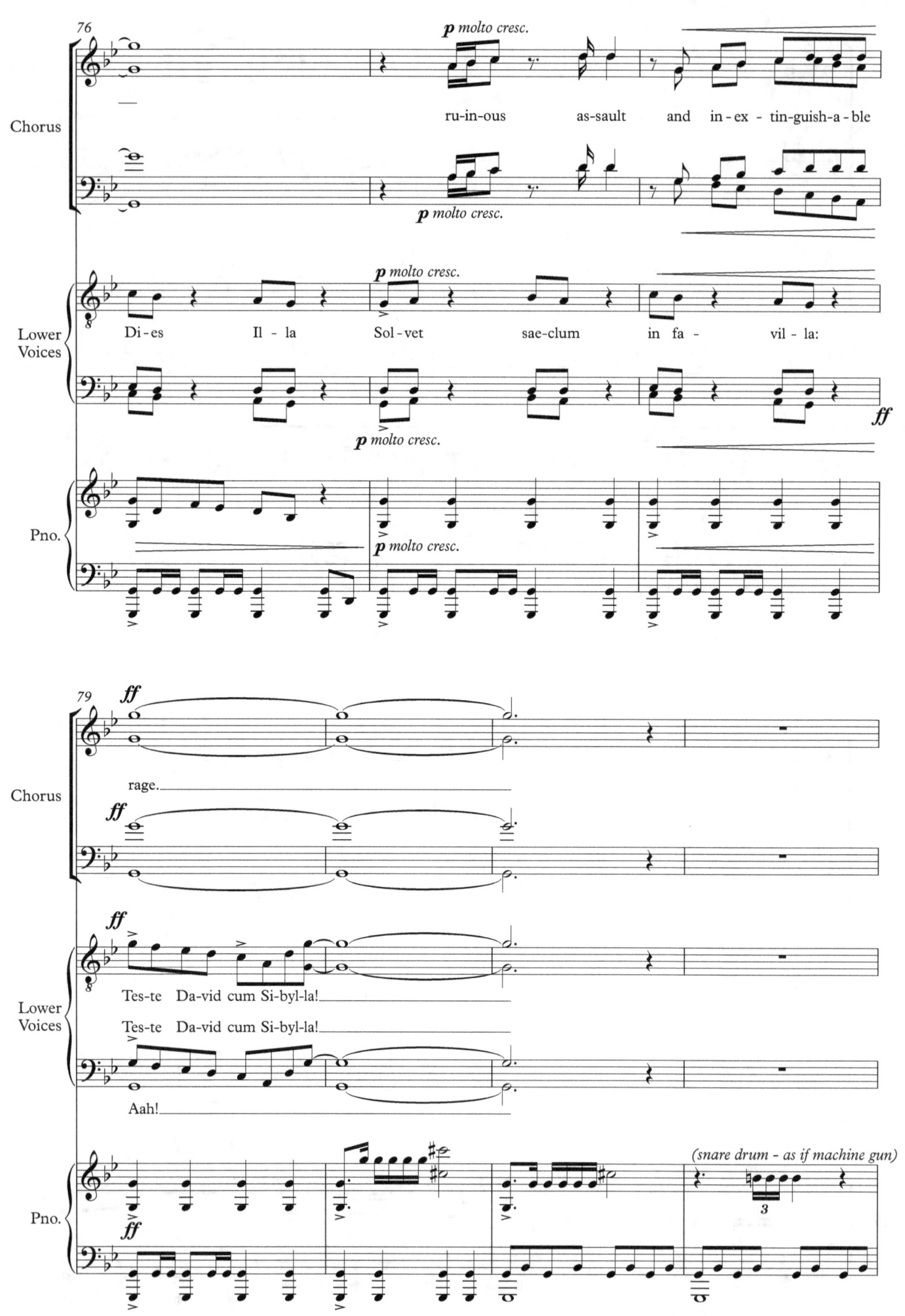

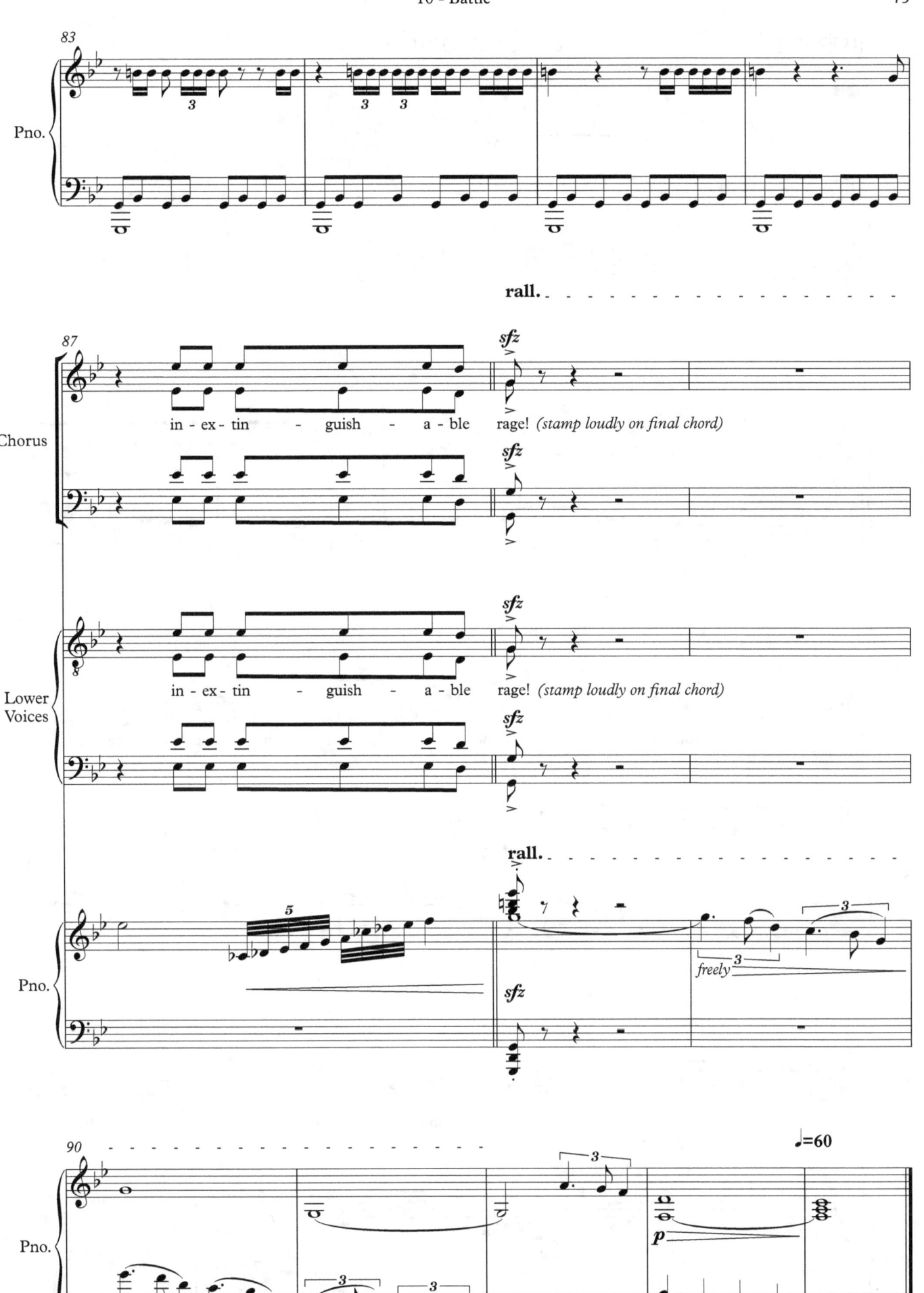

76

"To the memory of my late mother, Gloria"

Soprano solo
Baritone solo
SATB Chorus

LOWER VOICES SIT

11 - Consolation

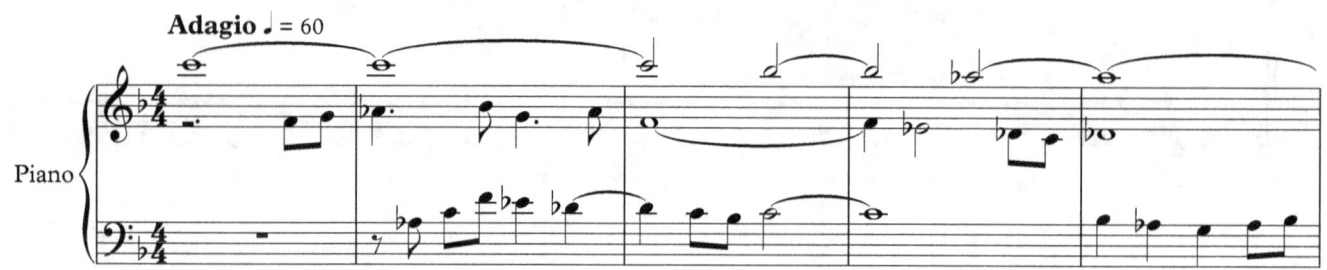

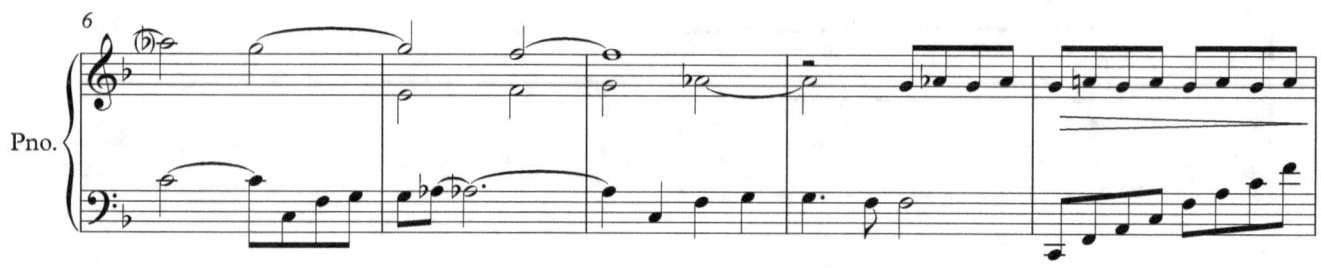

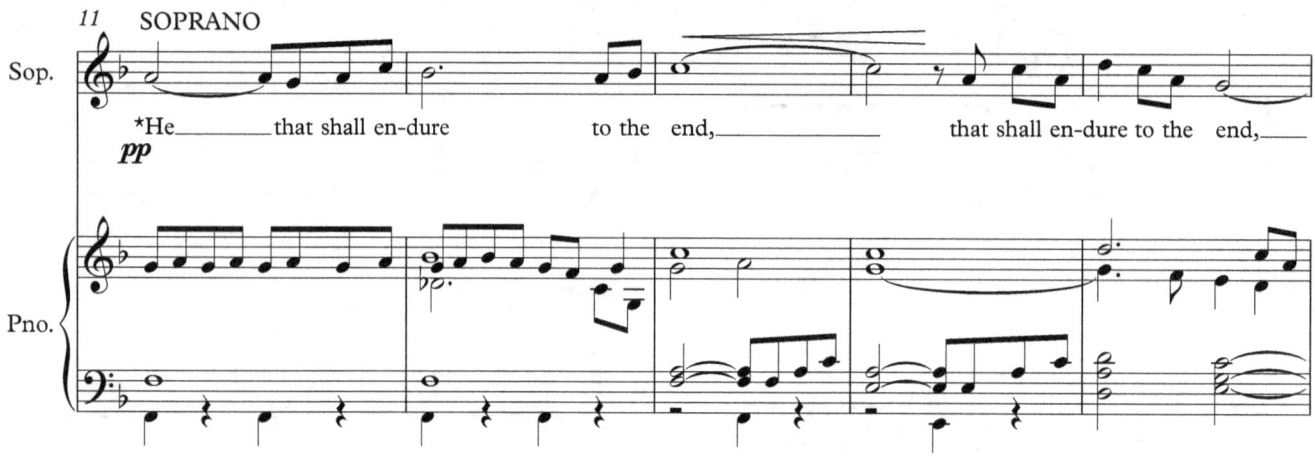

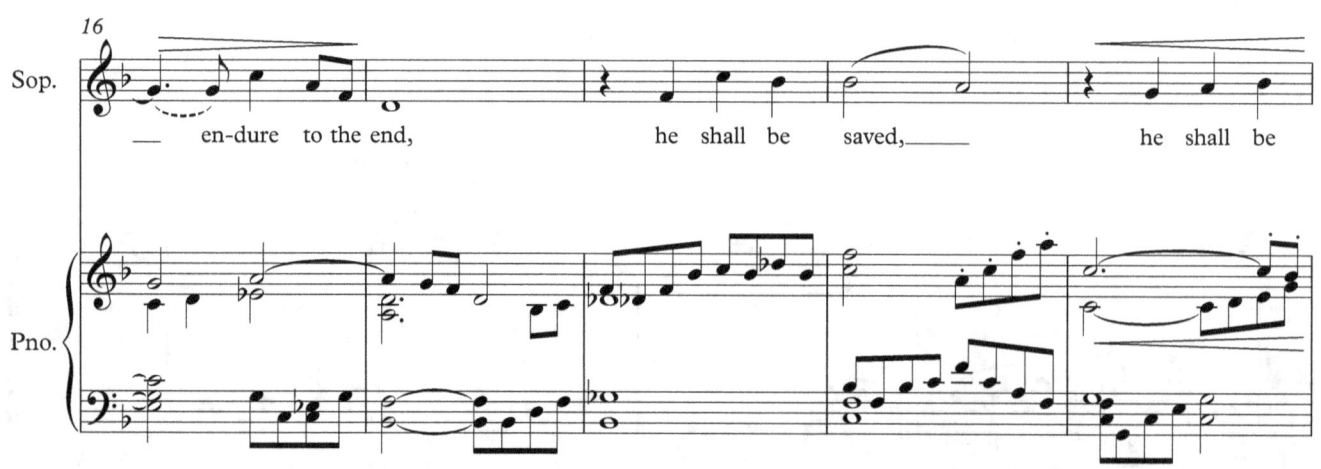

*Matthew Ch: 24 (amended)

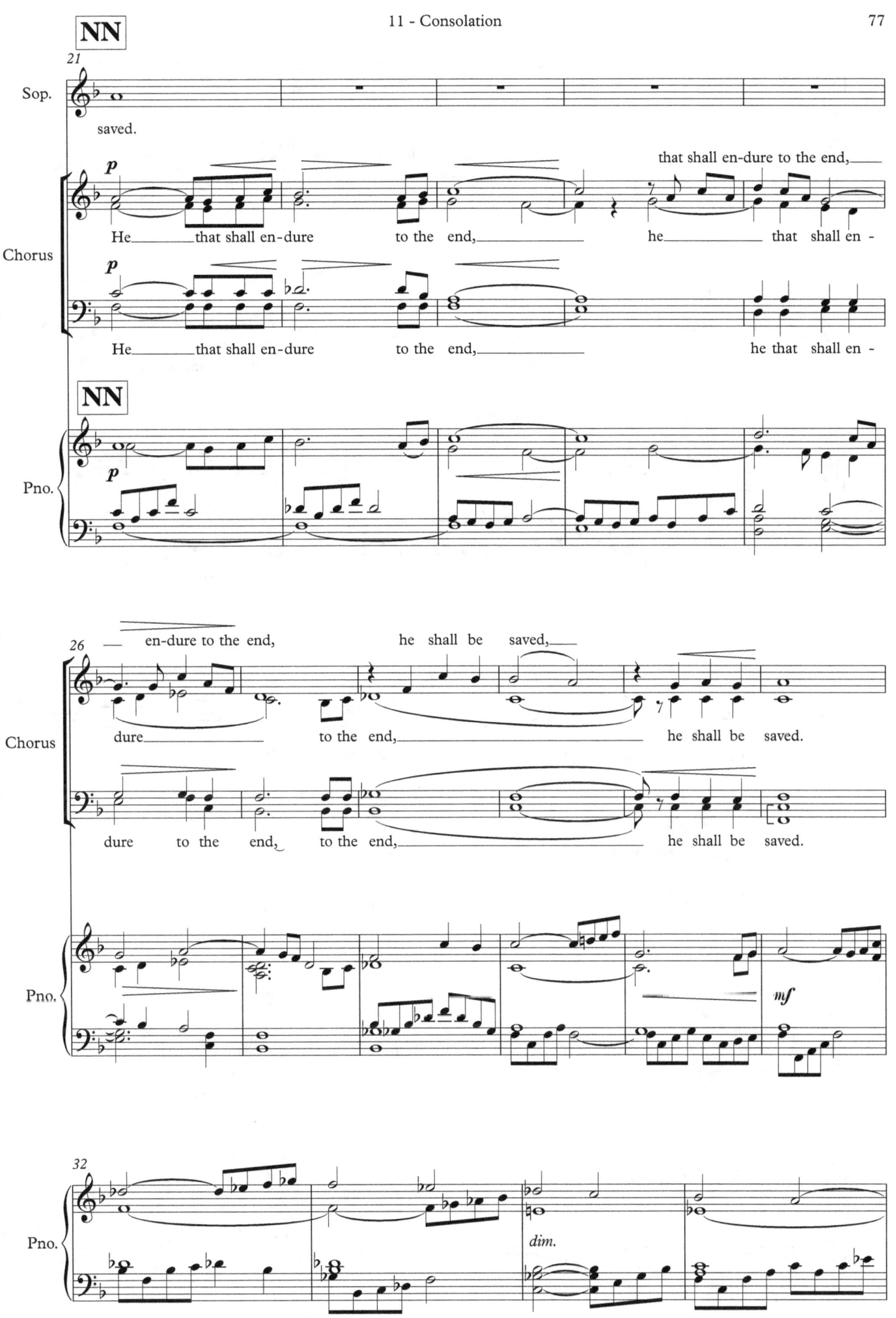

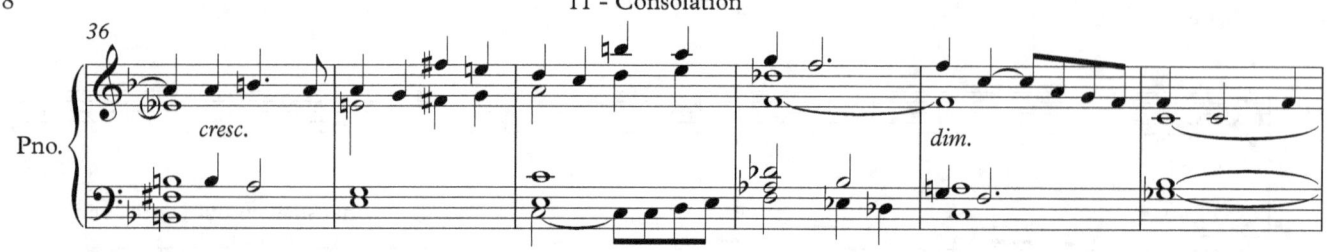
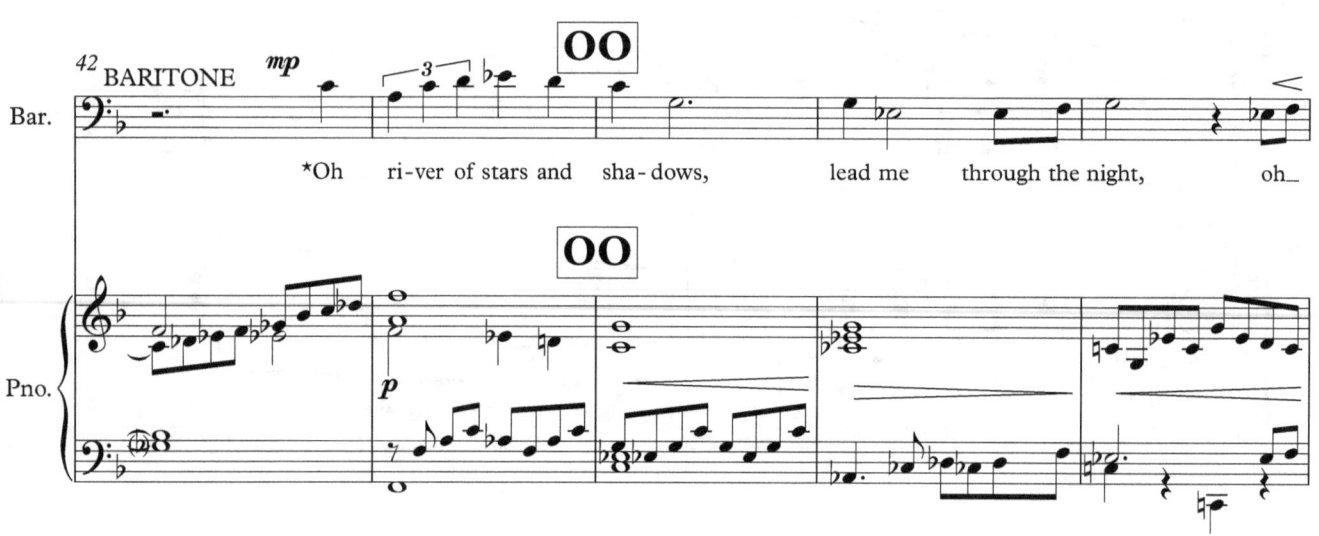
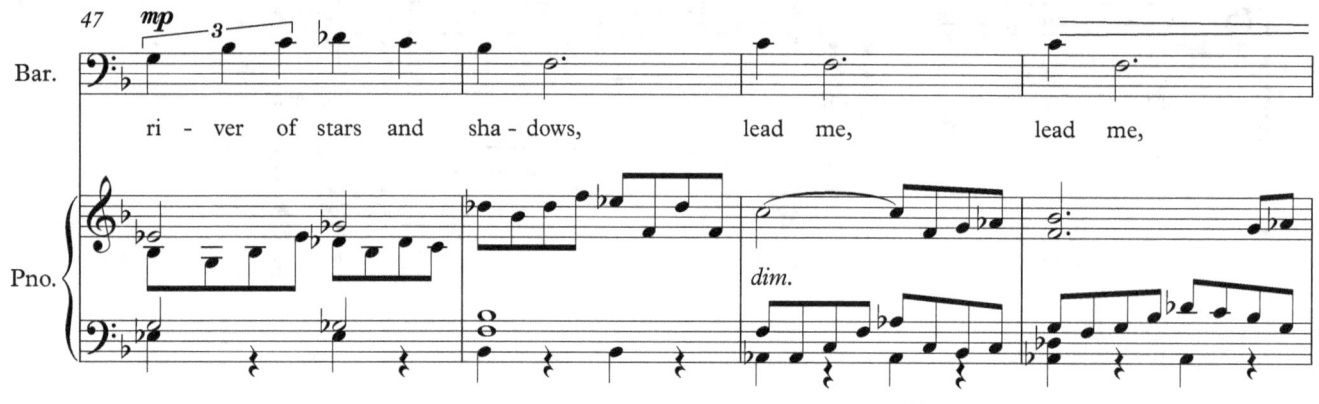
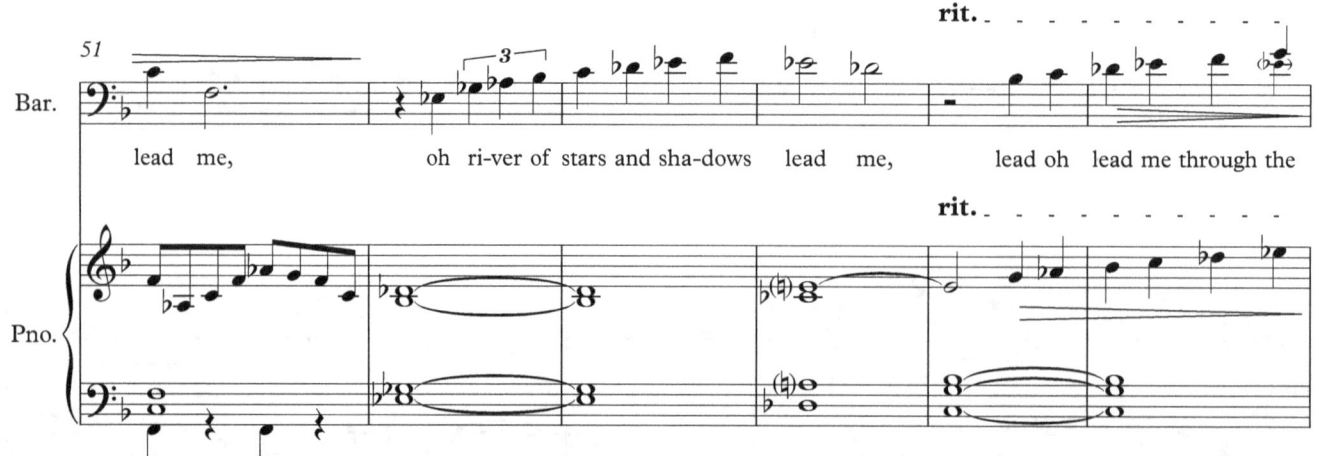

*Siegfried Sassoon (1886 - 1967): from *Before The Battle*.
Copyright Siegfried Sassoon by kind permission of the Estate of George Sassoon

11 - Consolation

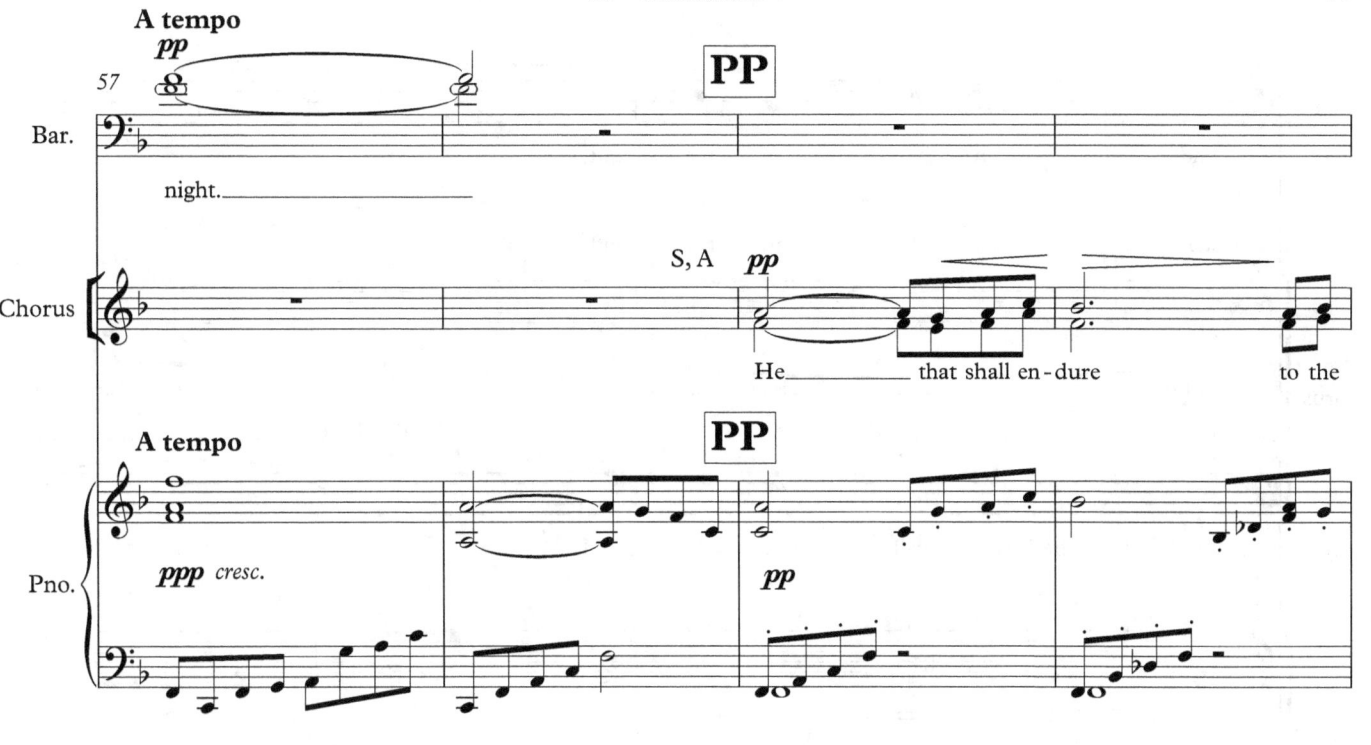

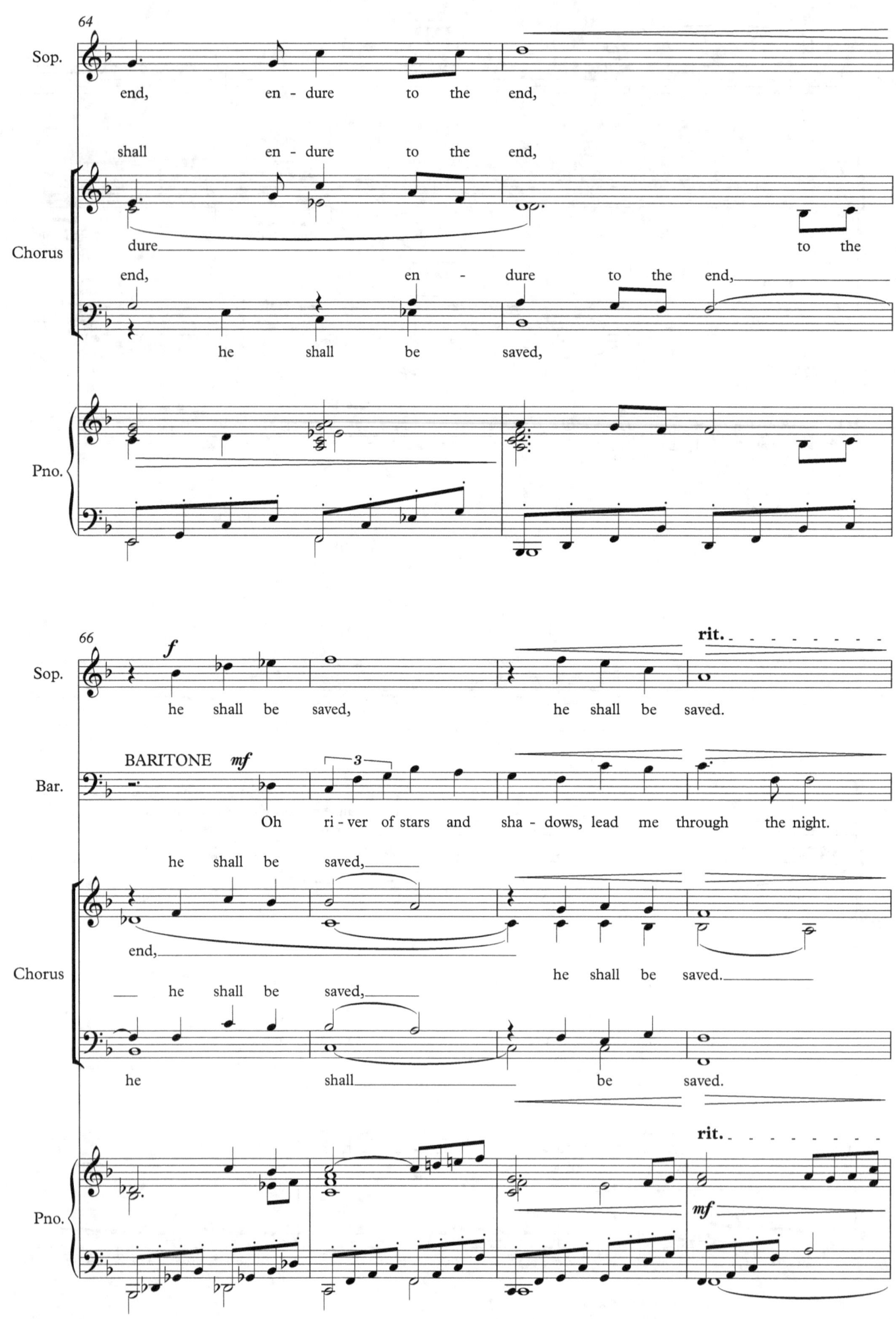

11 - Consolation

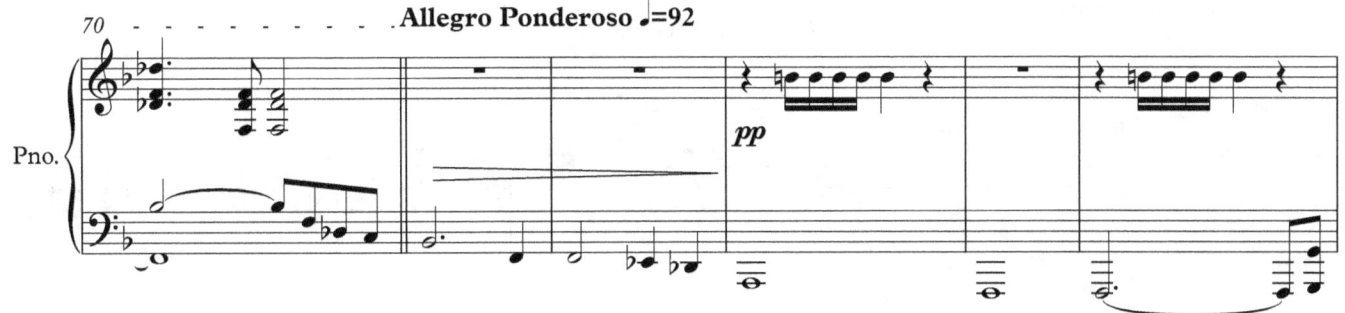
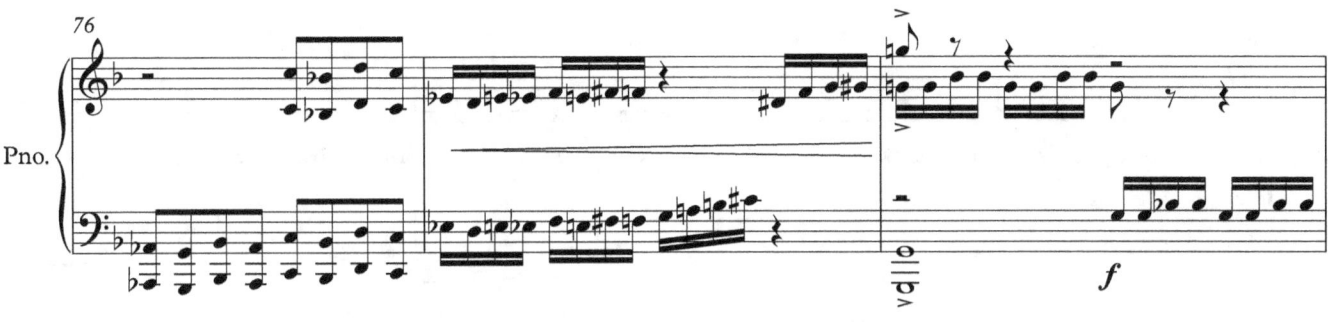
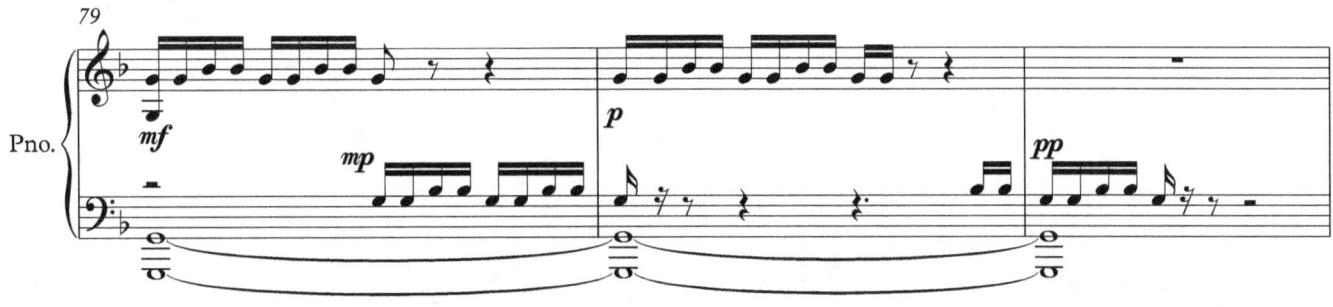

Dedicated to William Leslie Jones – Grenadier Guards 1915-18

Soprano Solo
Upper Voices

12 - Longing

UPPER VOICES STAND
CHORUS SIT

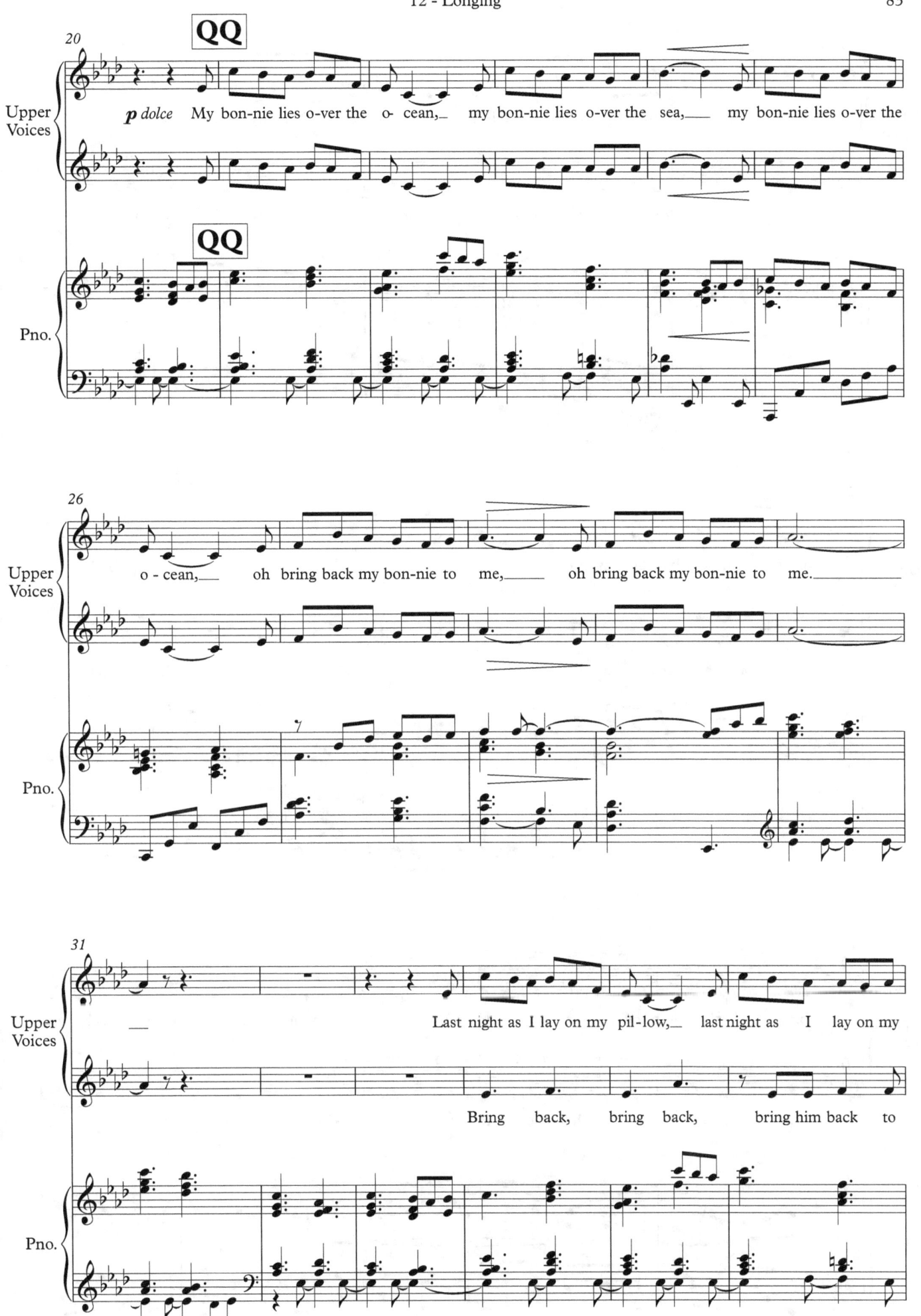

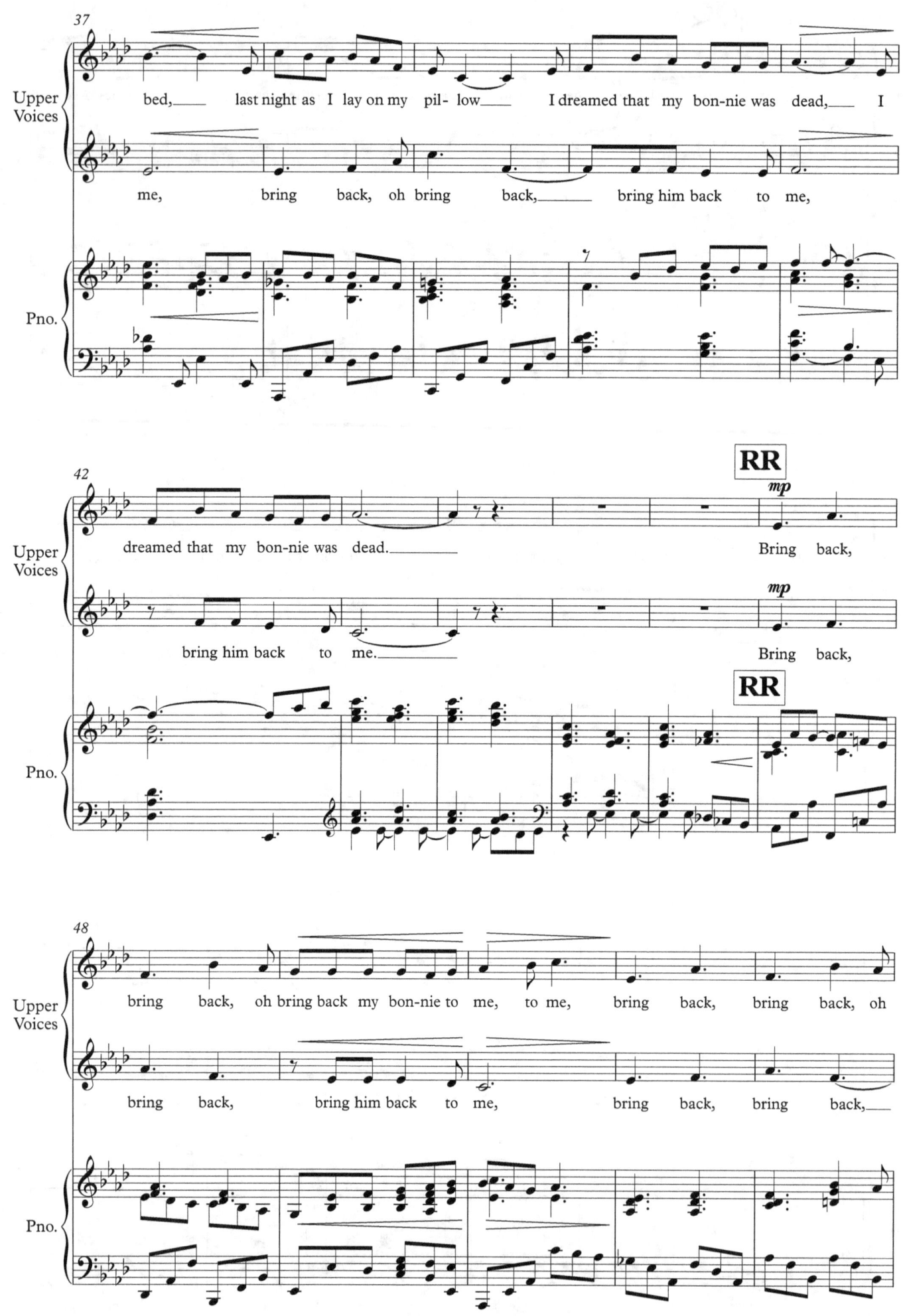

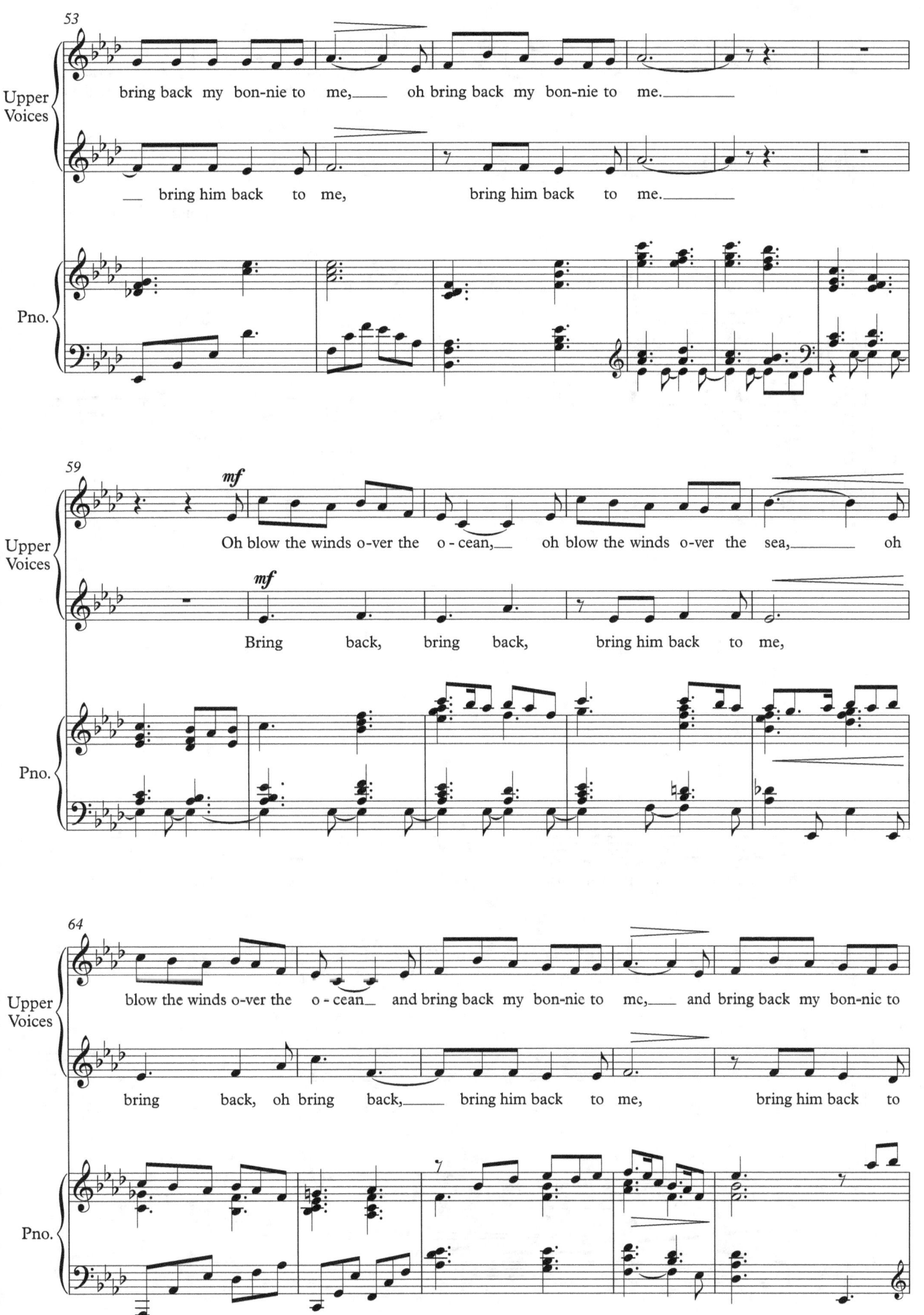

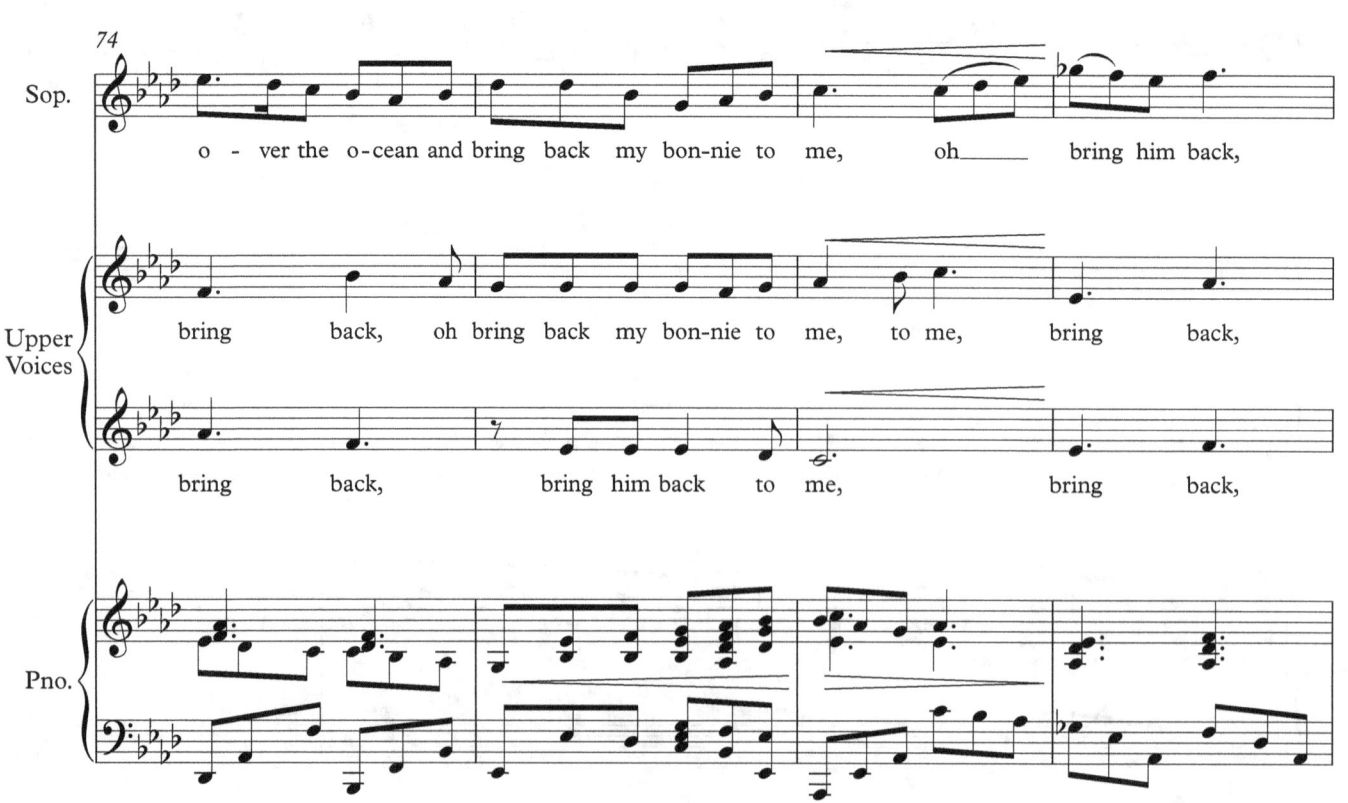

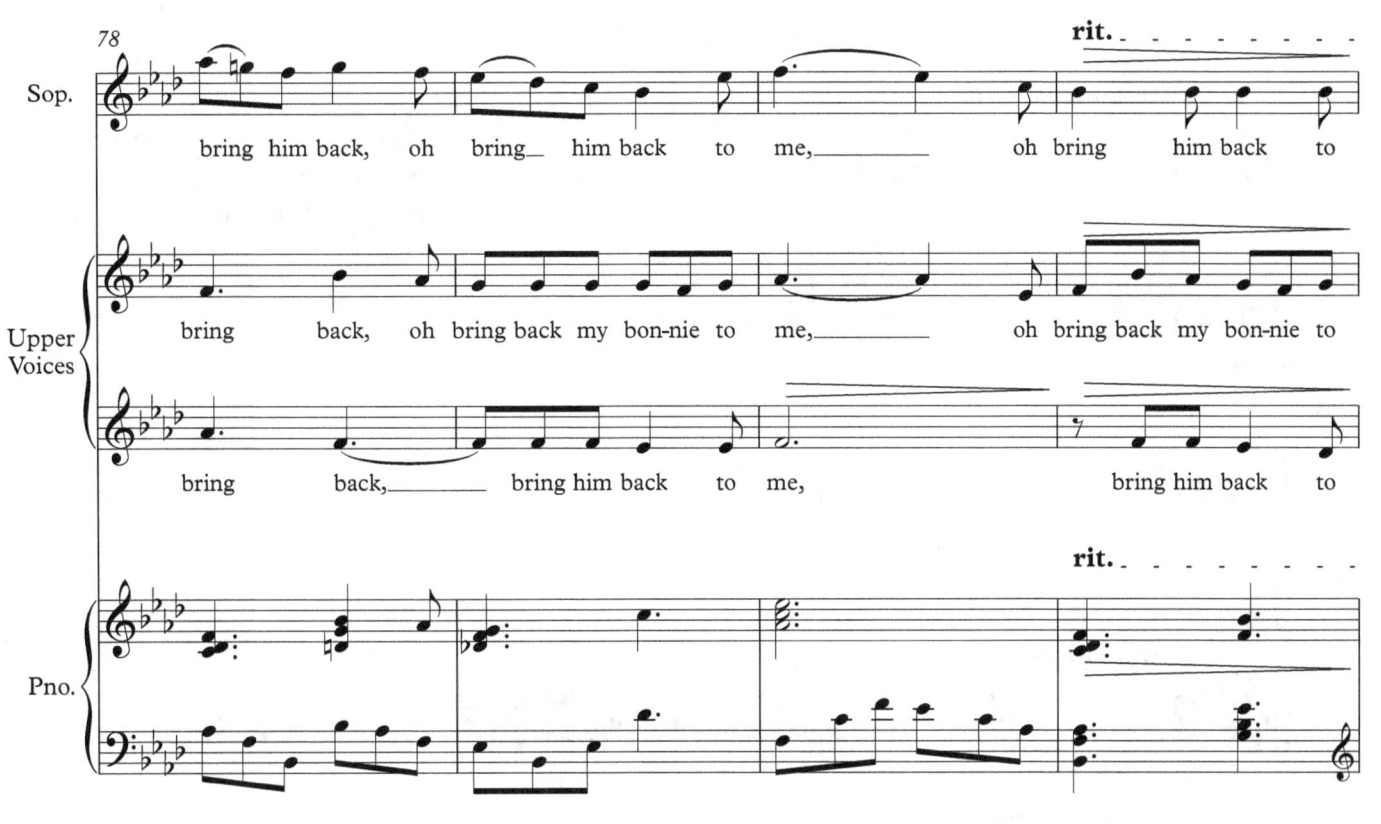
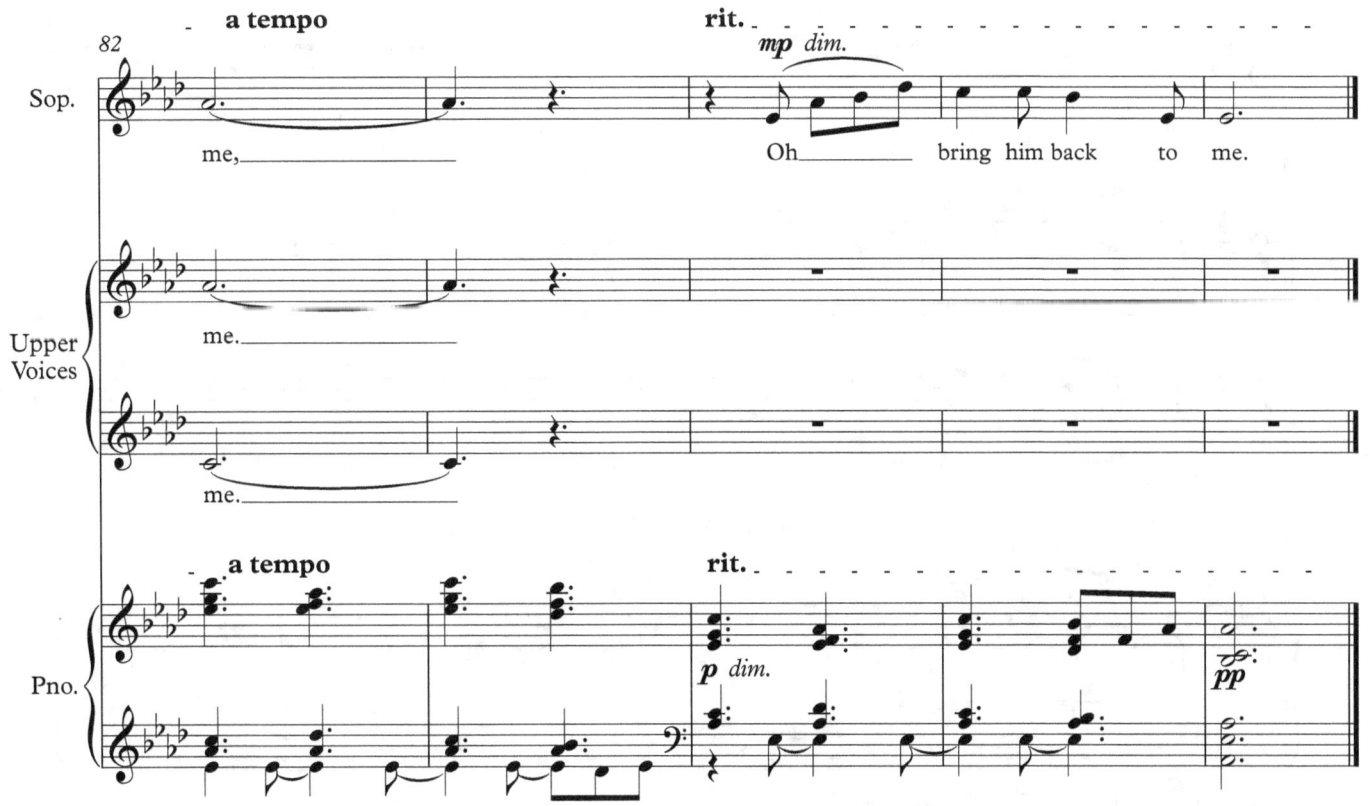

88 UPPER VOICES SIT / CHORUS STAND *For Jessica* Soprano Solo / SATB Chorus

13 - Petition

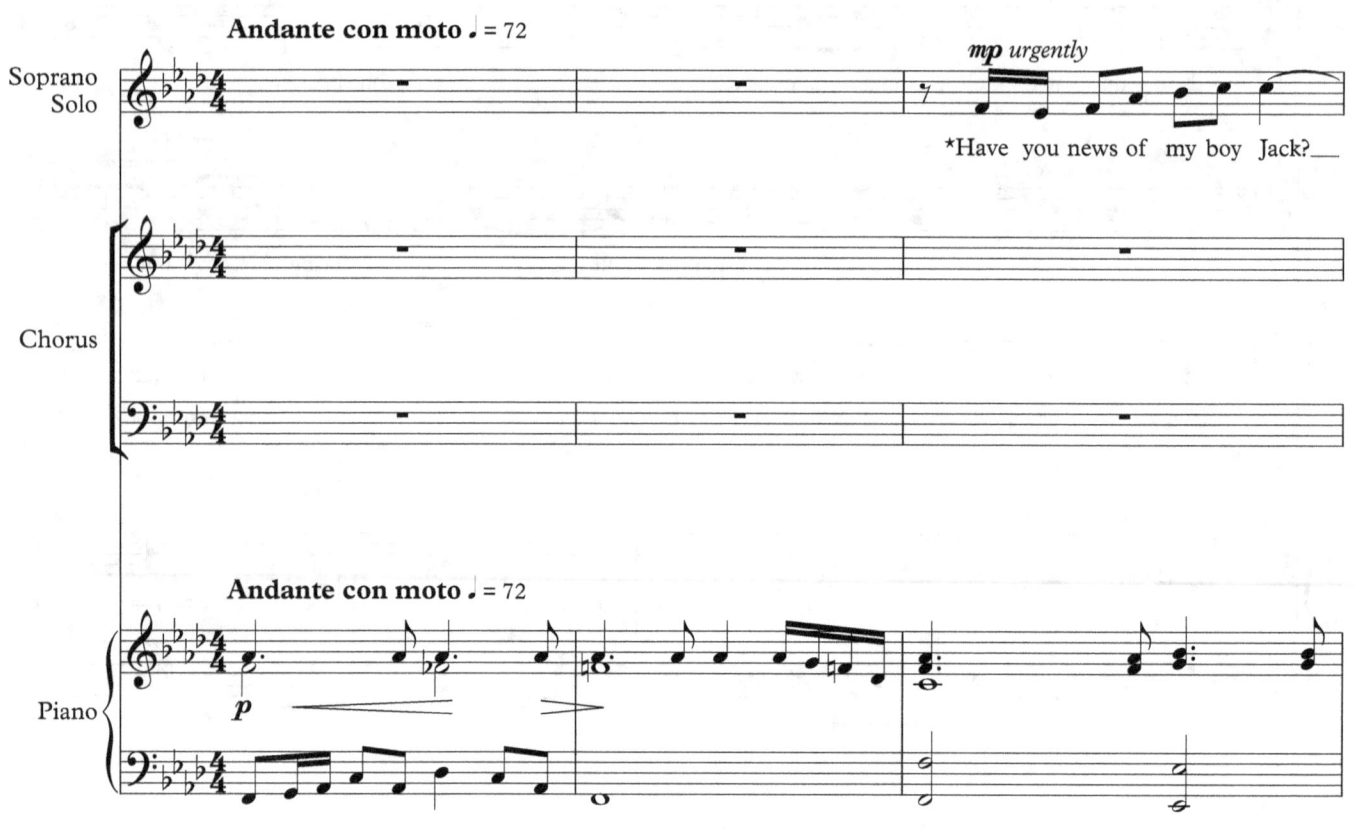

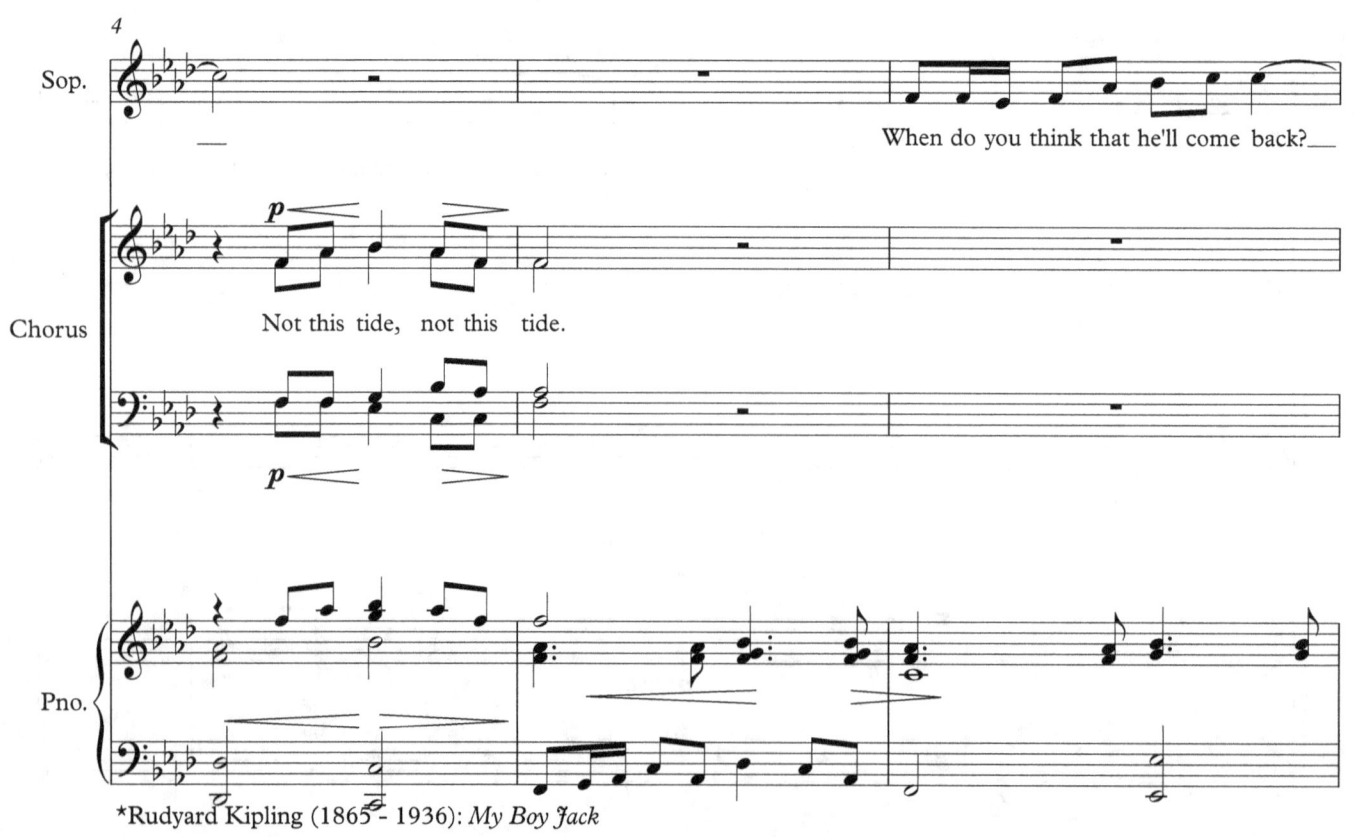

Rudyard Kipling (1865 - 1936): My Boy Jack

13 - Petition

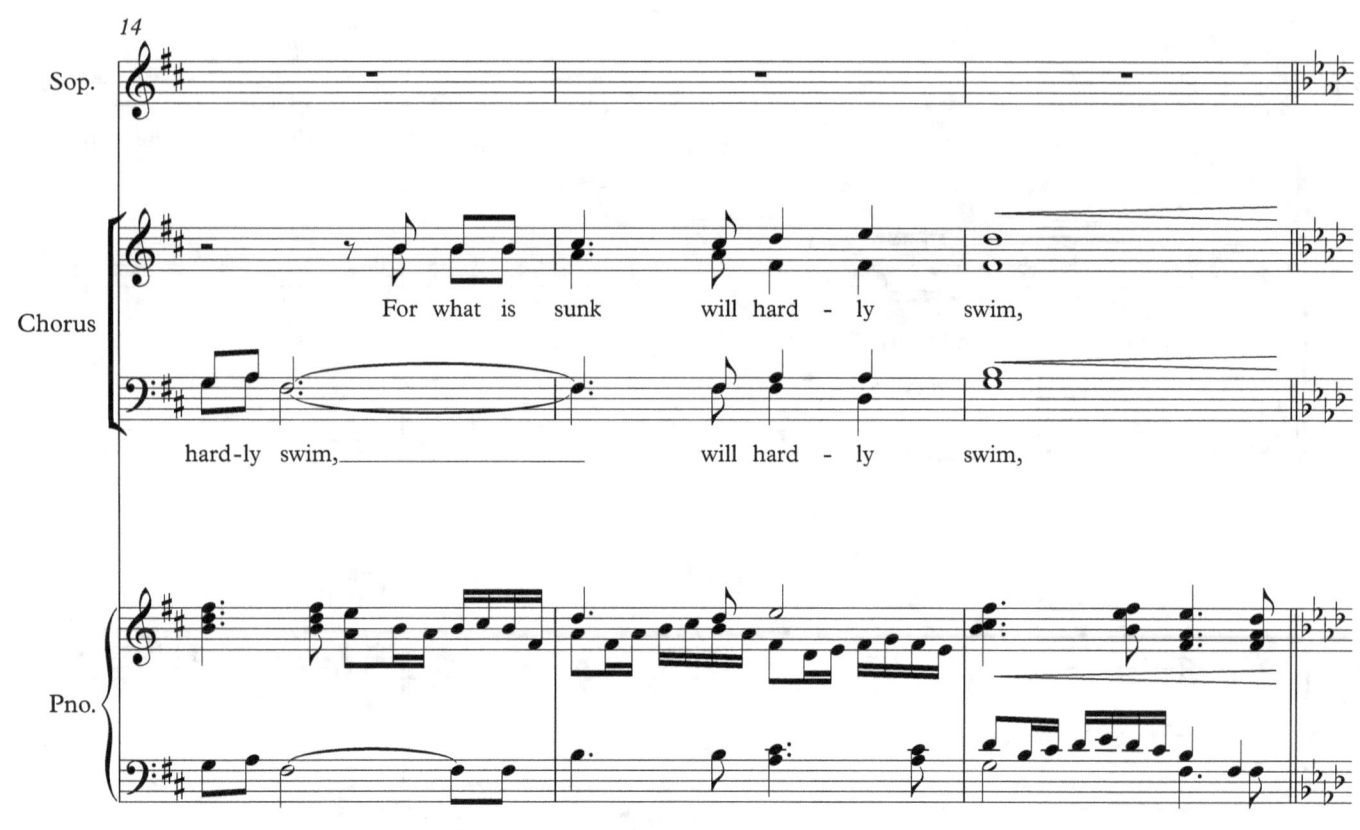

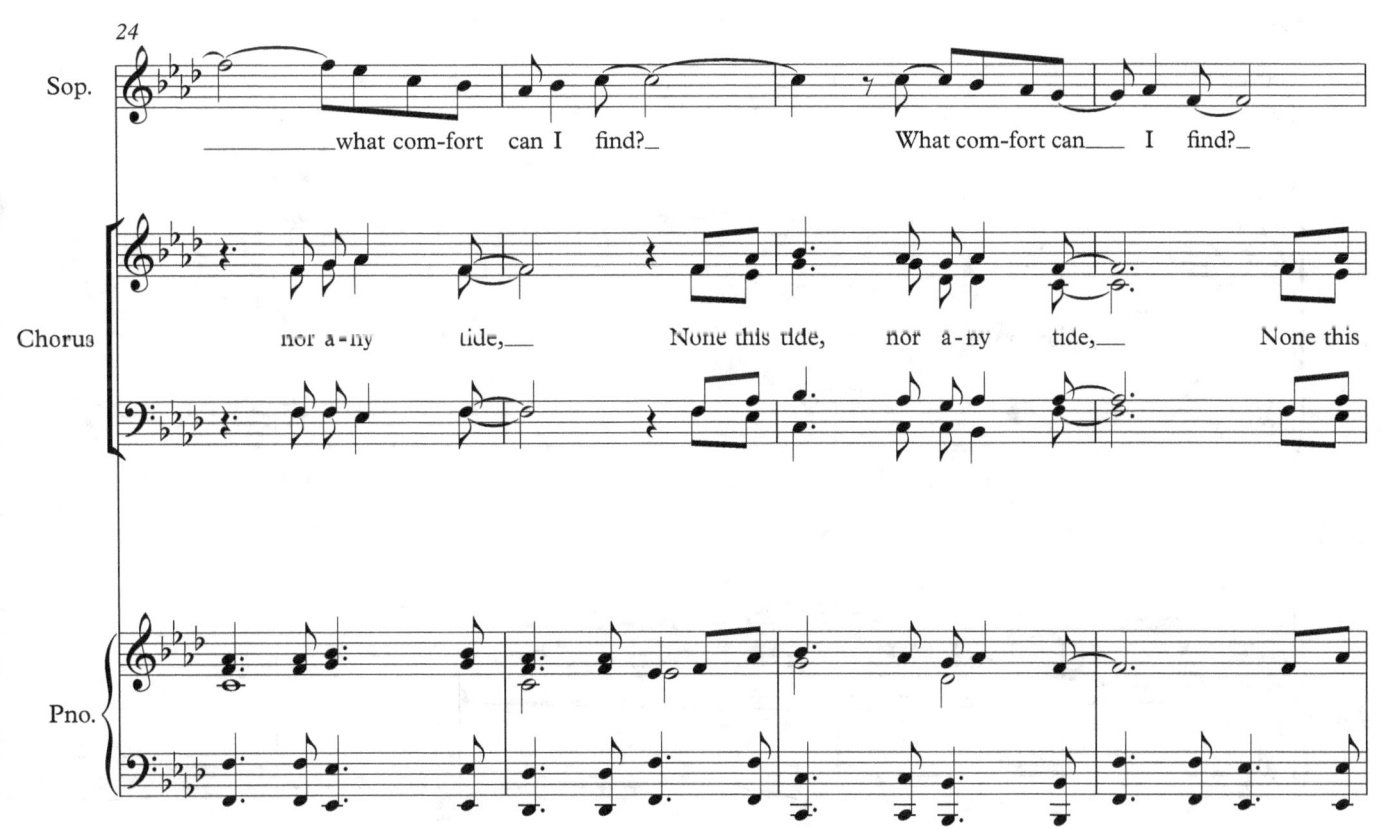

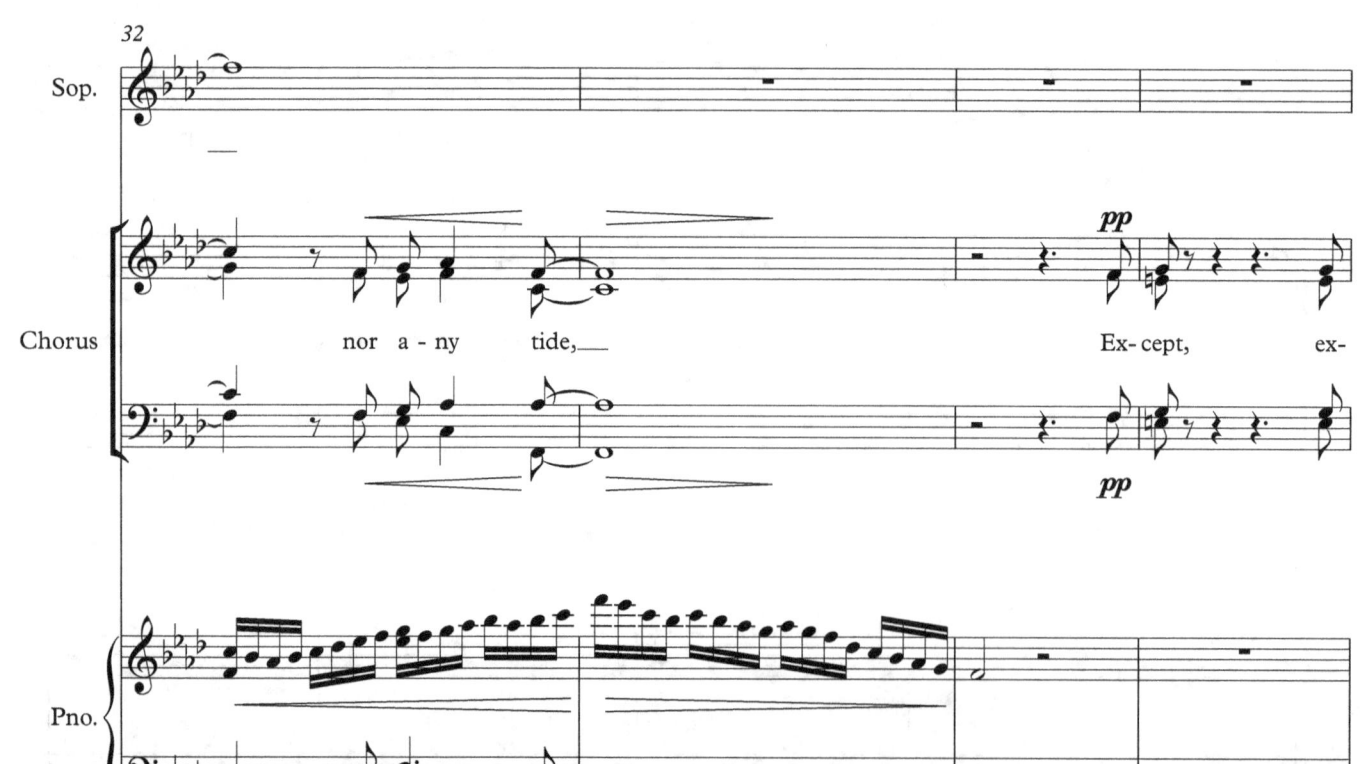

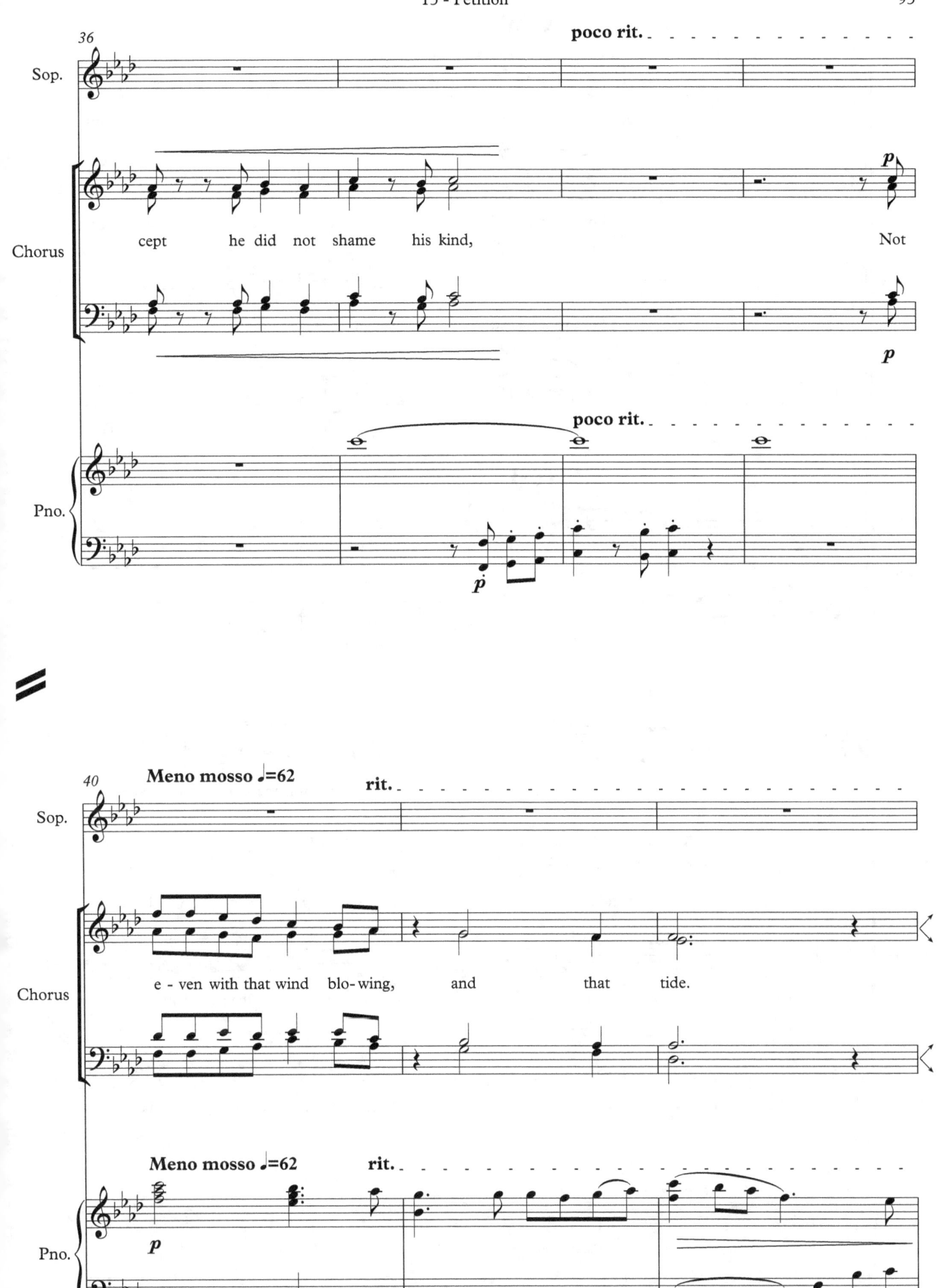

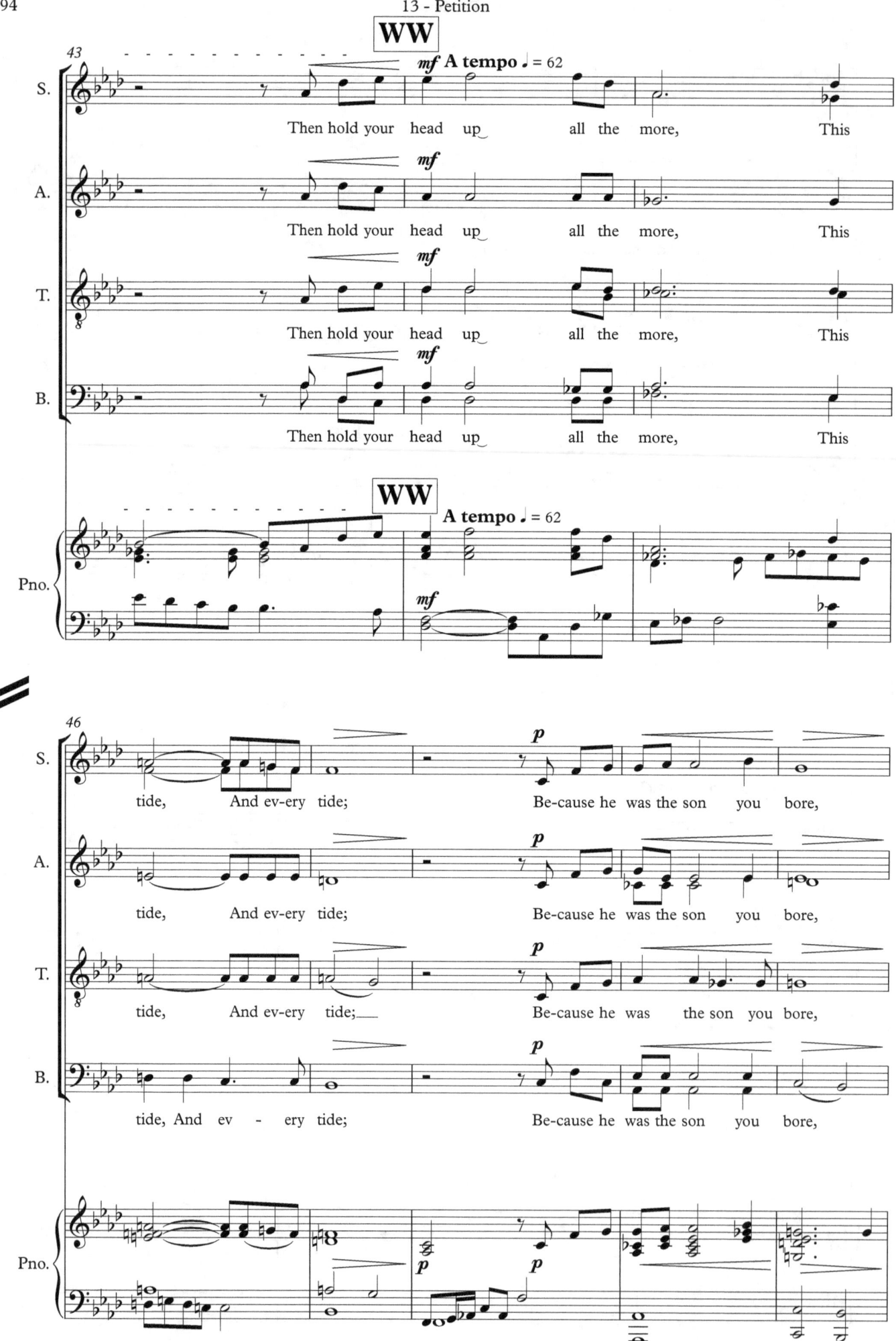

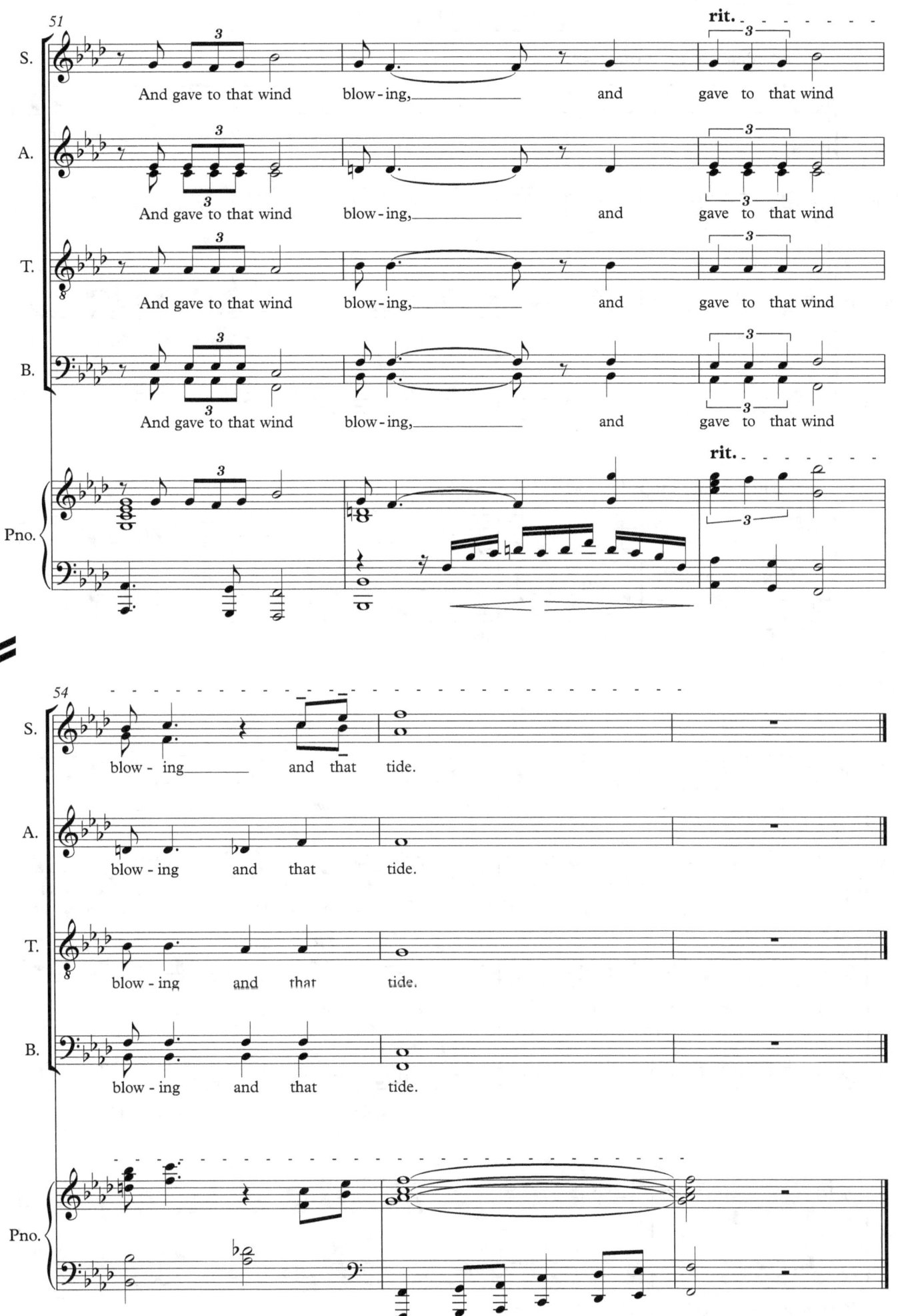

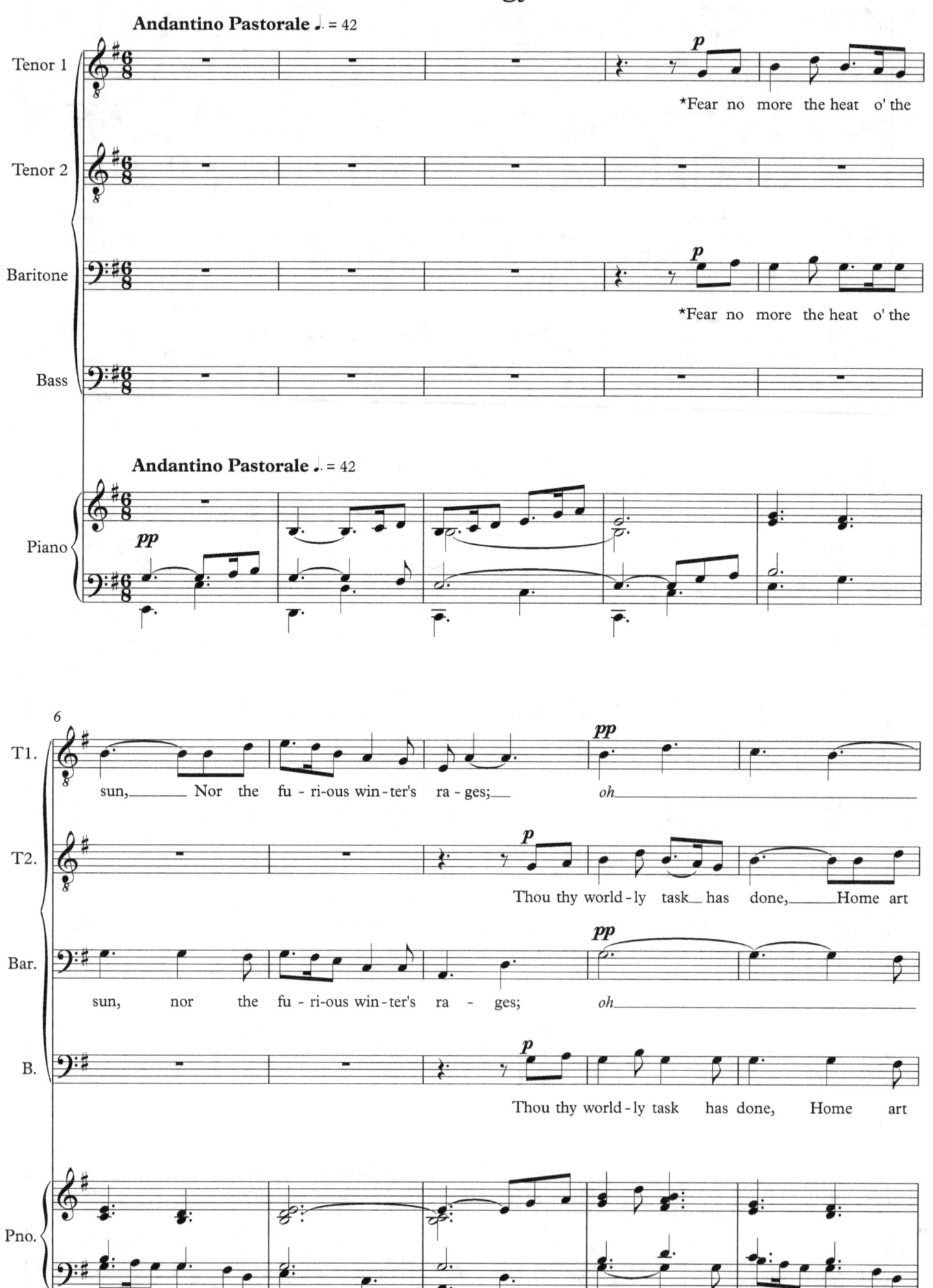

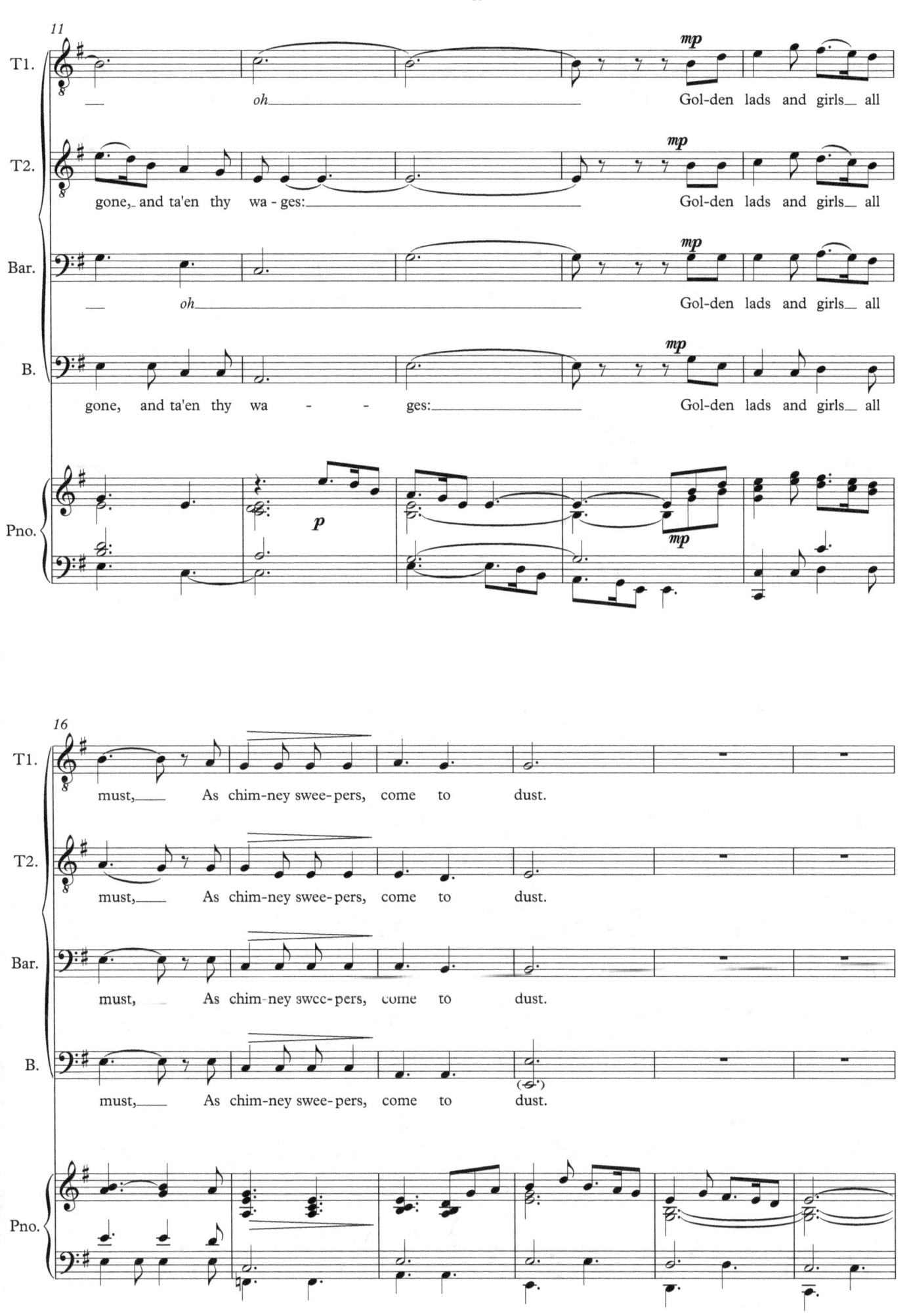

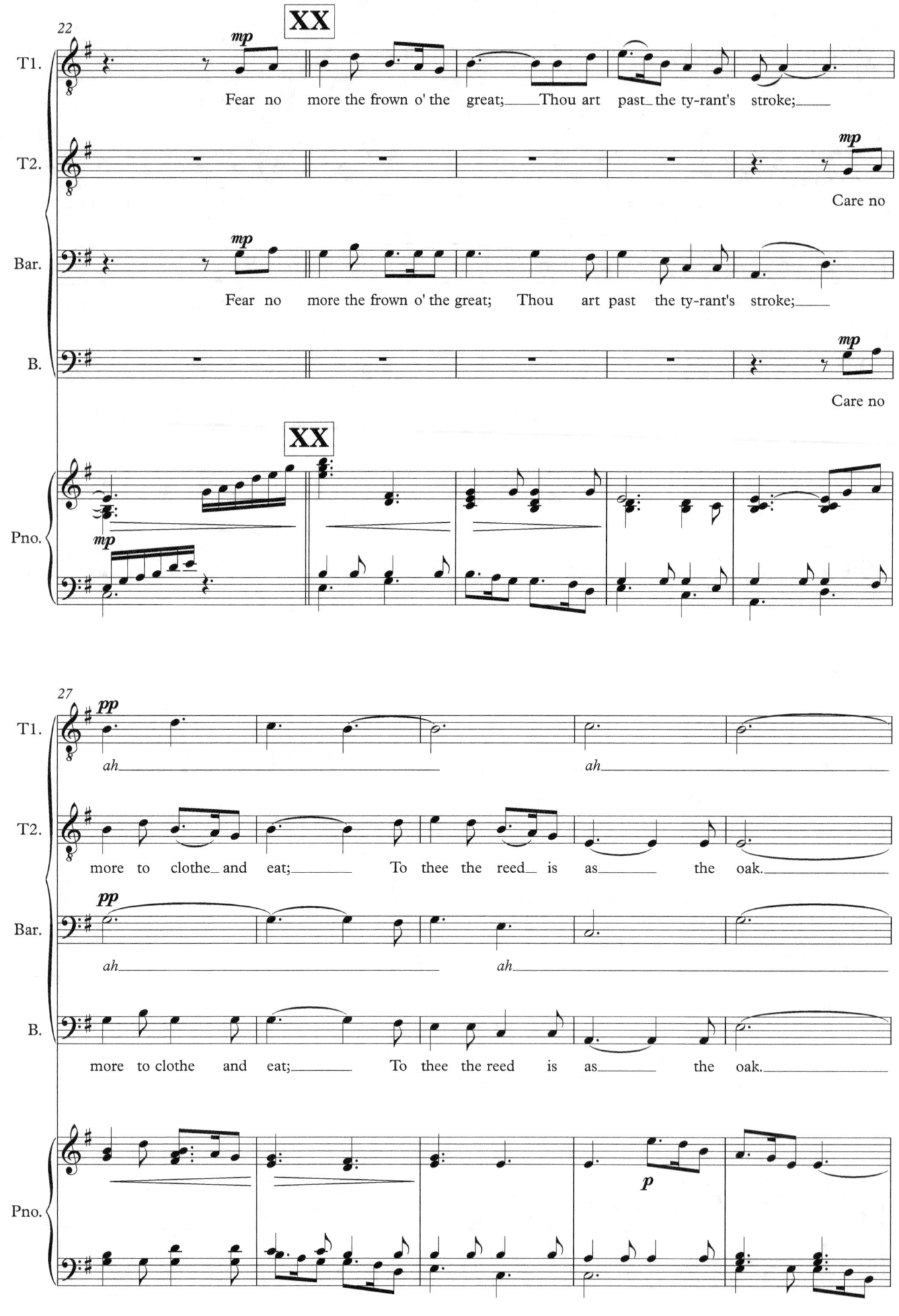

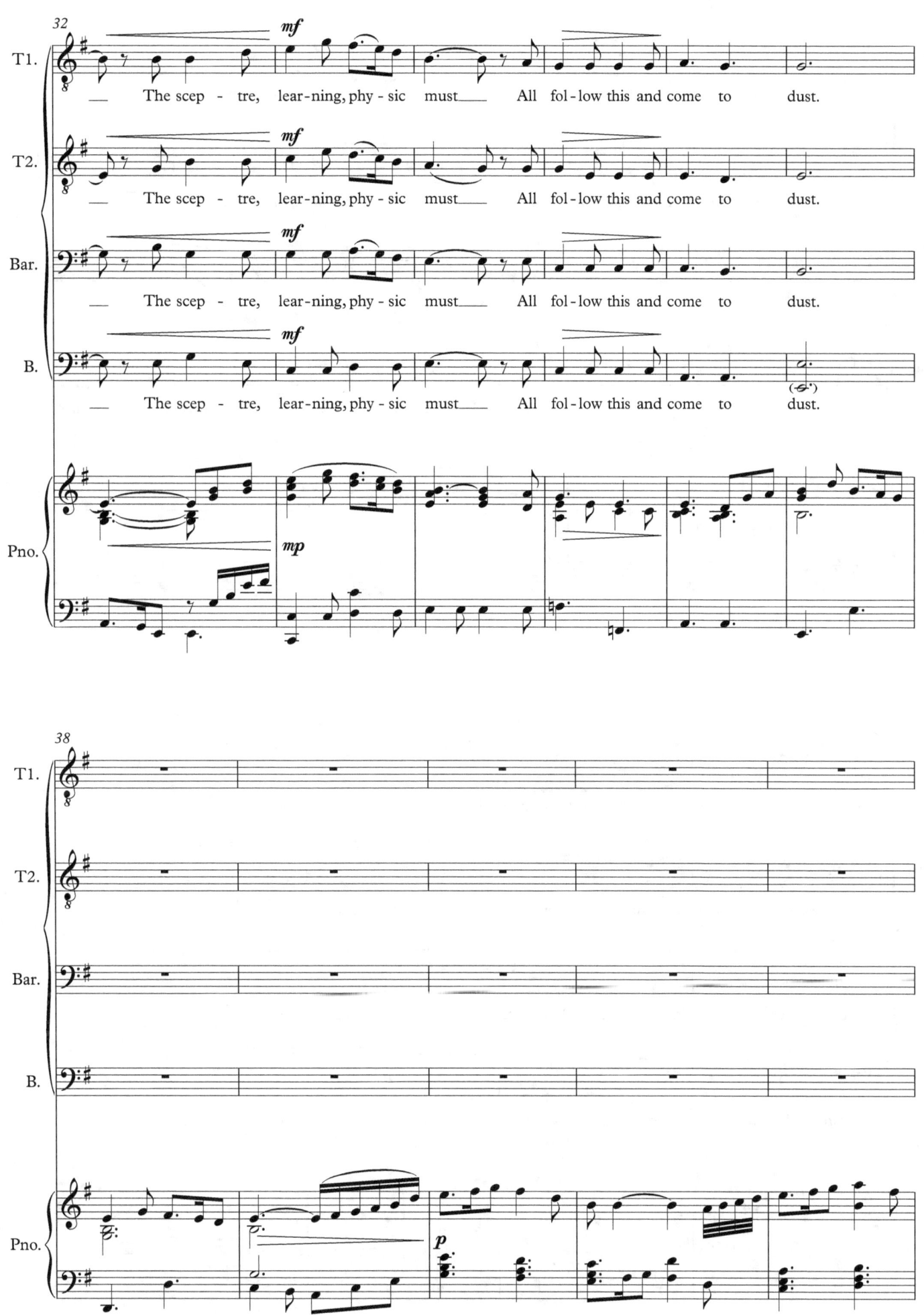

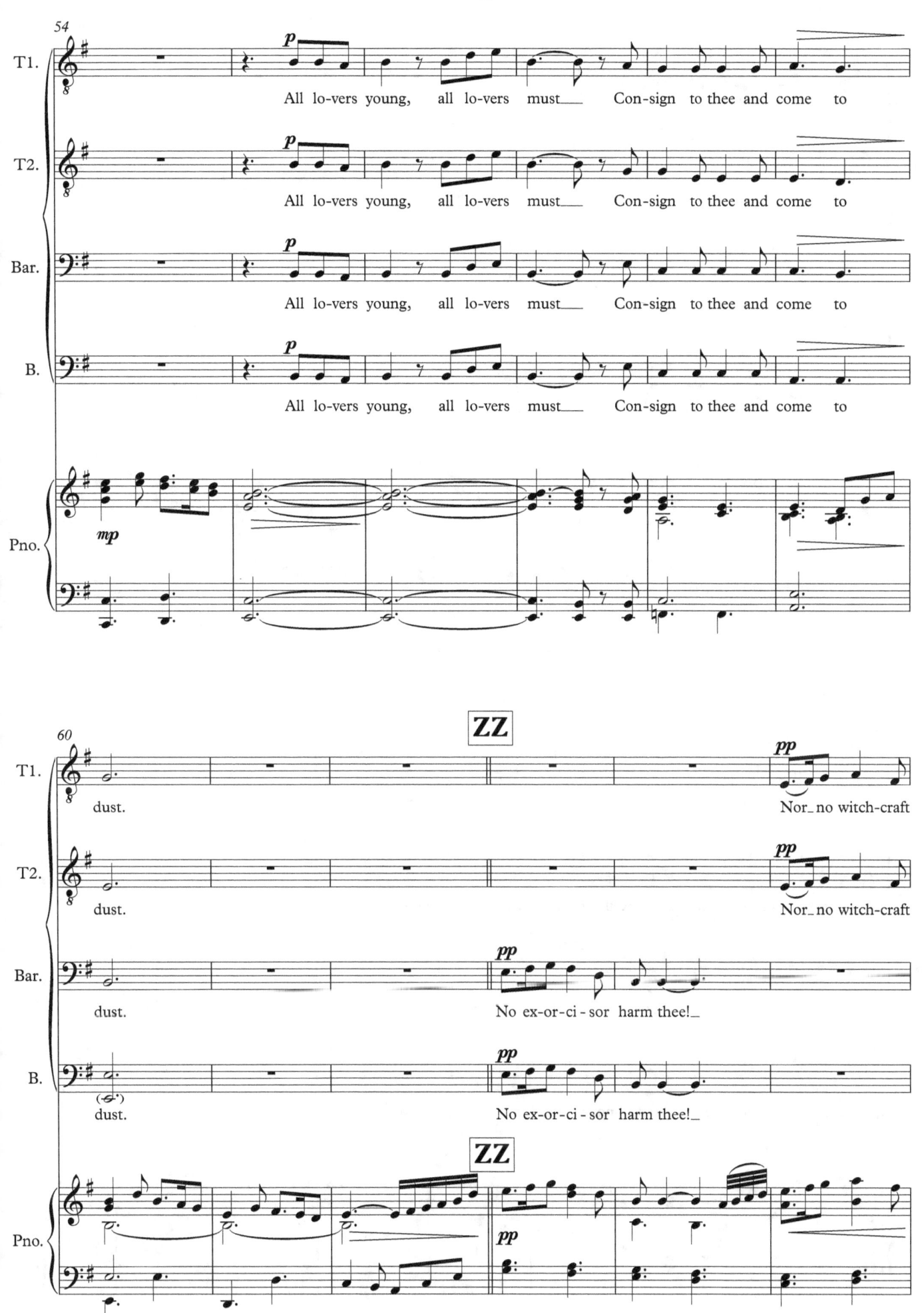

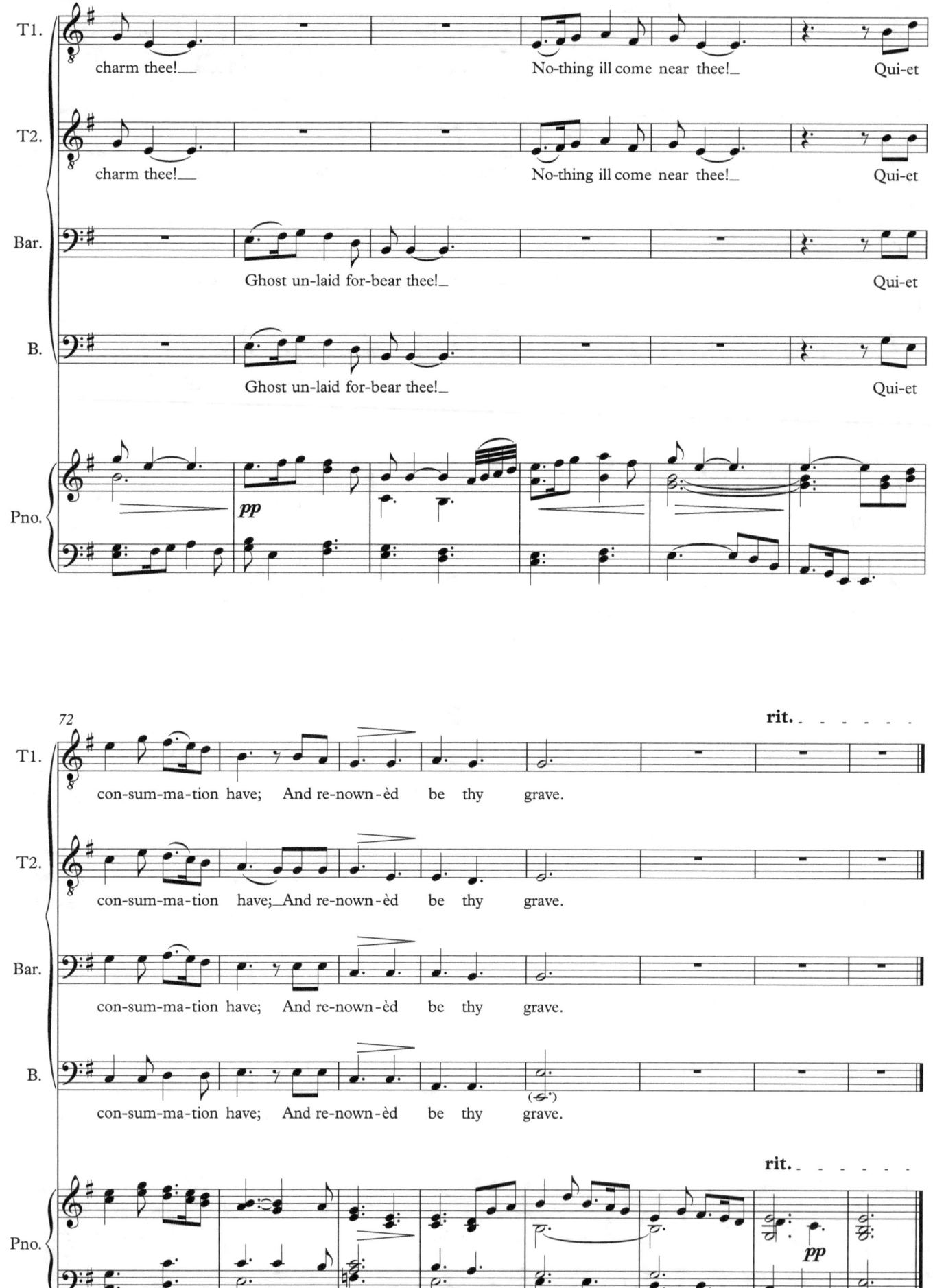

Soprano and Baritone Solos
Upper and Lower Voices
SATB Chorus

For Ben (1973-2008)

15 - Threnody

UPPER VOICES STAND
CHORUS STAND

103

Before the music begins, with all singers standing, there should be an extended moment of silence. If facilities allow, there may also be a poppy drop.

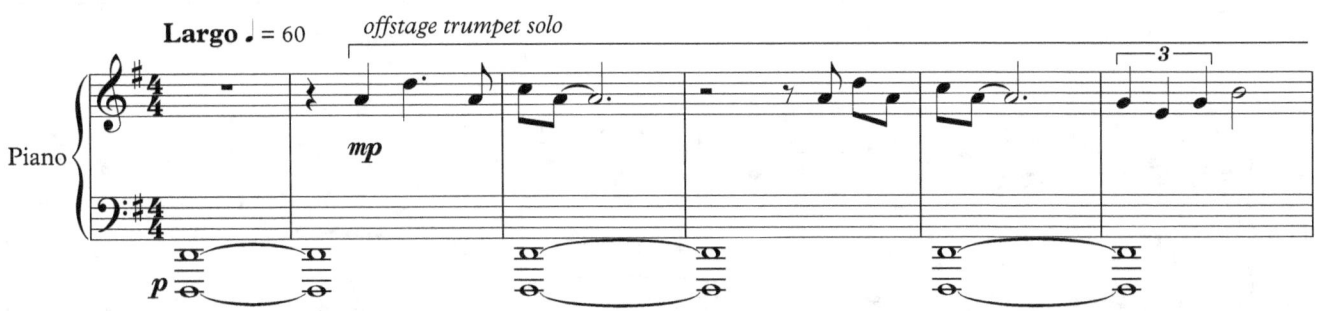

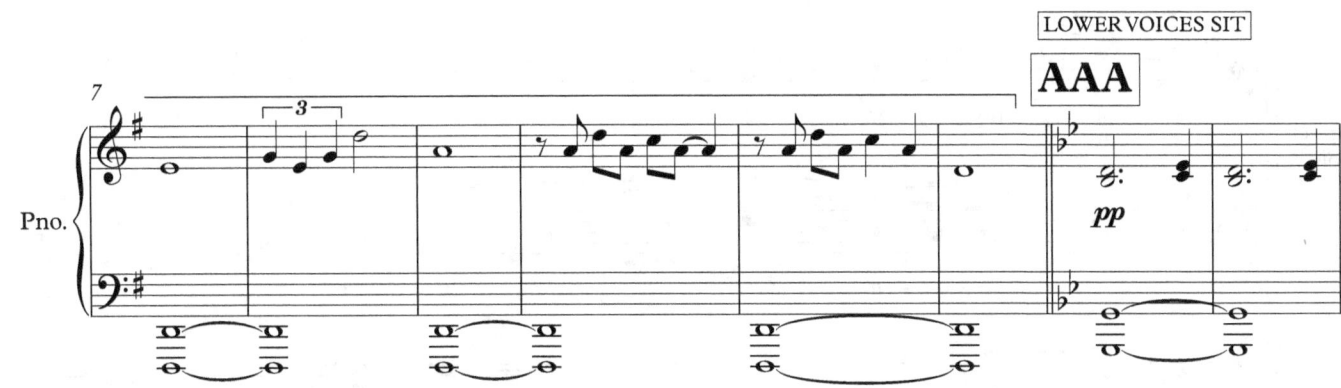

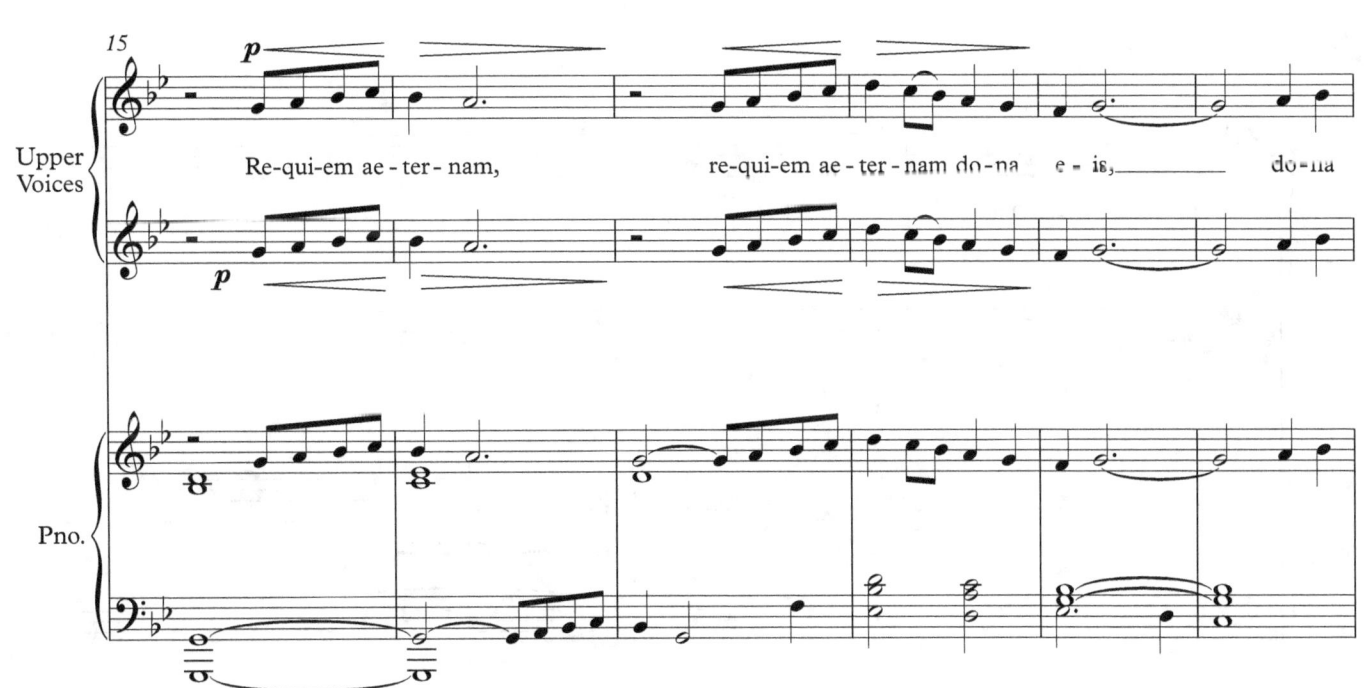

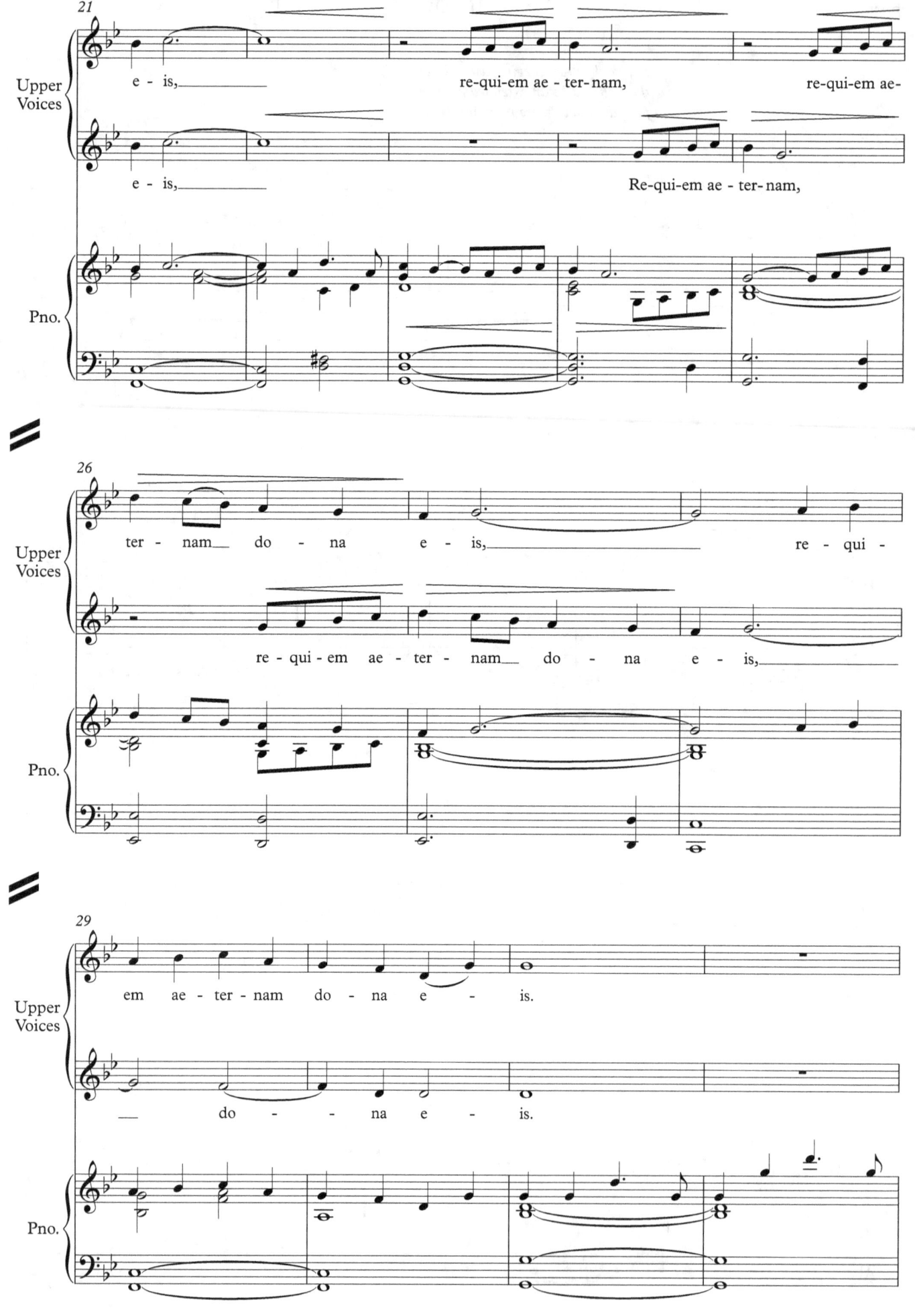

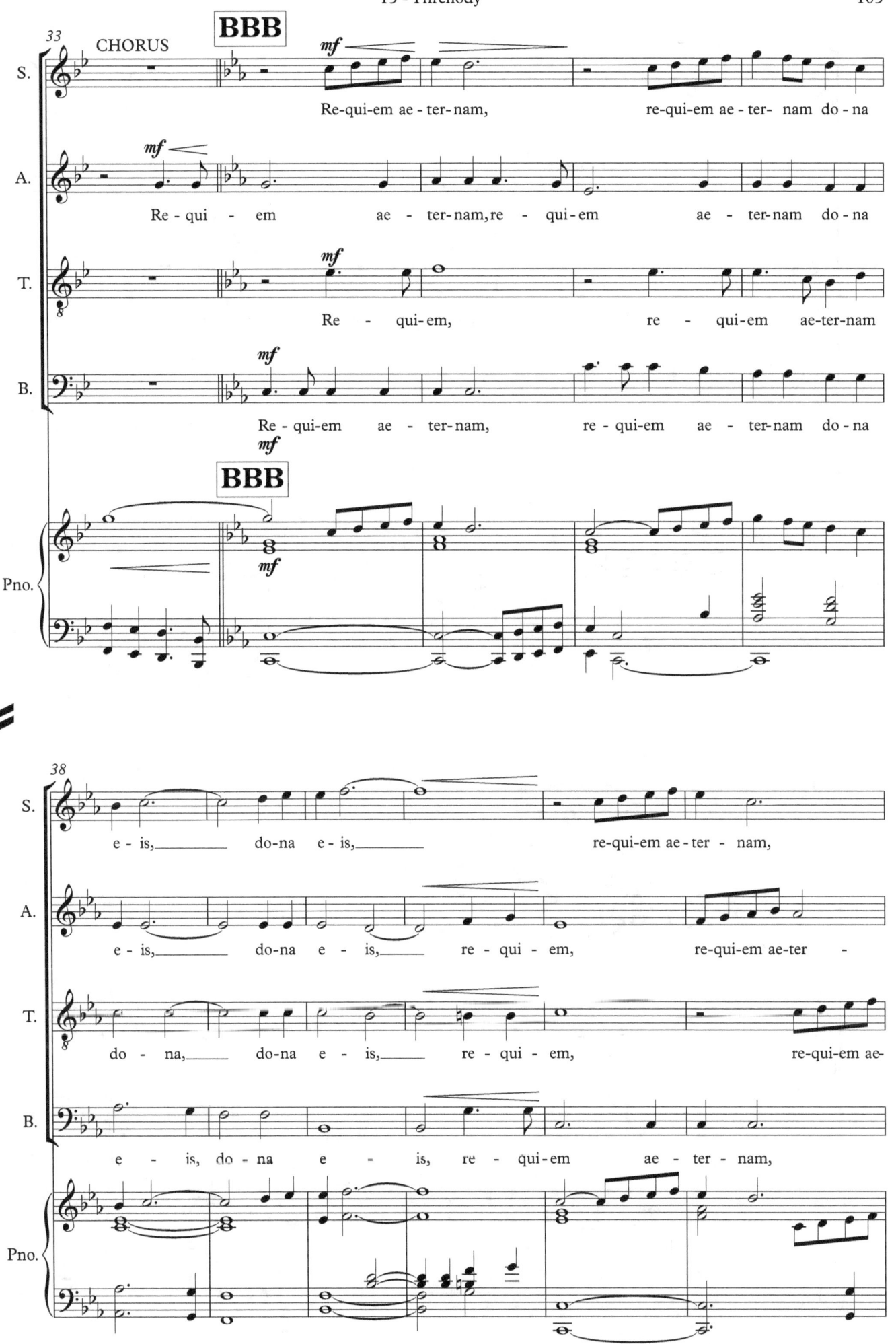

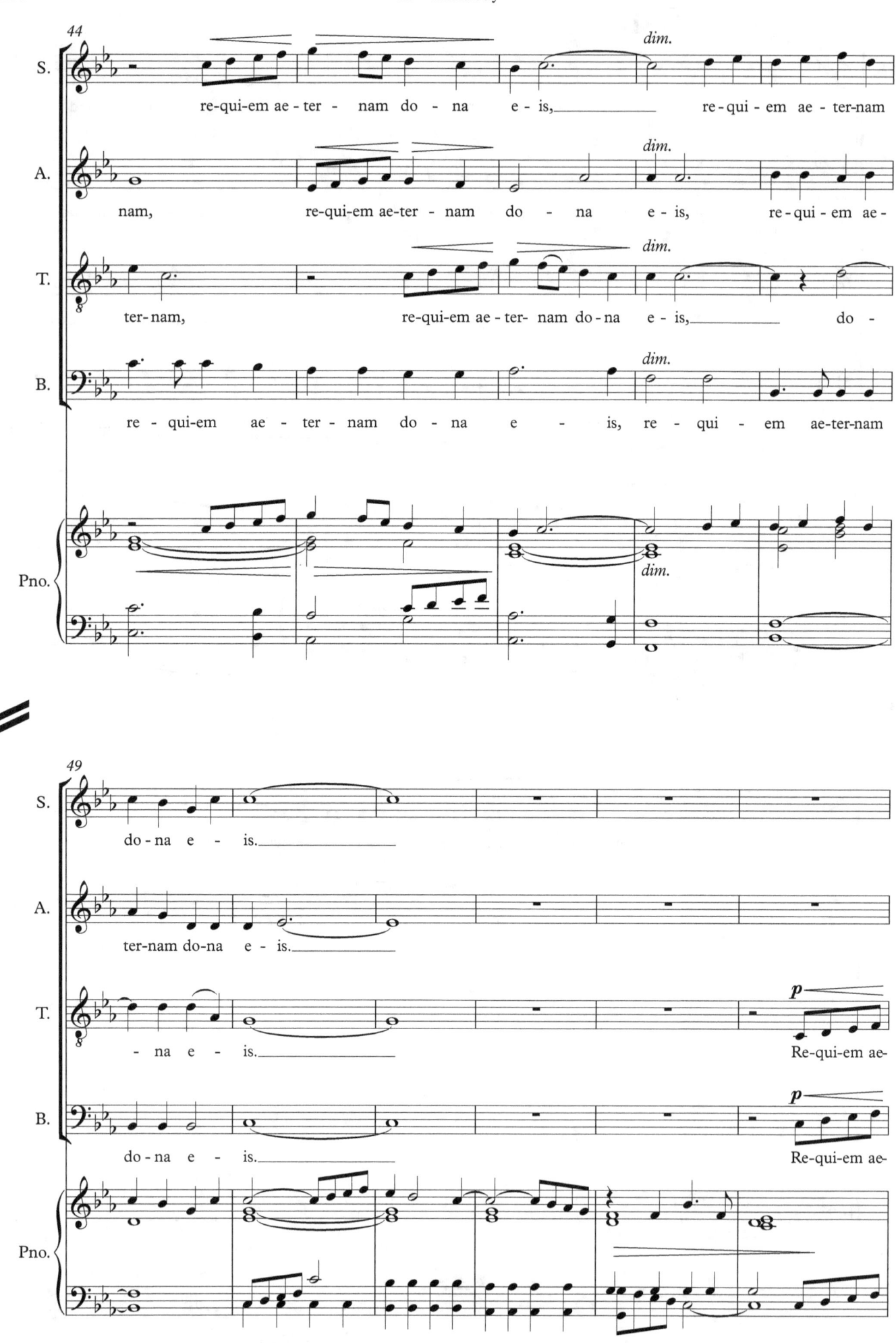

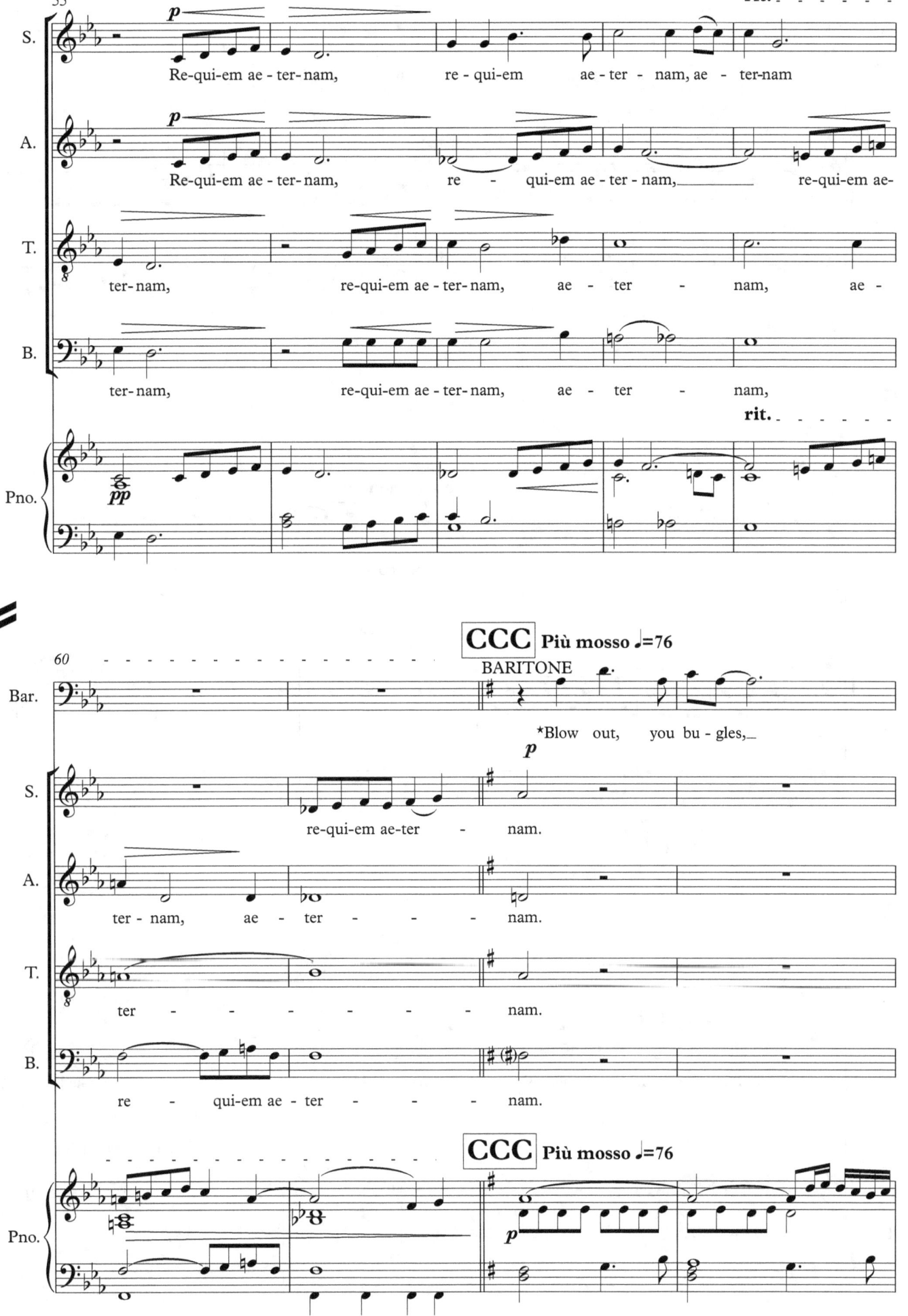

*Rupert Brooke (1887 - 1915): *The Dead*

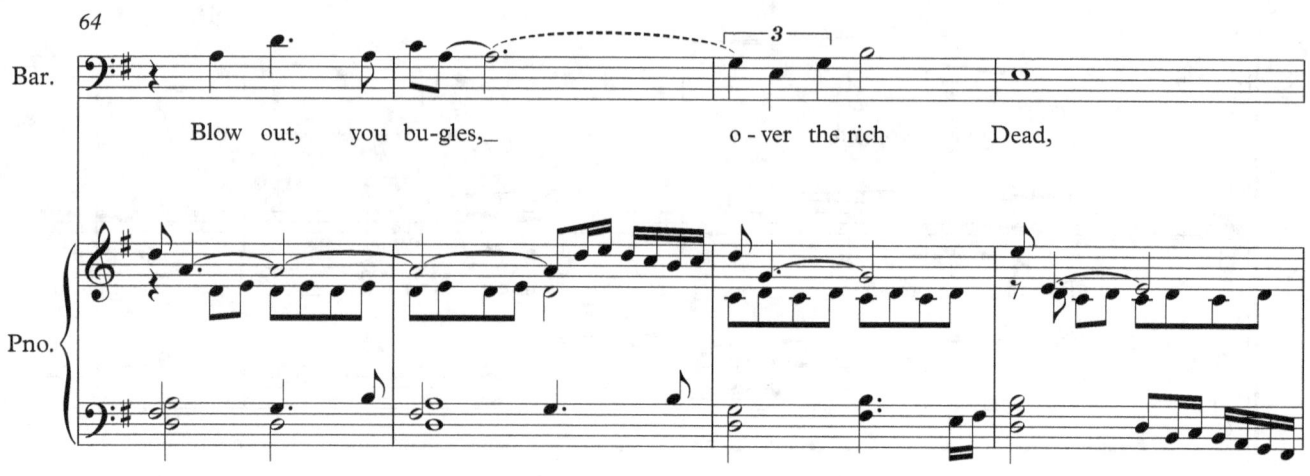

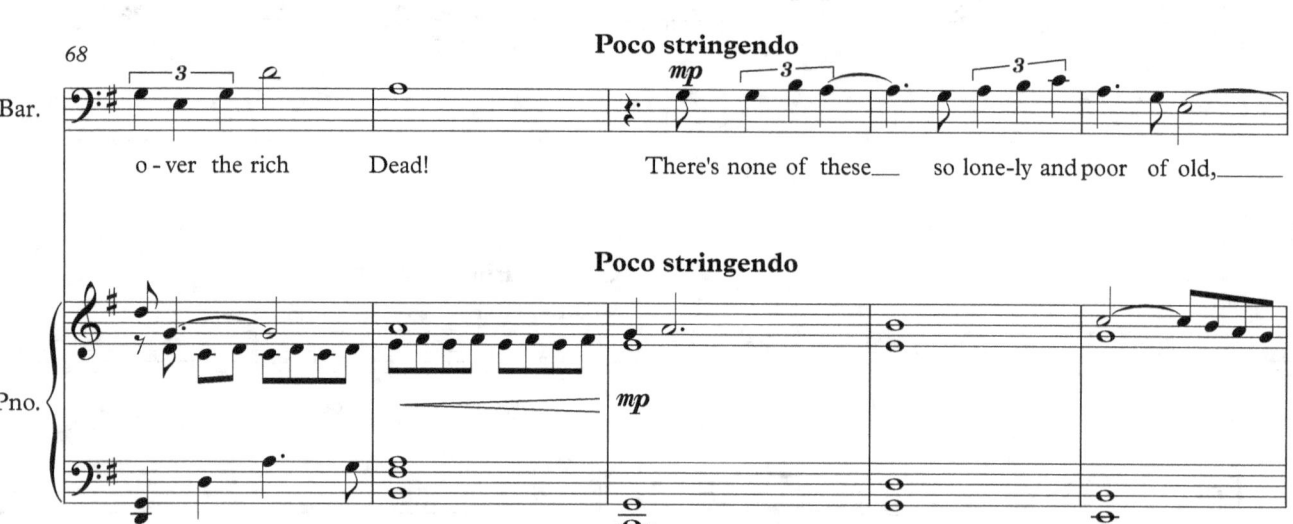

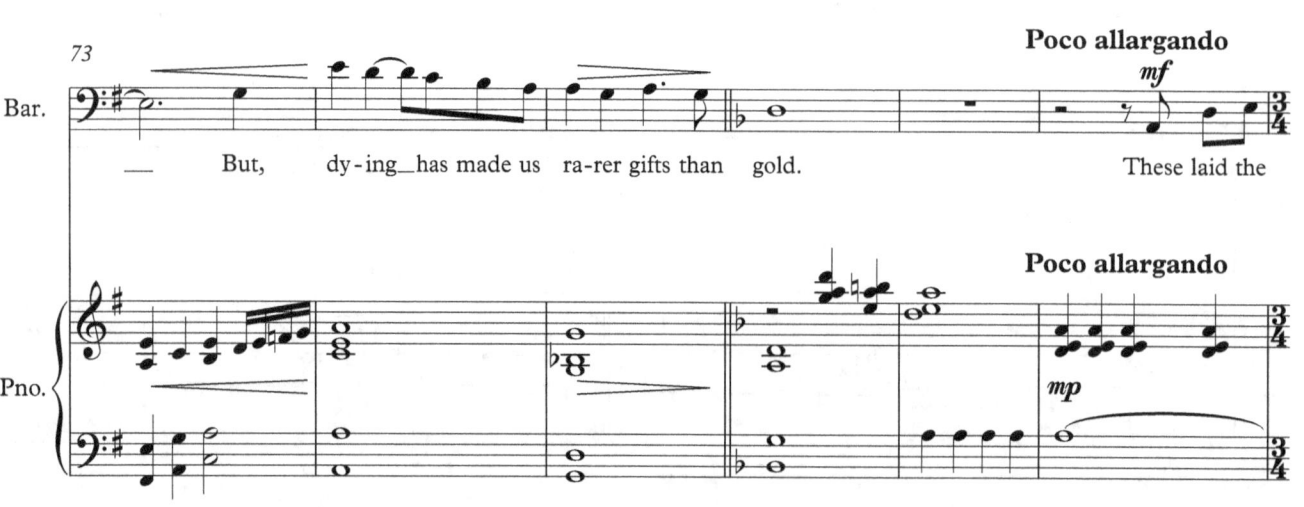

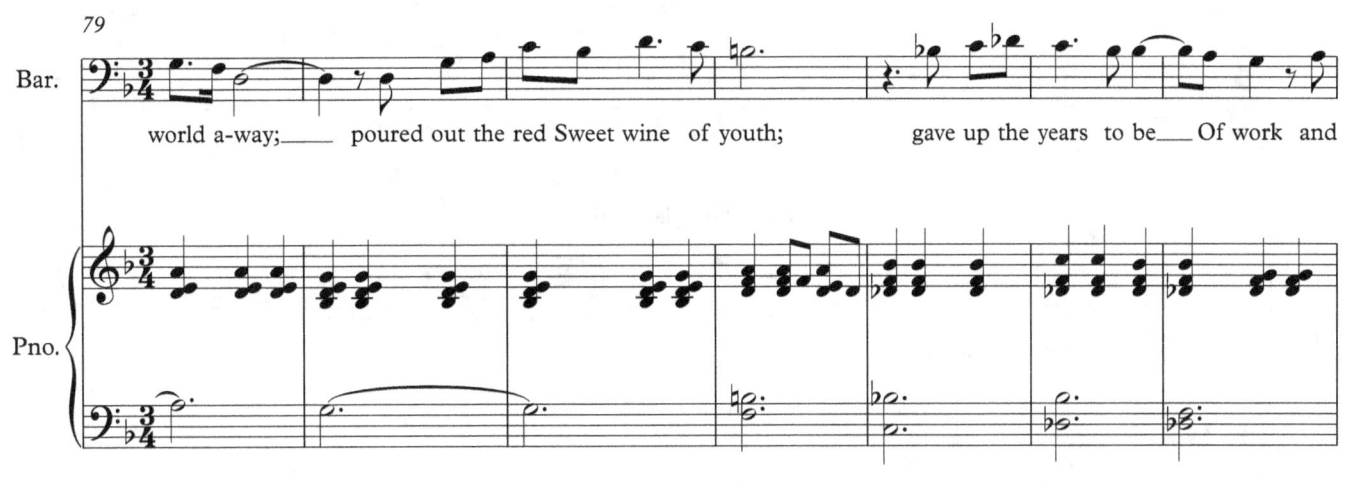
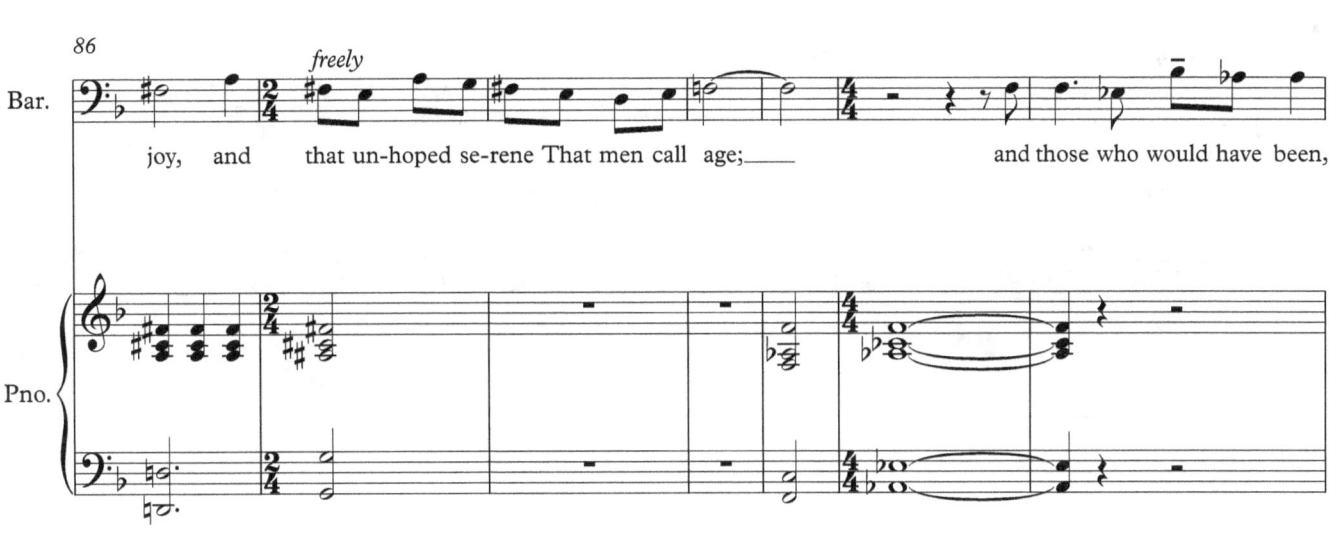
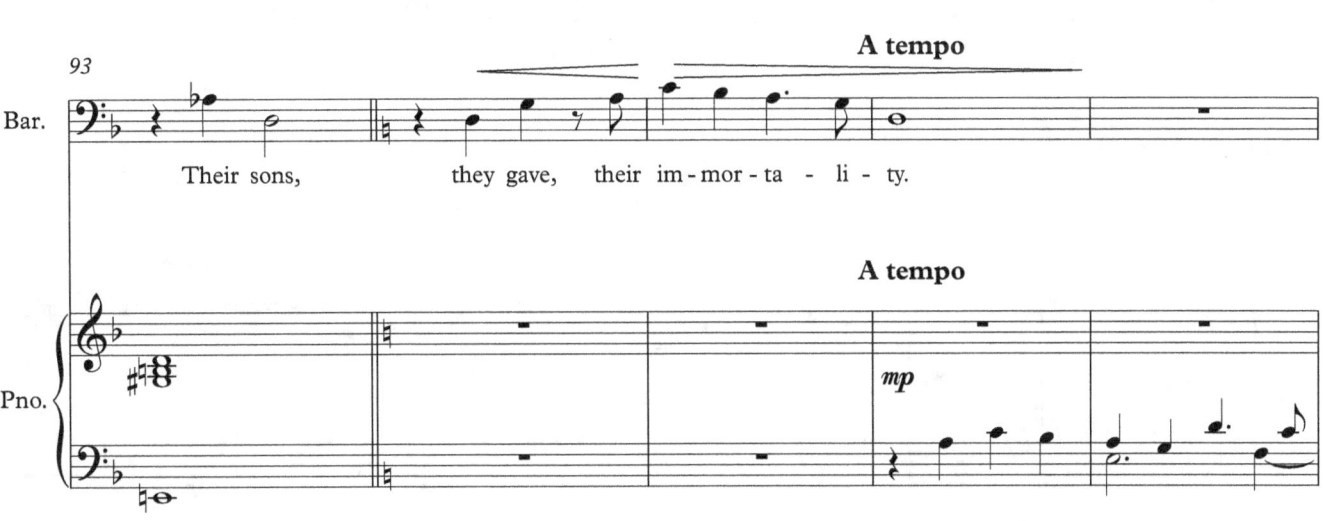

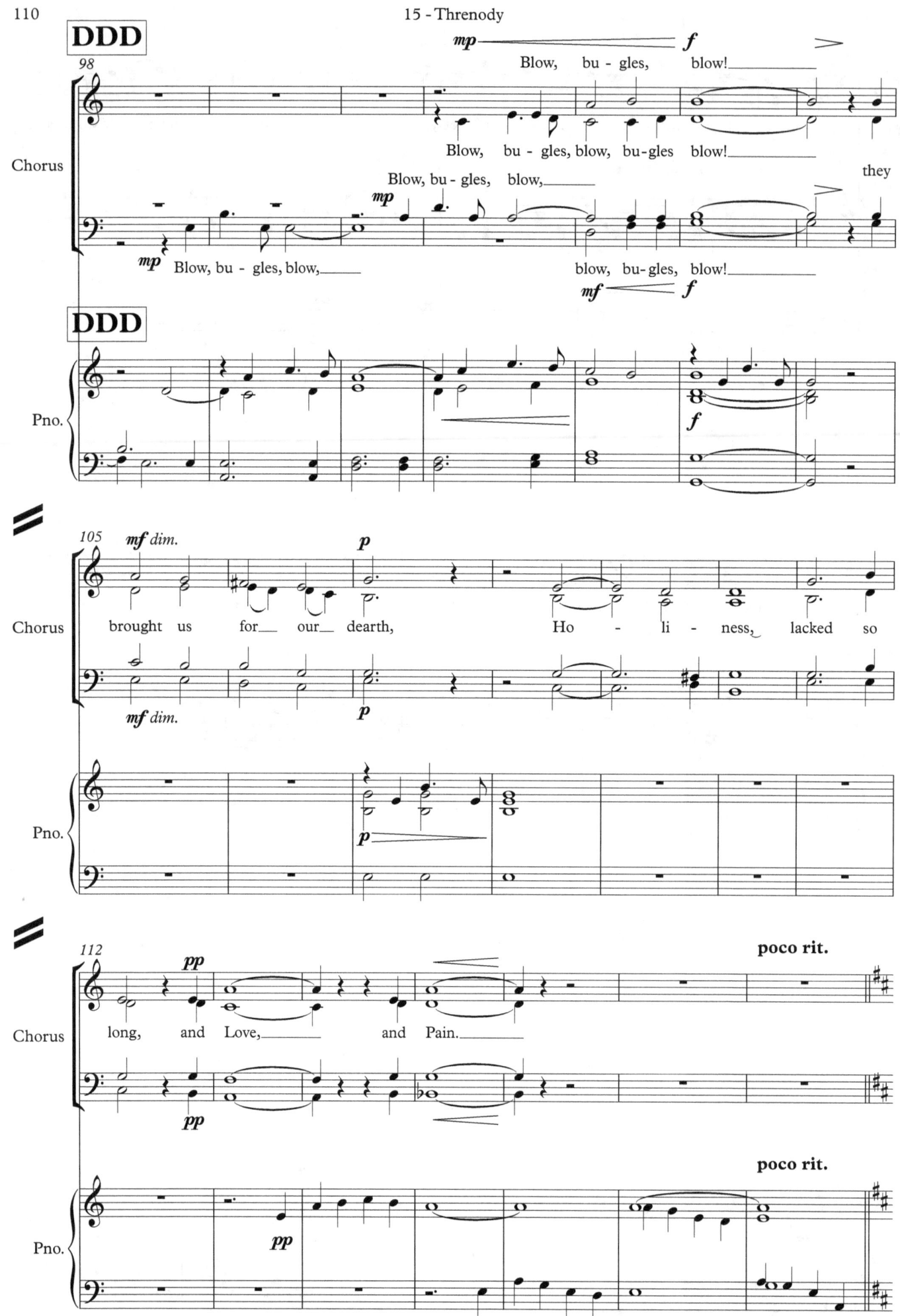

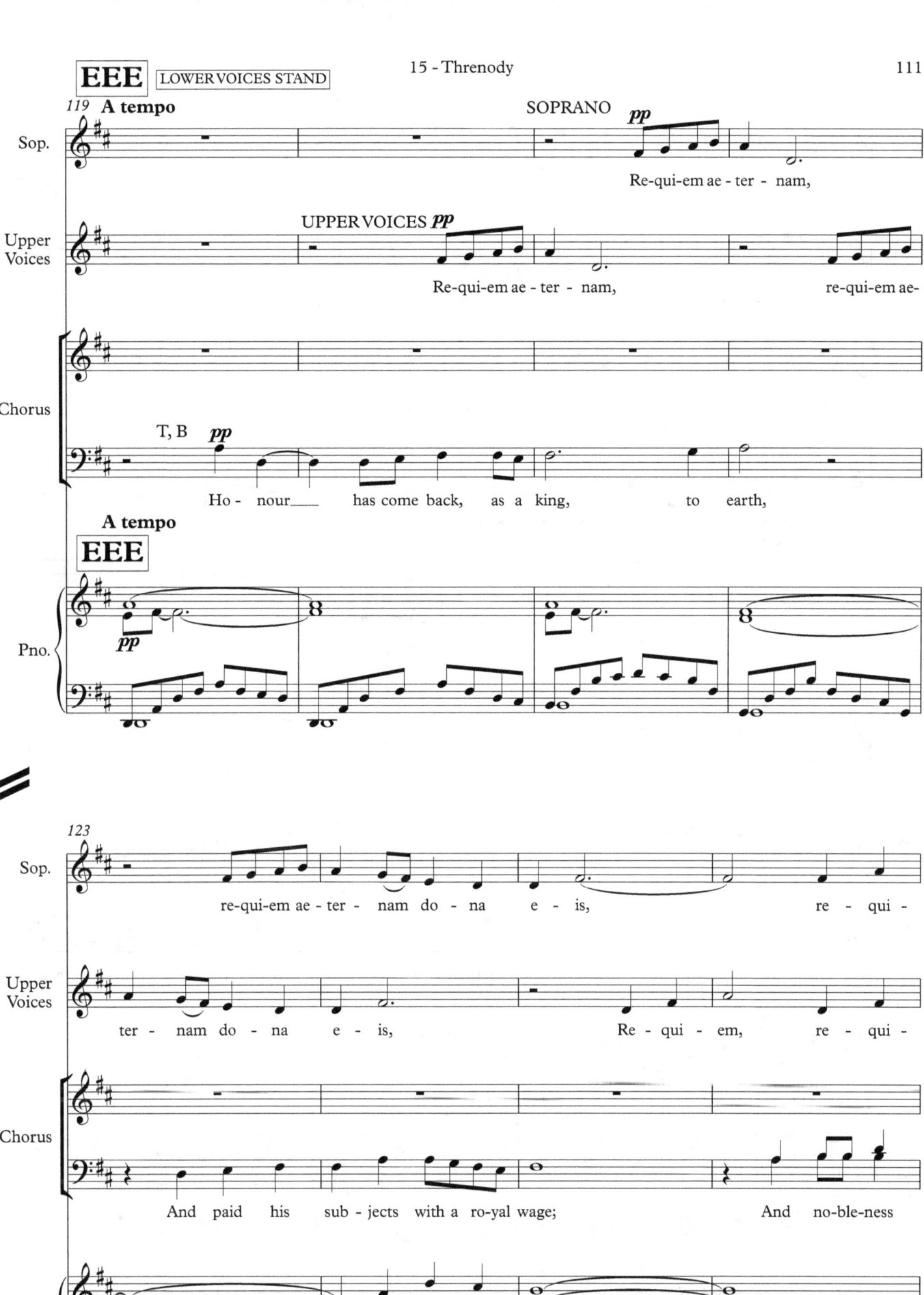

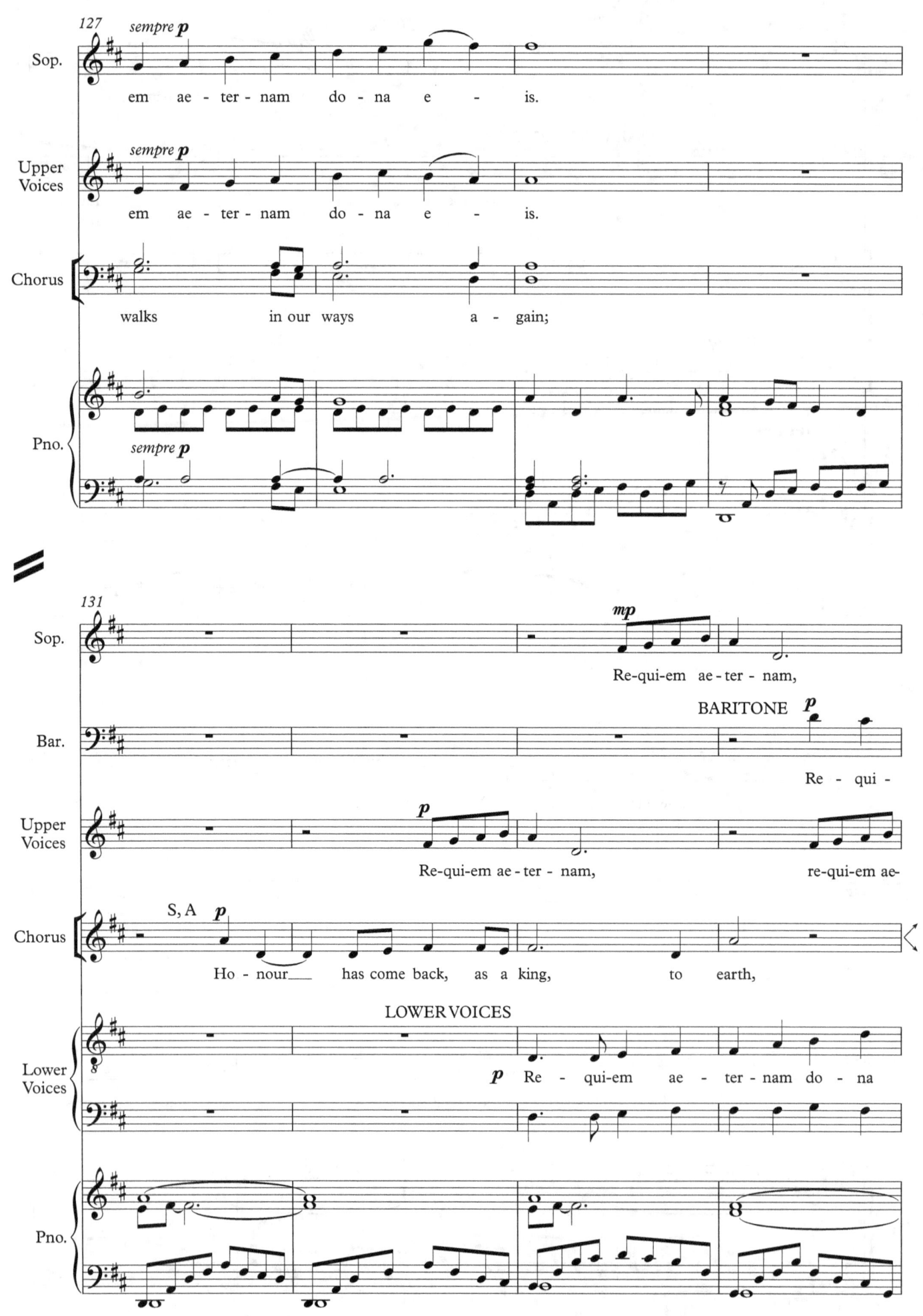

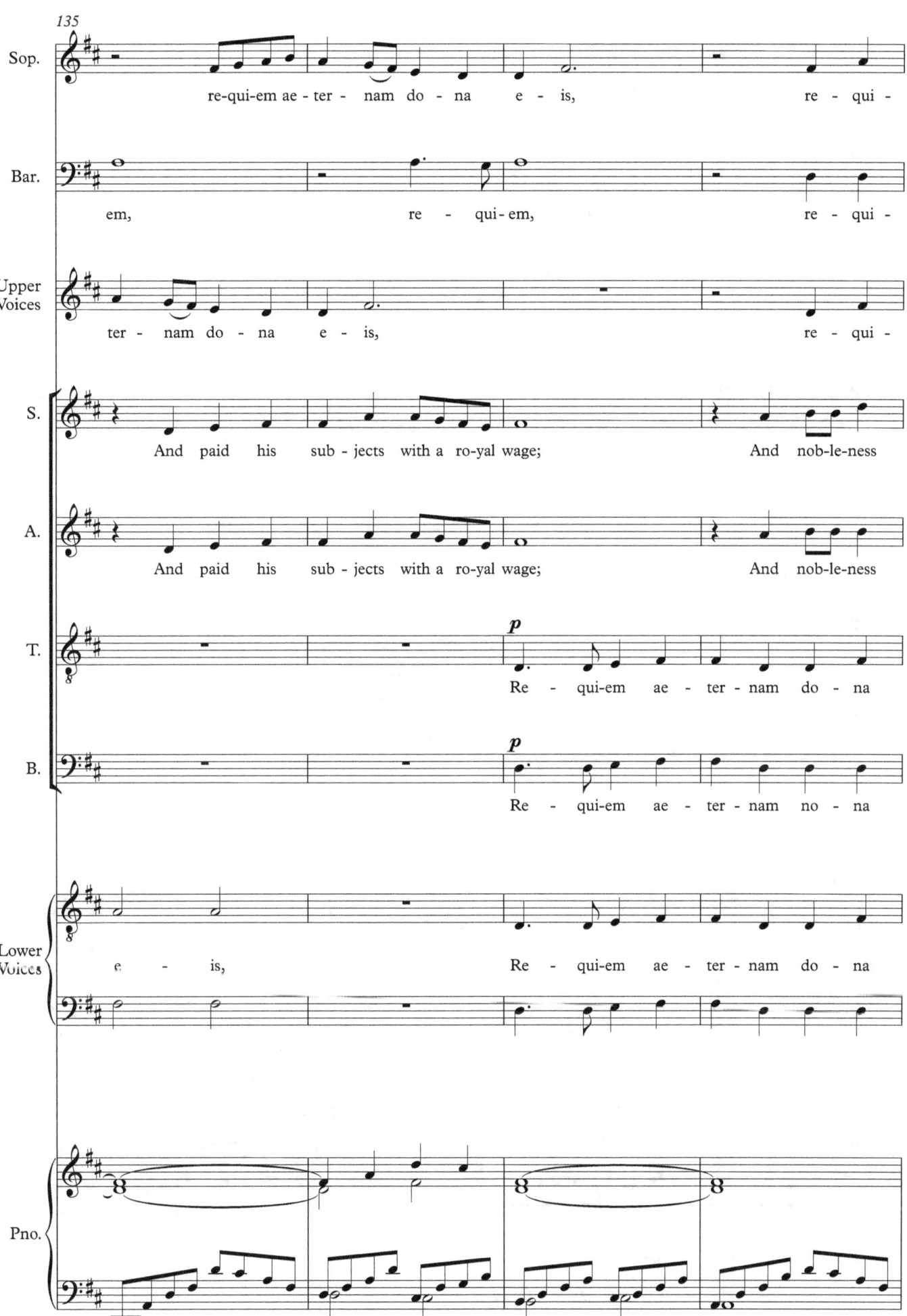

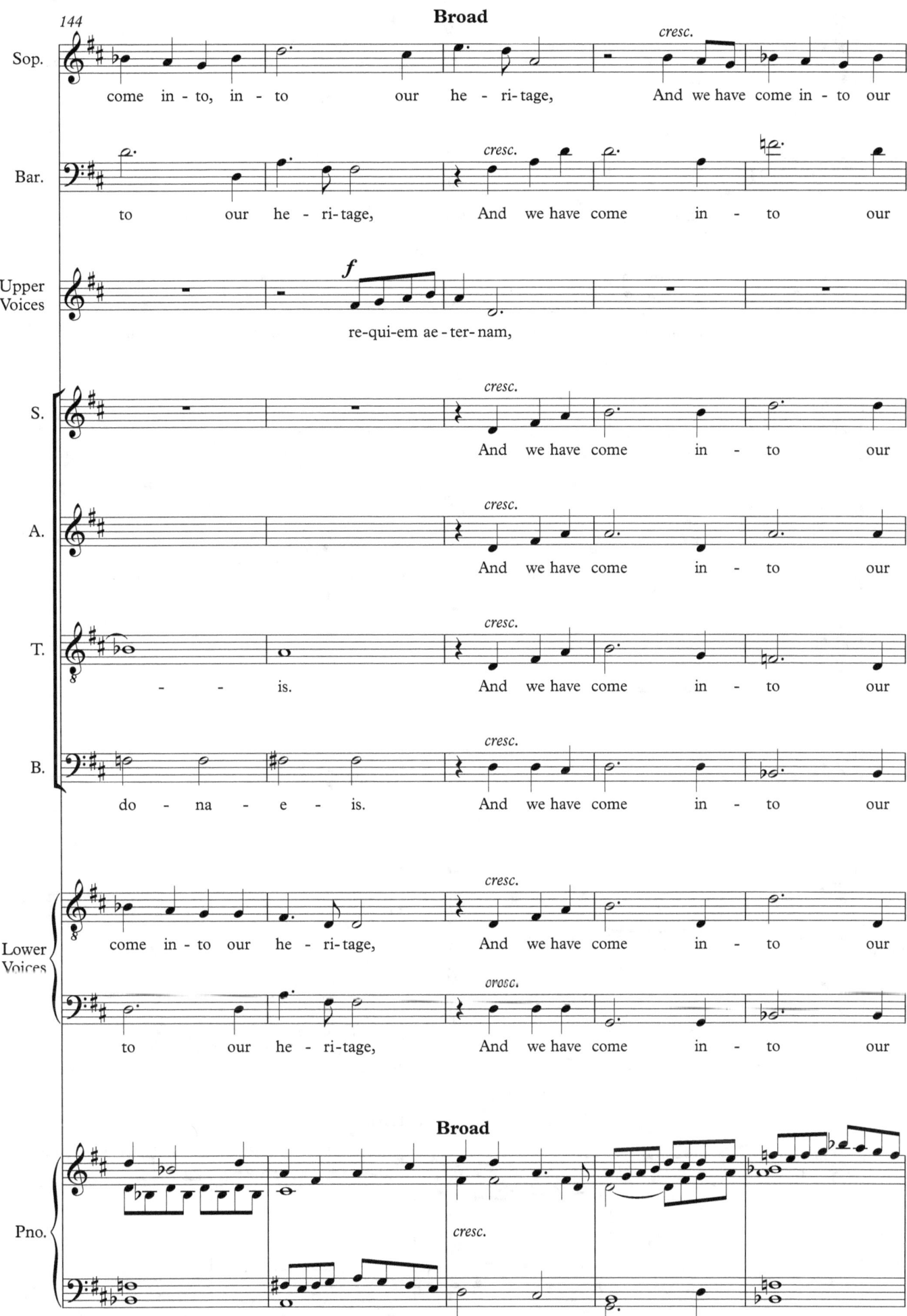

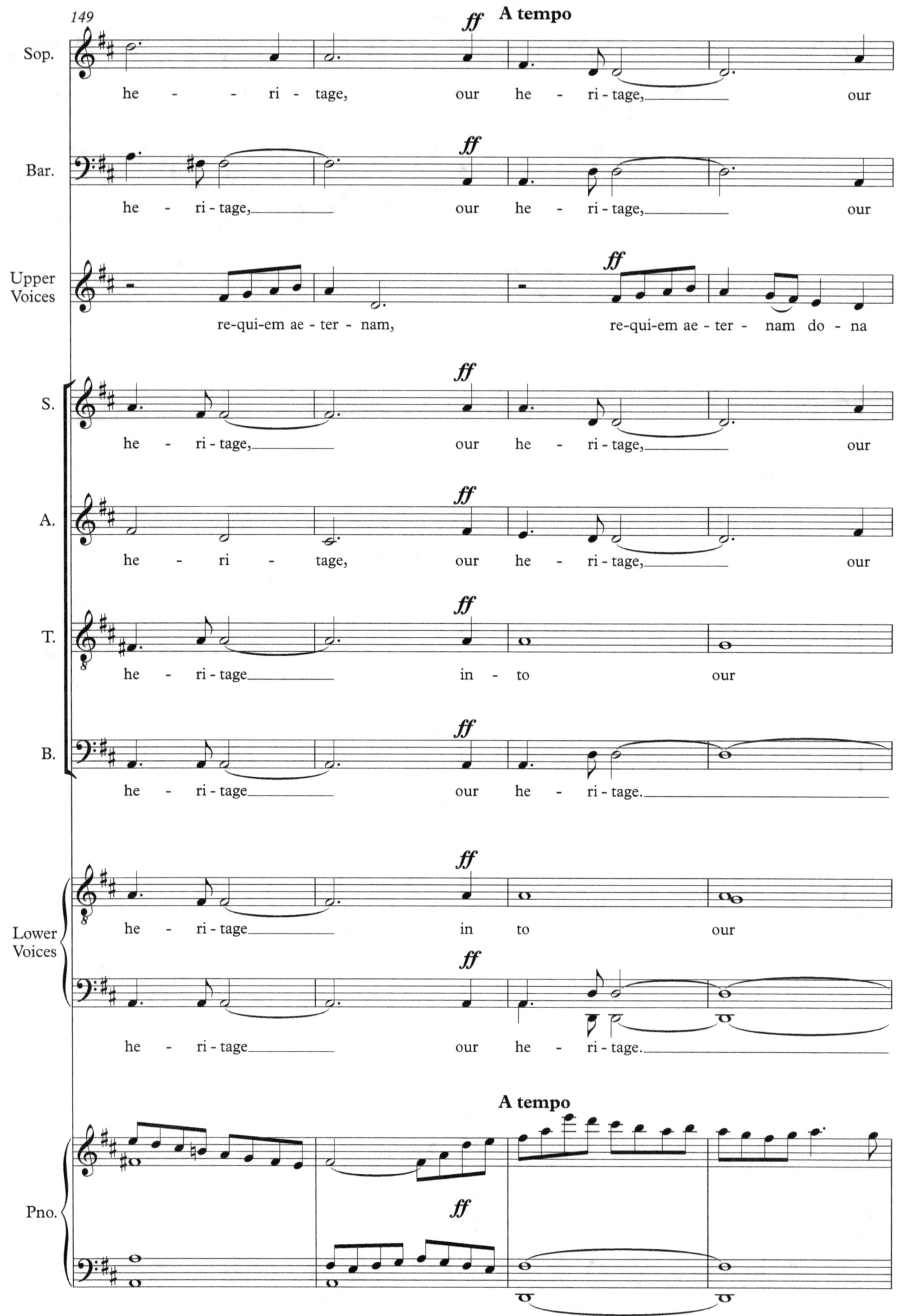

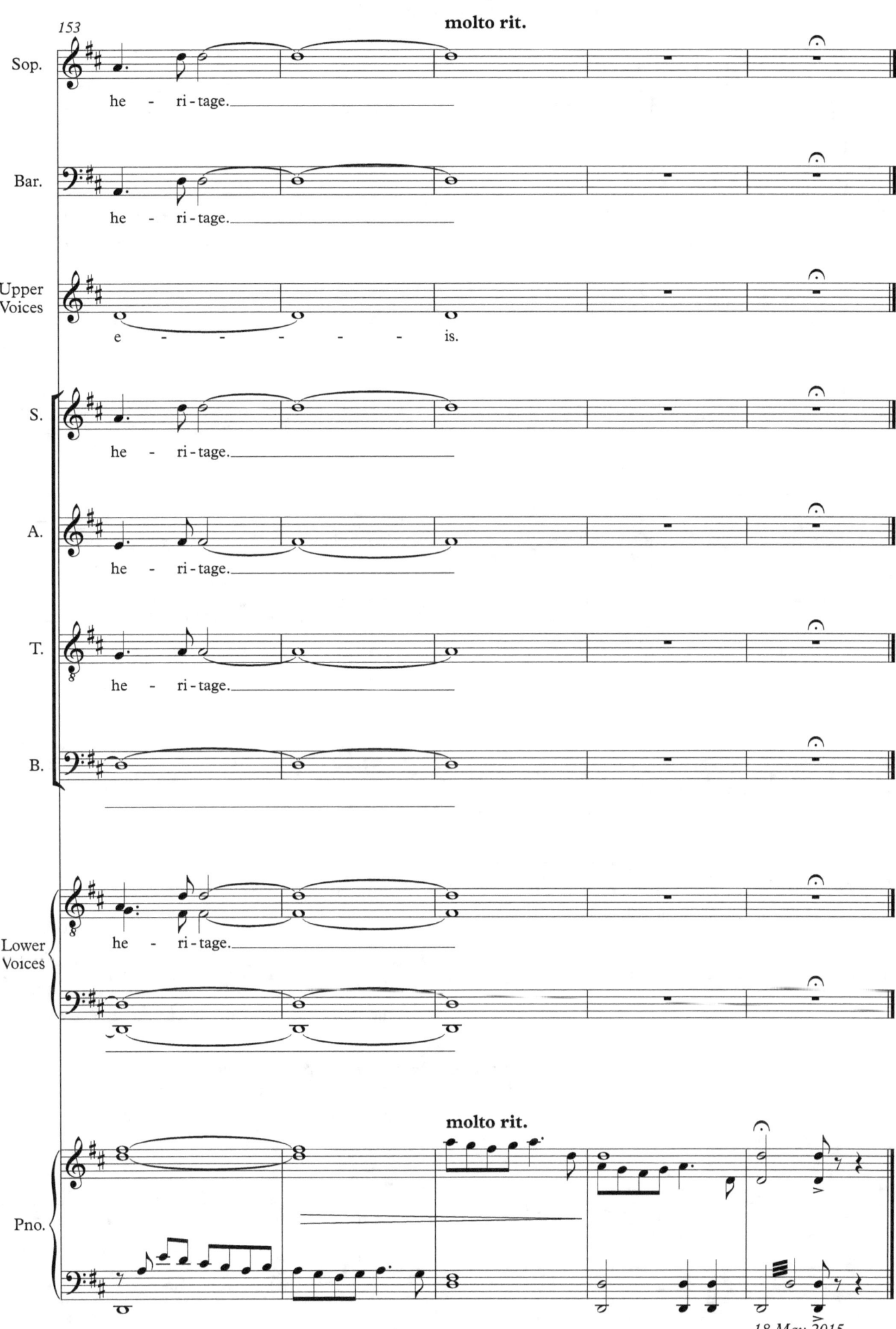

Appendix. 14 - Elegy
(alternative version for SATB)

SATB Chorus

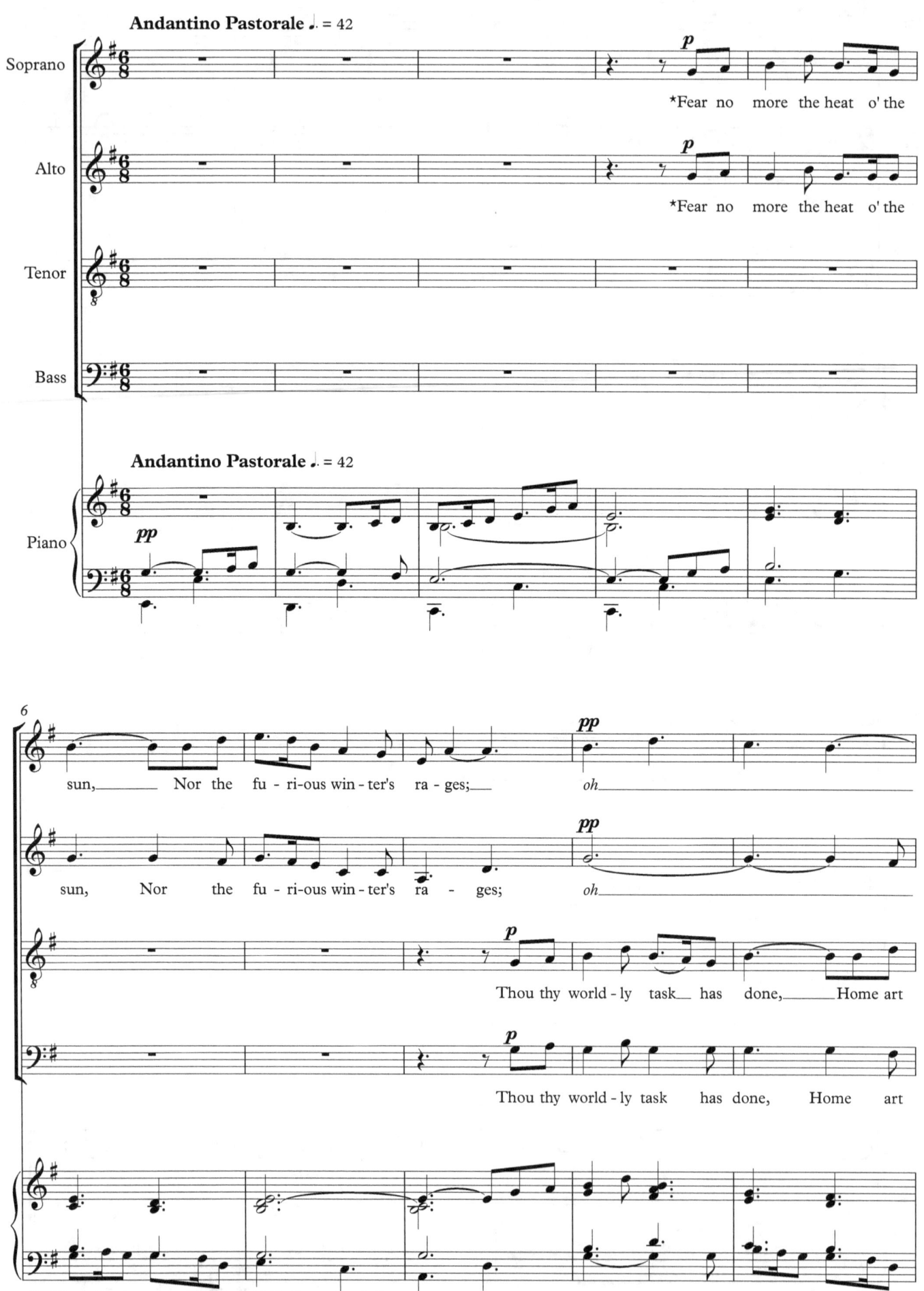

*William Shakespeare (1564 - 1616): from *Cymbeline*

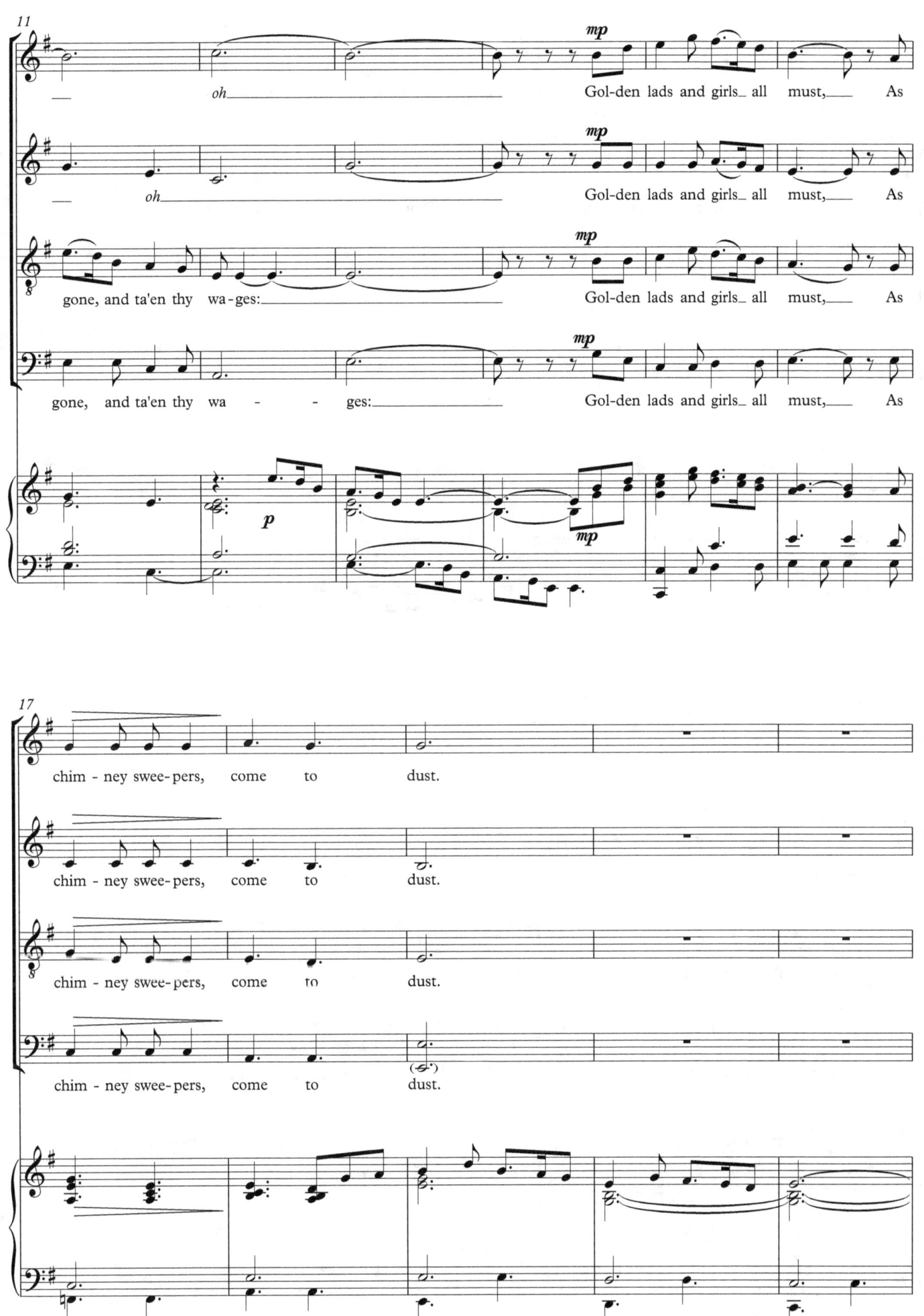

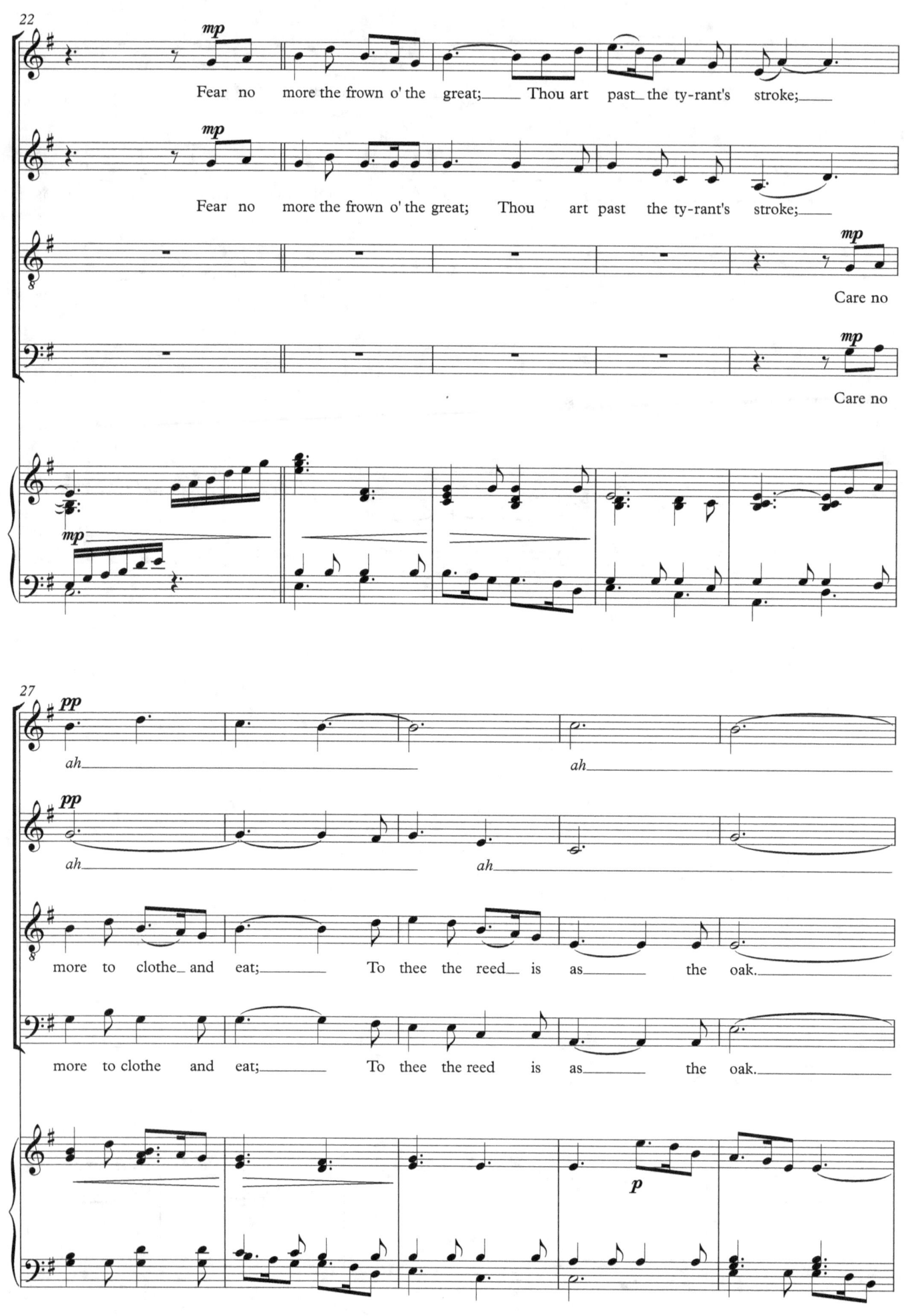

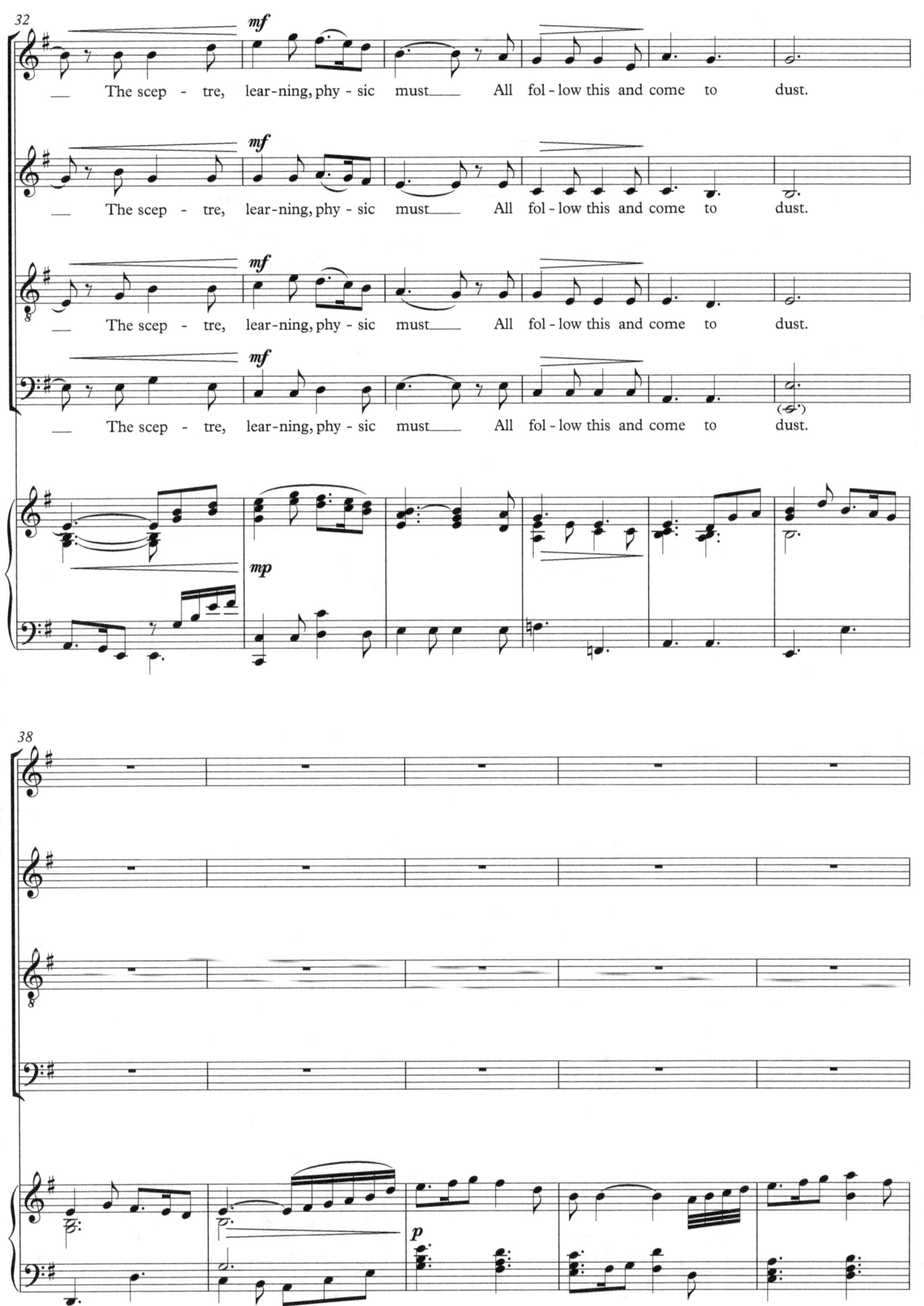

122

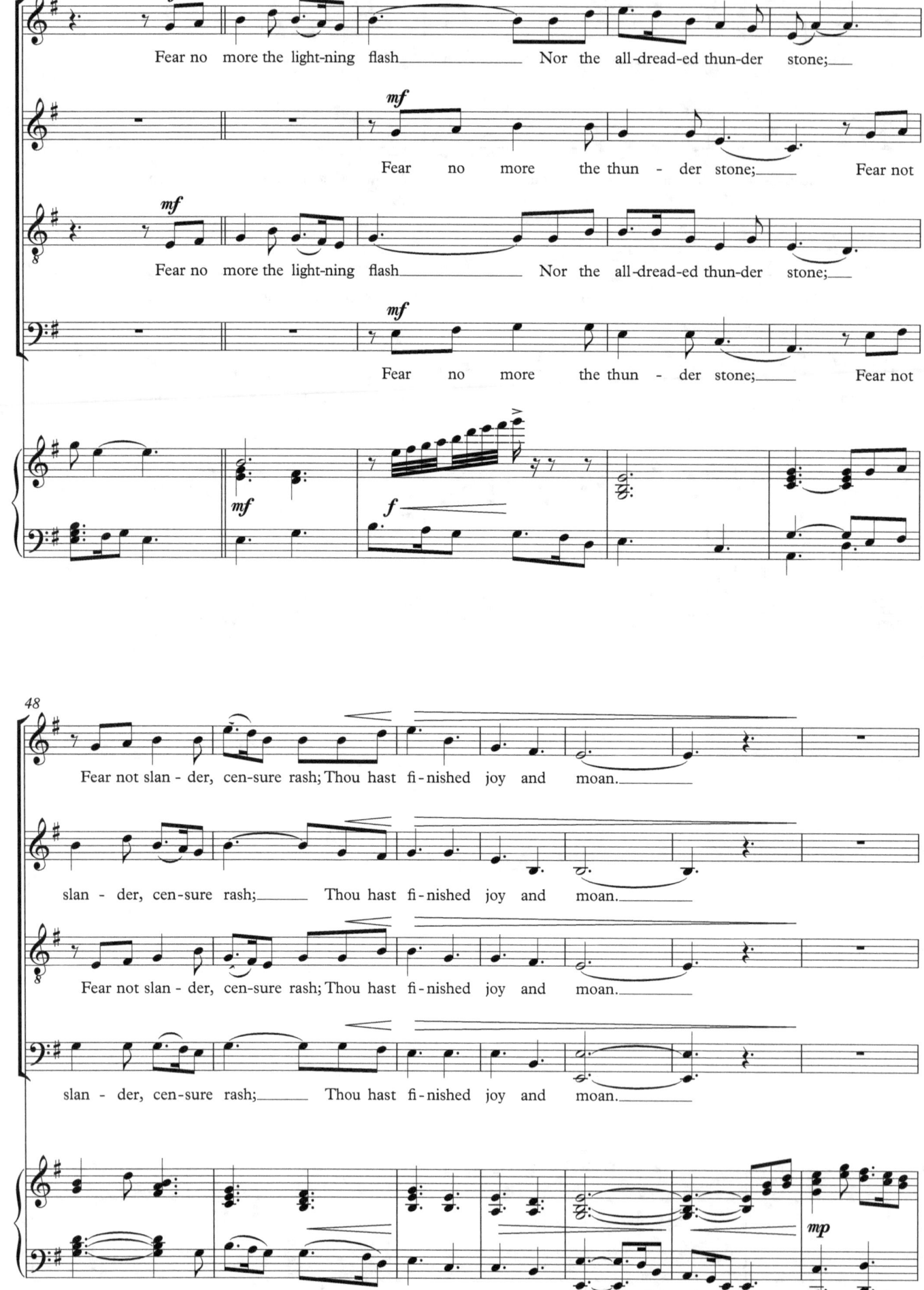

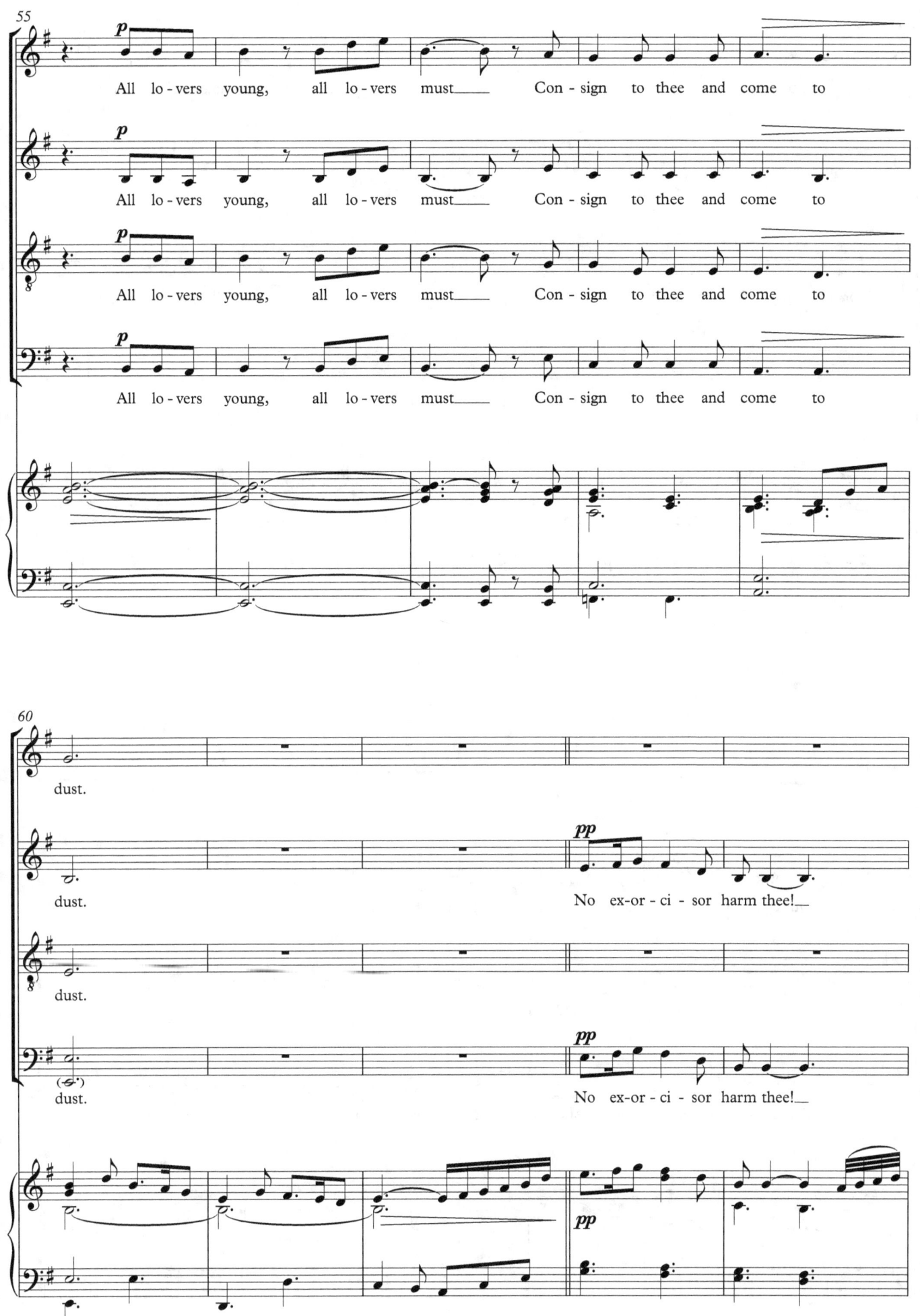

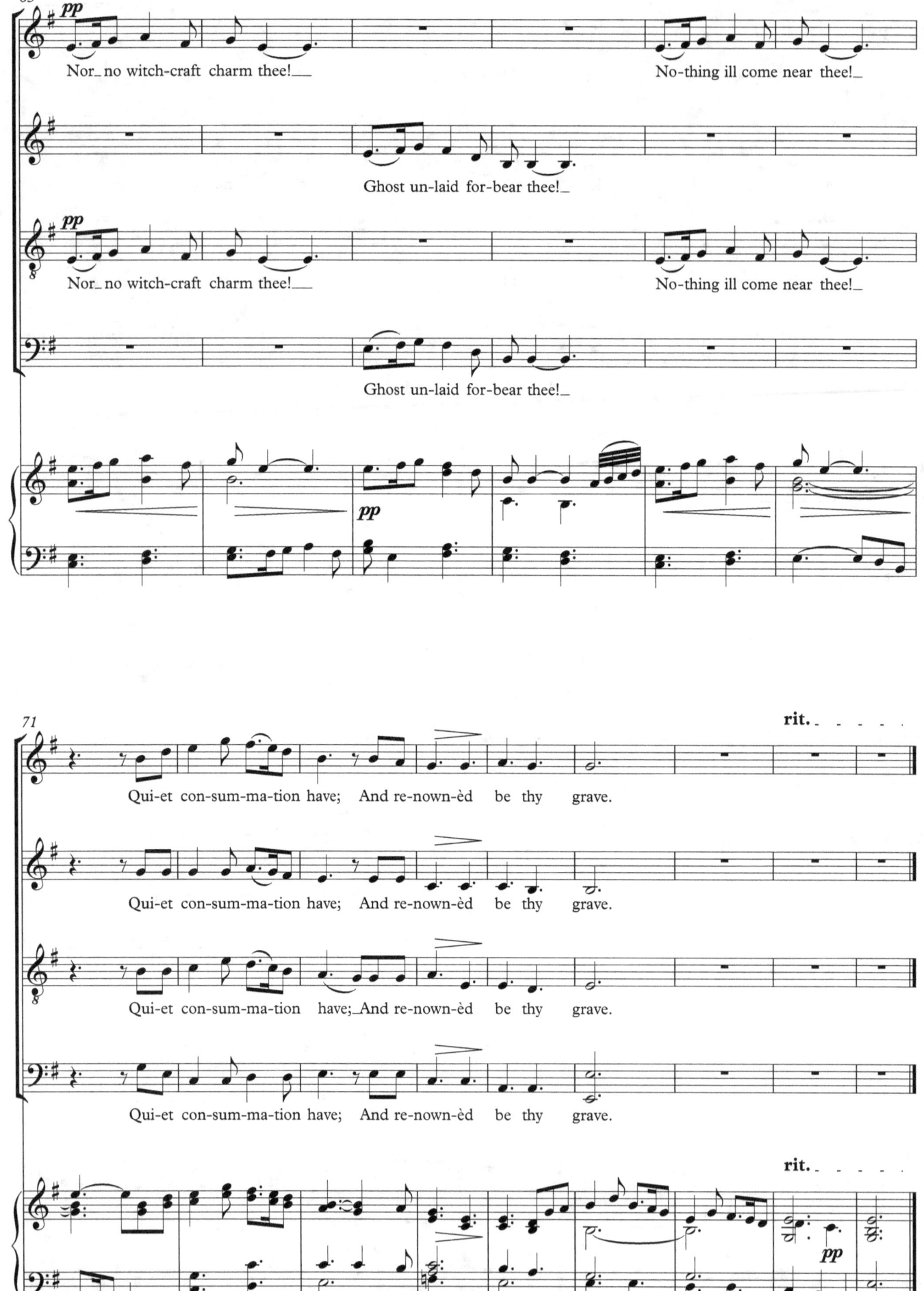

www.ingramcontent.com/pod-product-compliance
Lightning Source LLC
Chambersburg PA
CBHW081047170526
45158CB00006B/1886